MICHAEL FREEMAN
FIFTY PATHS TO CREATIVE PHOTOGRAPHY

An Hachette UK Company
www.hachette.co.uk

First published in the United Kingdom in 2016 by
ILEX, a division of Octopus Publishing Group Ltd

Octopus Publishing Group
Carmelite House
50 Victoria Embankment
London, EC4Y 0DZ
www.octopusbooks.co.uk

Distributed in the US by
Hachette Book Group USA
237 Park Avenue
New York NY 10017 USA

Distributed in Canada by
Canadian Manda Group
165 Dufferin Street
Toronto, Ontario, Canada M6K 3H6

Publisher: Roly Allen
Associate Publisher: Adam Juniper
Managing Specialist Editor: Frank Gallaugher
Senior Project Editor: Natalia Price-Cabrera
Editor: Rachel Silverlight
Art Director: Julie Weir
Designer: Eoghan O'brien
Picture Research: Giulia Hetherington
Senior Production Manager: Peter Hunt

ISBN 978-1-78157-347-1

A CIP catalogue record for this book is available from the British Library

Printed and bound in China

10 9 8 7 6 5 4 3 2 1

MICHAEL FREEMAN
FIFTY PATHS TO CREATIVE PHOTOGRAPHY

ilex

CONTENTS

INTRODUCTION

Can photography truly be creative? Or does it just record what's there? Not everyone has been convinced. Plato said: "Will we say, of a painter, that he makes something? Certainly not. He merely imitates." He would, no doubt, have seen photography the same way. He was wrong. Creativity with a camera is a balancing act. It means engaging with life and with unpredictable events. Capturing moments. But it also means doing this with a personal flair. Your own way of thinking and seeing.

You're taking the viewer by the hand and showing them exactly where you were at a moment in time that can never be repeated.

You're saying "let me show you what I saw. No one else's, just my view."

You're showing something you valued, which caught your imagination and feeling.

Something that's worth sharing with all of us.

And there are ways of bringing out the creativity, bringing it to the light. Practical ways that you can follow.

Paths, in fact...

50 paths.

THERE ARE NO RULES

This is not an engineering course. There's nothing to get correct. There is, however, plenty to get wrong, and you can be sure that if you follow anyone's rules to get somewhere in photography, the images will be boring by definition. In fact, if there's anything more tired and limp than "here are the rules," it's "break the rules," a double disaster.

Why should there be any rules in what ultimately is a creative activity? Rules are designed to make things accurate, predictable and repeatable, and that's pretty much the opposite of what you'd want from an interesting, surprising photograph. So, you might wonder how it is that inappropriate rules for being creative get started in the first place. They are dreamt up by people who are not creative but think there ought to be a simple, logical formula that would allow them to be.

Here's the origin of one of the better-known rules, the Rule of Thirds. It turns out that the term was invented in 1797 by John Thomas Smith, an engraver and painter of little note, misinterpreting the artist Sir Joshua Reynolds who simply made the point that if there are two distinct areas of different brightness in a picture, one should dominate and they should not be equal. Smith wrote, "Analogous to this 'Rule of Thirds,' (if I may be allowed so to call it) I have presumed to think…[.]" Unfortunately, no one told him forcefully enough that, no, he wasn't allowed.

Since then, this silly instruction to make divisions a third of the way into the frame has been followed with mediocrity by artists and photographers who lack imagination. It should be obvious that if all photographs were composed like this, they would all be similar and uninteresting. Think of photos of any kind that have inspired you. How many are divided into thirds? The real puzzle is why it gets repeated so often, and never with any examples that are worth looking at.

There are, however, all kinds of known visual and psychological effects, and that's a different matter. The human vision system is trained to make predictions from what the eye sees. It's trained to recognize, imagine, and extrapolate.

SOME TIRED OLD "RULES"

▶ Rule of Thirds
▶ Don't shoot into the sun
▶ Don't place things in the middle
▶ Don't cut heads off
▶ Avoid overexposed highlights
▶ Avoid blocked shadows

Guy Bourdin 1928–1991

Influenced by Surrealism and the contemporary work of Helmut Newton, Bourdin was given extraordinary freedom at *Vogue* and by his client Charles Jourdan to do nothing less than shake up fashion photography. He sidelined the product in favor of unexpected and strangely composed imagery, suggesting peculiar narratives.

OPPOSITE

Charles Jourdan, Spring 1978
Highly stylized and reduced, this was one of a series of advertising shots by Guy Bourdin for the French shoe manufacturer Charles Jourdan.

"I didn't write the rules—why should I follow them?"

W. EUGENE SMITH

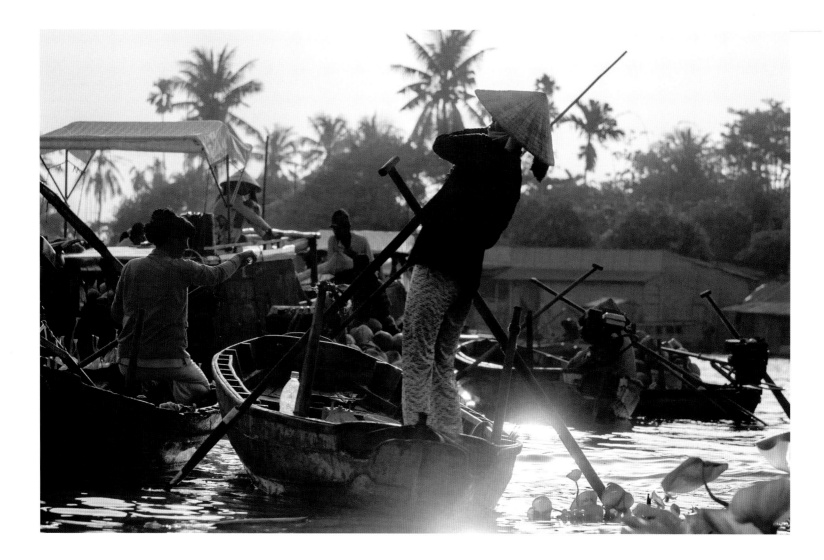

WHAT DRAWS THE EYE

- ► Eyes
- ► Human face
- ► Words (in any language)
- ► Sharp edges
- ► Contrast

ABOVE & RIGHT

The triangular structure works satisfyingly to bring order to this Vietnamese delta scene because that's the way the eye works, but it's just a device and should never be treated as a compositional rule.

Another known effect that works but should never be turned into a repetitive rule is that certain things attract the eye more strongly than others, among them the human face and especially the eyes. This picture, taken in Cartagena, Colombia makes deliberate use of this effect. When the girl looked sideways, the whites of her eyes became prominent, guaranteeing that the viewer will see her, even though her face actually occupies only 1/400th of the image area.

For instance, it likes to join things up. In the photograph opposite of a Vietnamese river scene, most people will see a triangle without analyzing it, but it registers (probably subliminally) as something that gives structure and a centralized stability to the image. In fact, there are two overlapping triangles at a slight angle to each other, with the woman's conical hat playing a part, but these are just the details that a photographer would notice at the time.

As another example, the eye is automatically drawn to certain classes of things in a picture, notably the human face, eyes in particular, and words (in whatever language). Knowing what aspects are most attention-grabbing, you can adjust the framing and composition to make them work for you. You can be reasonably certain that the viewer's eye will eventually go to a face and its eyes, even if they are small, so you can make them small if you choose. In the shot below of the cocteleria (that's "oyster cocktail," not the martini kind), the sign was bound to receive first attention, but even though the face occupies a much smaller percentage of the picture area, the eye will eventually end up there because the photographer chose to capture the moment when the girl looks, and the whites of her eyes show clearly.

These are not rules, they're effects. You can make use of them if you want, but none of them will by themselves make the photograph better or more interesting.

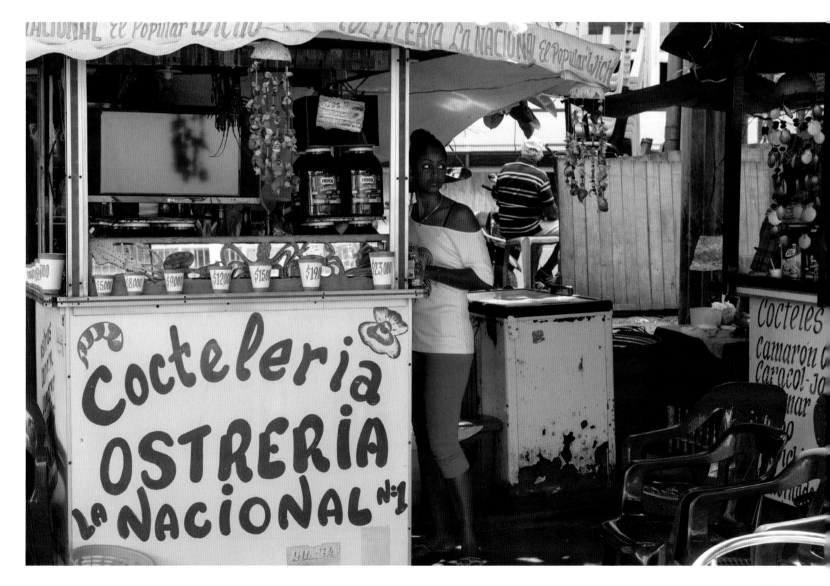

2. STUDY THE FORM

If you seriously want to succeed in the world of photography, you owe it to yourself and everyone to whom you show your pictures to know what's already been achieved and by whom. Not to copy, but to understand. Study other photographers' work, both established and contemporary. Decide which images you like, analyze why, and understand the underlying ideas and approaches that you can use yourself. Most photographers put a lot of effort into making images, and you can benefit from that.

Now, some people like the idea of coming into things with an innocent eye, but while there's certainly a justification for that, it isn't going to get you very far for very long. Look at the equivalent in painting. Naïve art, like L.S. Lowry's stick figures, works because it's childlike and totally ignores what everyone else does, and it works only in small doses. The photographic version uses toy cameras—the more plastic the lens, the better. For the rest of us, we're trying to find our place in the real world of photography, and knowing what that world consists of is a good start. More to the point, discover what the best of that world is. Look at what's gone before and what's happening now, not even necessarily for inspiration (though that's a useful byproduct), but to get a sense of the territory of good photography. At the very least, it will stop you from feeling extremely pleased with yourself because you invented a new way of shooting—only to find it was done ages ago by someone else. That's why philosophers use the terms H-Creativity and P-Creativity. H-Creativity (H for Historical) means that no one did it before and it's really original. P-Creativity (P for Psychological) means the person doing it thinks they're the first but only because they're not aware of what went before.

Even so, there's really no need to obsess about originality. It's overrated and over-claimed, and as advertising guru John Hegarty put it in his book *Hegarty on Creativity: There Are No Rules*, it depends mainly on the obscurity of your source. Like the word "unique," "original" gets used far too often and frequently without much justification. What, after all, is truly original, meaning something done for the very first time? You could claim that one of the special things about photography is that every moment is unique, but that's splitting hairs. Take just about any image that has some demonstrable freshness and, if you research hard enough, you'll almost certainly find that it was inspired by an earlier image in some way. That is exactly what happens in all creative media, and it's perfectly fine. Art proceeds this way, building on what went before.

It also helps to know that every creative domain—from art to film to theater and photography—goes through fashions when it comes to what people like. A truth that's unpalatable for some photographers is that even the most creative work becomes successful only when someone else champions it, and if you're out of current fashion, you may just have to wait a while. A young Chinese photography student asked me after a talk I gave at a Hangzhou university, "What if no-one likes my work?" That's a tough question, and the answer is a tough one, too. It might be because you're ahead of your time and on a far edge of creativity. Then again, it might also be because it's not as good as you think it is. Show it to a trusted photographer friend or get a portfolio review from a professional whose work you like. If you get a green light, stick to it even though you may have to wait for recognition.

Art Kane 1925–1995

A fashion photographer active from the 50s to the early 90s, he shot portraits of many musicians, including Bob Dylan, Sonny & Cher, Aretha Franklin, Jim Morrison, Janis Joplin, The Rolling Stones, and more.

THE 70S: PHOTOGRAPHY BREAKS OUT

Color magazines boomed in the 1970s on both sides of the Atlantic, and with this came an insatiable demand for imaginative photography that could sell both the magazines and the advertised products that they carried. The lines between editorial and advertising blurred, and photographers like Art Kane and Guy Bourdin, among others, were the new stars.

"The more pictures you see, the better you are as a photographer."
ROBERT MAPPLETHORPE

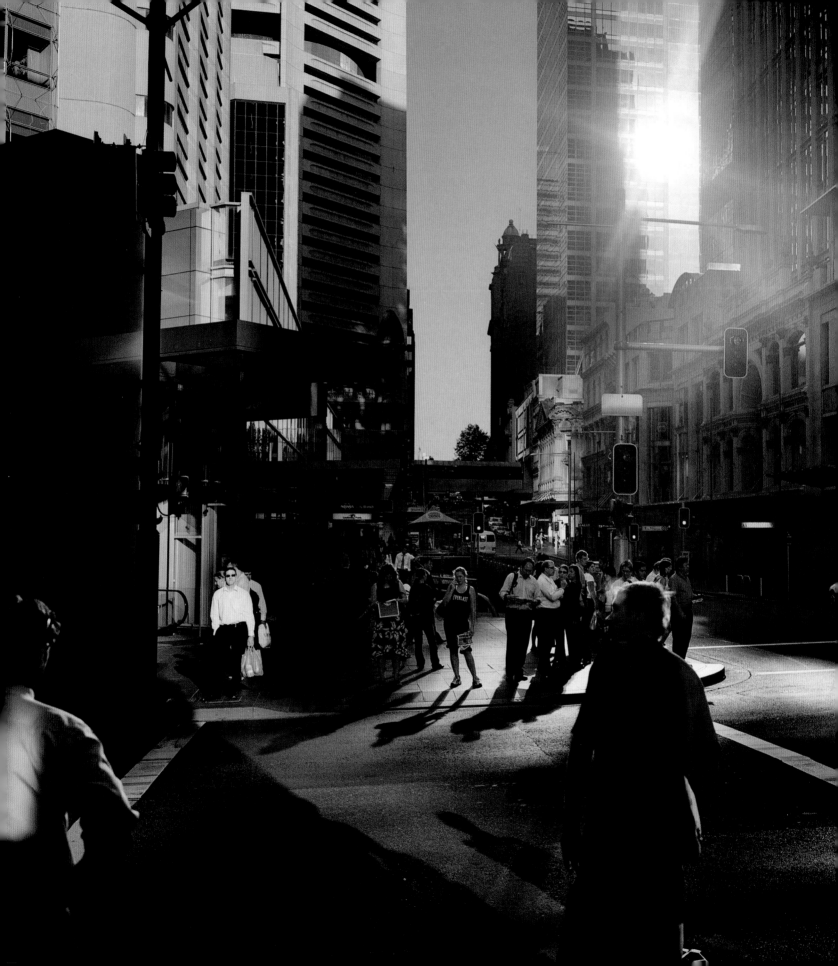

Trent Parke 1971–

A member of Magnum, Australian Trent Parke's early work was as much about how startling city light could be as its ostensible subjects, and in his almost fanatical pursuit of natural lighting effects he created a highly distinctive body of work. Almost none of it is by chance. Parke applies persistent research and effort into achieving exact results.

Ernst Haas 1921–1986

By contrast to Parke's planning, Swiss-born Haas delighted in simply coming across color effects in his personal work. He was very much the color pioneer of Kodachrome, and in the 1960s and 1970s was a star of the New York advertising and editorial scene. Although he fell out of favor in the art world (during the MoMA-led overhaul that began in the 1970s, in which he was accused of being too commercial) his rich saturated color work has more recently been rehabilitated.

OPPOSITE
Australia, Sydney, George Street. 2006
A large body of Magnum photographer Trent Parke's work is light-driven, with strong characteristics. In particular, he is drawn to low, clear sunlight reflecting in complex ways in downtown city business districts. This view of George Street, a favorite Parke location, is a prime example of his front and back reflections interacting.

BELOW
Street Crossing c. 1980
Trent Parke's work, striking though it is, did not arrive independently, and builds on that of others. Ernst Haas, influential in editorial and advertising photography particularly in the 1960s and 1970s, also explored the drama of strong sunlight and shadows in Manhattan, with an added eye for clean and distinct color.

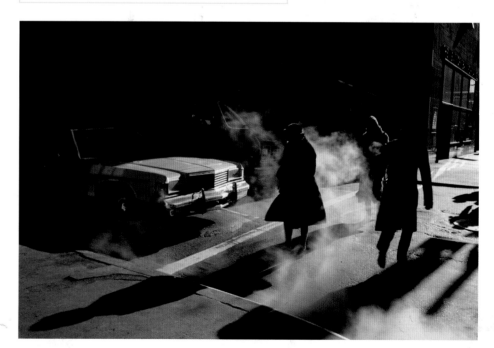

EMBED AN IDEA

Any image is stronger and works better if there's an idea behind it rather than just being clever eye candy. It doesn't always have to be a high-concept piece, but the fact that you thought the photograph was about something—that you created it with some purpose—automatically makes it more interesting and worth the viewer's while. This doesn't have to be a daunting task. Photographers who are even slightly interested in what they're shooting normally think about the meaning behind the shot to some degree and have some ideaof what features could be exploited visually.

Here, the portrait of an artist is quite a simple idea, almost obvious you might think. The painter, Yue Minjun, has made his considerable reputation in China by using the motif of a grotesquely grinning pink face, usually in multiples, as "a self-ironic response to the spiritual vacuum and folly of modern-day China," as the Saatchi Gallery puts it. With their clean-shaven heads, these iconic figures bear more than a passing resemblance to Yue himself, apart from the maniacal expressions. They are indeed distorted versions of a self-portrait. Their graphic strength and size make his paintings a natural backdrop for any photo portrait; we began that way almost without thinking, but it quickly seemed that it should be possible to make more of a connection. Yue is a naturally serious person, so a contrast between him and his painted versions would help to stress the point of his work. All that remained was to find a painting that would work as a background—a crop into two large grinning heads that would leave space for the artist between them. I sat Yue in front and close enough to have all in focus and left him to look serious at the camera. This was a deliberately straightforward, logical but nevertheless satisfying path to the final shot.

OPPOSITE

Yue Minjun in his studio, Beijing. 2007
A simple, even obvious, idea for a portrait of Chinese artist Yue Minjun was to take the connection between him and his parody versions of himself a short step further—by contrasting his normal serious expression with the manic grins in the paintings. Cropping in on the large canvas removes the distraction of seeing it as an object in a studio, and makes it the setting.

"You can't depend on your eyes if your imagination is out of focus."
MARK TWAIN

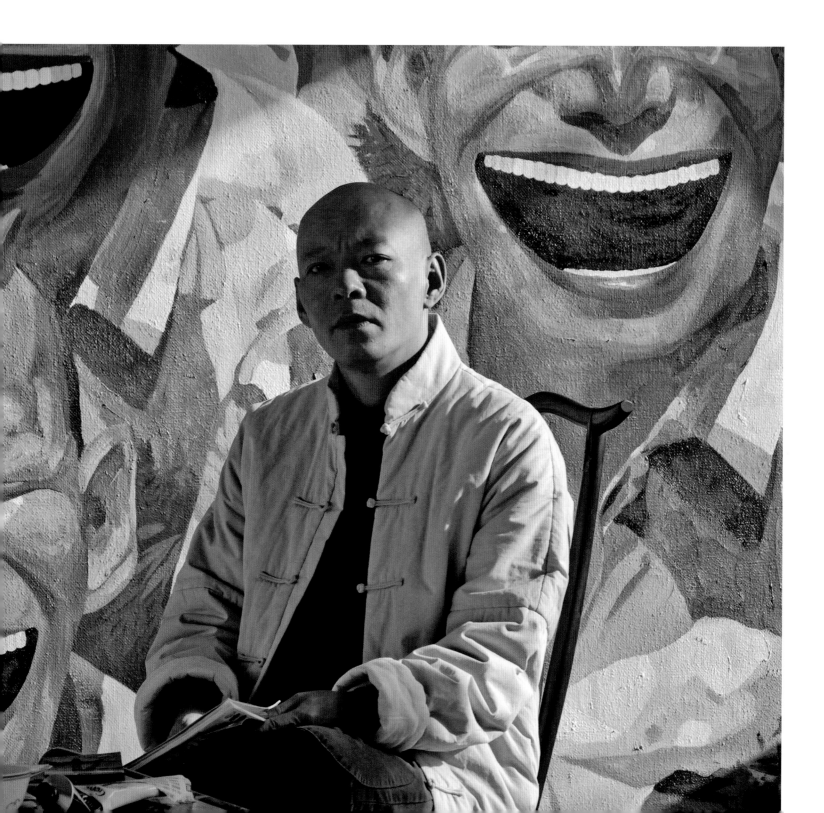

Hell's Gate trail, Qimen. 2015
After the shooting described in the text, the image was processed to conform to the style of a mountain-water painting, firstly in black and white, taking care to lift brightness and lower contrast in the upper part, to correspond to lighter, diluted brush strokes. The 3:2 format was cropped to be more vertical for the same stylistic reason.

BELOW
One of the classic styles of mountain-water scroll painting (there are many) uses brush and ink to convey a rising vertical landscape with an economy of strokes, which vary in density to show distance. Falling water provides the linking structure, and there is often a small figure to show man's subordinate relationship to the greater natural world—a recurring Daoist theme.

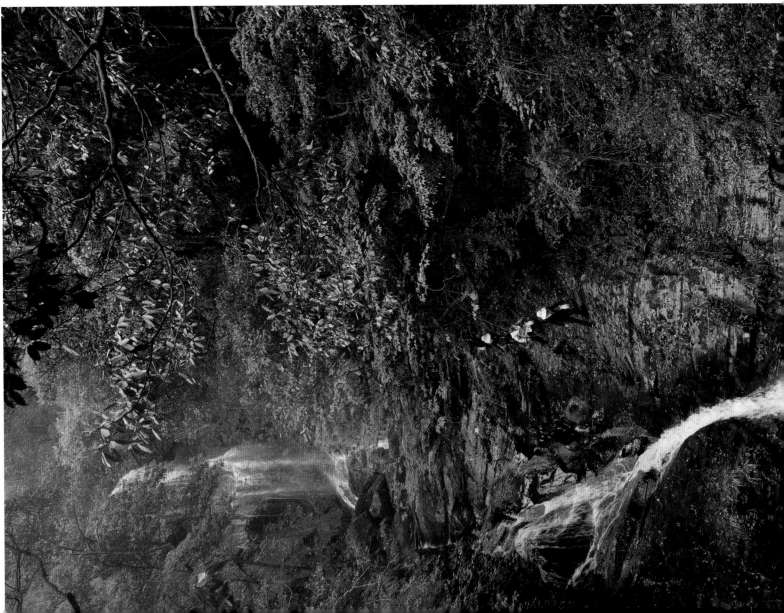

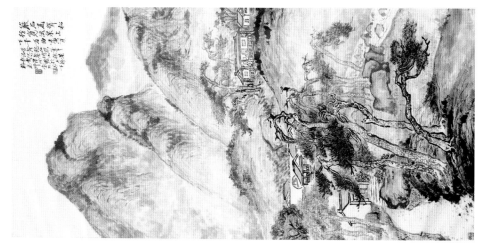

The only danger in making your concept the driver behind your image is being tempted to rely on it to the exclusion of visual skill. With so much contemporary fine-art photography based on concept these days, you can see the pitfalls in many galleries and shows. Strong idea + weak execution = questionable photography. Never use clever ideas as a crutch to support poor imagery.

A little less obvious in its idea is the image above of a waterfall with a small group of women climbing down the side of it. This was an assignment for a book on fine tea, and here we're in the depths of the mountains of Anhui Province in China. Our hosts, the tea growers, were taking us up this attractive but difficult trail; the best tea grows high on the mountains. When we reached this point on the trail, the view was impressive, though there were no people. As a landscape shot it was just okay, but my friend and coordinator pointed out a vertical arrangement had all the makings of a typical Chinese "mountain water" brush-and-ink scroll painting. There's a particular form to these, involving graphics that are intended to lead the eye upward, tiny figures, and

vertical stacking so that more distant upper levels appear to sit on top of the lower ones. The diminutive size of the figures is important, coming from Daoism and the idea that man is subordinate to, yet at one with, nature.

Making sure that I could include people in the composition involved a lot of kind effort on the part of our hosts. Cellphones didn't work there, so someone had to climb much higher to find out when the pickers in the upper tea garden would be returning so I could be prepared for the shot. Everything else in the mechanics of the shot—timing, framing (and later cropping), focal length, and some subtleties of processing—was redirected toward this idea of a traditional "mountain water" painting.

4. BISOCIATE

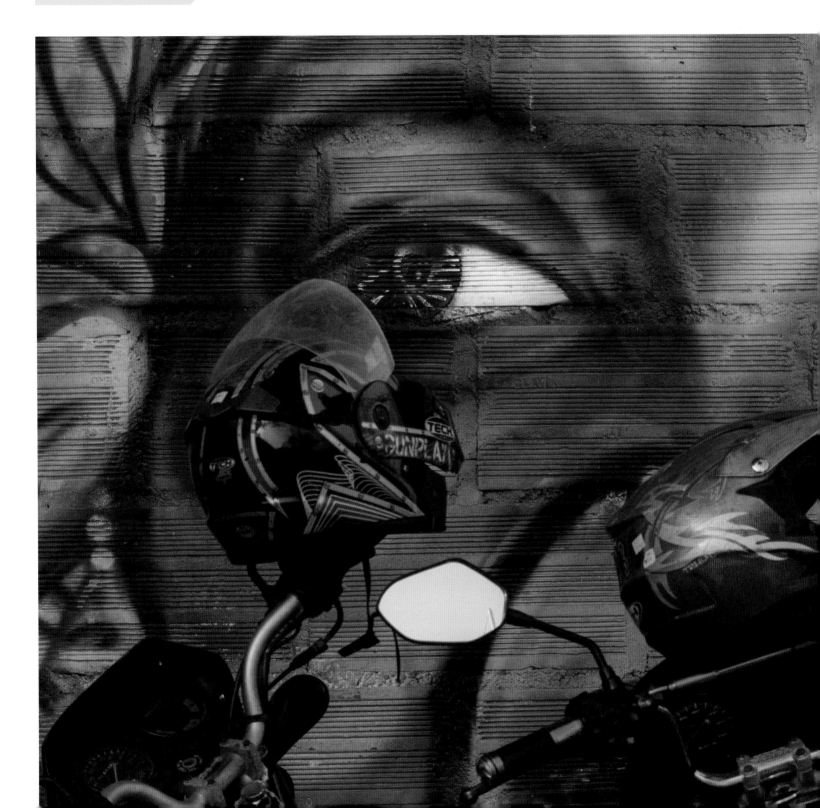

"Creativity is the defeat of habit by originality."

ARTHUR KOESTLER

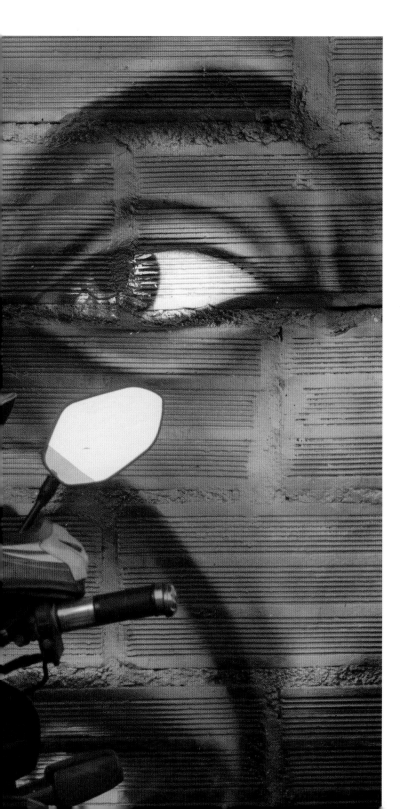

Making unexpected connections is central to creativity. Arthur Koestler, in his book *The Act of Creation*, shares the idea that creativity came from two different frames of reference—different contexts intersecting—and that this is what delivers a jolt to the audience. It's how a lot of jokes work; you think you're listening to one situation, but the punch line comes from somewhere else, out of left field. It turns out that this is quite a workable model of creativity, and at least one computing solution to what's known as "creative information exploration" (CIE) is based on it.

Yes, it can work for photography. Koestler called his approach "bisociation" to distinguish it from the more commonly used "association." In association—which everyone, including photographers, uses regularly—you make links based on similarity, or on what you know happened before. This all takes place within what Koestler called a "matrix" of thought, by which he meant any skill, ability or habit governed by some sort of code. So, the normal way you compose and frame shots would be a matrix. You do it in certain ways that you know work for you because you've done them before and you've thought about it. You place the subject off center so that it has more of a relationship with its background than if it were dead center—that kind of thing. It's all about familiarity. You could also call this matrix a knowledge base. Bisociation, on the other hand, means thinking in two matrices at the same time, using two frames of reference. It's about joining unrelated and often conflicting ways of thinking or, in the case of photography, seeing.

OPPOSITE

La Matuna, Cartagena, Colombia. 2015
Once the connection between the eyes and the wing mirrors was spotted, making the most of it visually meant finding the exact viewpoint. A longer focal length made the proportions of mirrors and whites of eyes similar, while a small aperture gave depth of field to keep both sharp. During processing, contrast was kept high to make the two pairs prominent.

23

In order to use bisociation in photography, the first thing to realize is that photography is special in that it's directly connected to the real. Except for obviously manipulated images, it's expected to show what was really there from life. So, reality nearly always makes up the first matrix. However, in successfully creative photographs, there is always a second frame of reference superimposed on the picture, a second matrix, and the less obviously connected it is, the more striking the idea behind the image is likely to be.

In the street detail on the previous pages, there's a bisociation between two different frames of reference. One is the reality of the stuff in the street: a parked motorbike and a mural. The second is pure graphics: two pairs of sharp, white ovals. There's no connection between the wing mirrors and the woman's eyes in the first matrix or frame of reference, but there's a very obvious connection in the second. Superimpose the second on the first and the connection becomes an unexpected coincidence. (We'll see more of this later, in Path 23: Coincidence on page 102.)

In the rather odd aerial image seen right, which takes a moment to register as such, the unexpectedly colorful and graphic arrangement of forest, water, and a sand bar also comes from two very different matrices intersecting. One is aerial photography, which is familiar even though it can still throw up surprising patterns because of the less-familiar viewpoint. The other is a technical process— false-color infrared film. Kodak developed this process during the Second World War for camouflage detection. Instead of the usual dyes for the three layers of film (red, green, and blue), in this transparency film, infrared appears as red, red as green, and green as blue, provided a yellow filter is used when shooting to block the blue light to which all the layers are sensitive. It wasn't intended to be used to make entertaining images, but of course it could, and that's creativity at work, too.

Sandbank in infrared, Upper Mazaruni River, Guyana. 1972
Exposed as intended with a yellow Wratten 12 filter, also known as "minus blue," this primary South American rainforest records as a startling red. The water, its reflections of blue sky killed by the filter, is black, which makes a strong contrast with the white sandbank. Bringing together film technology and a graphic aerial viewpoint creates a striking, surreal image.

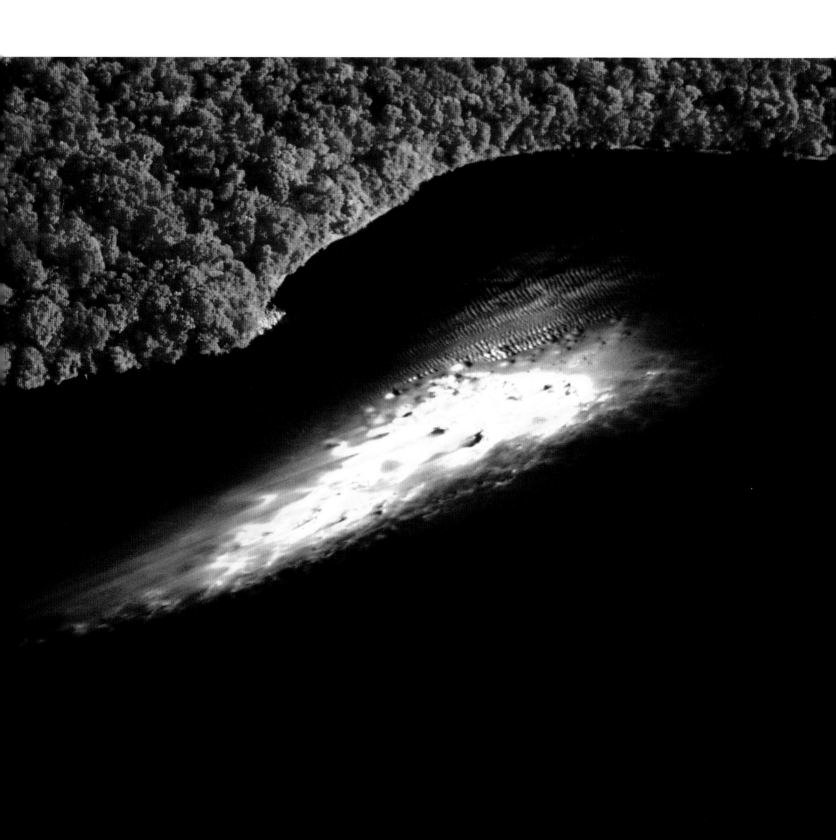

5. ONE STEP FURTHER

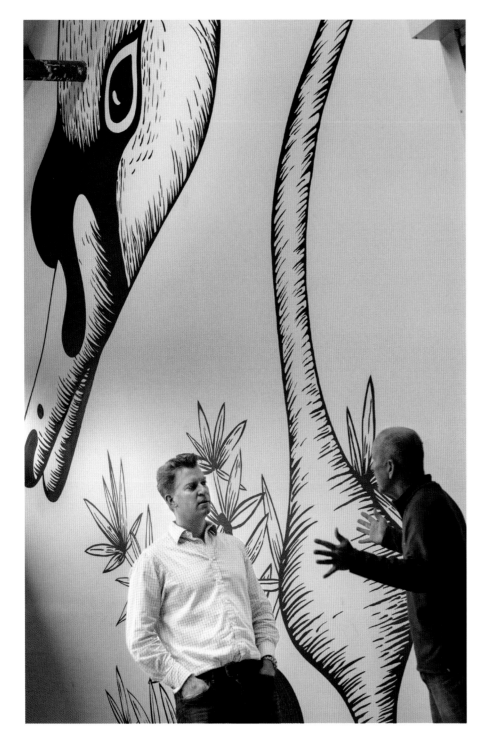

There are many paths to creativity, some less daunting than others, and among the easier ones (if you're feeling cautious) is steady improvement. The key here is to step rather than leap. Instead of shaking up your entire approach to a creative problem, take one element of the shot at a time and think of ways to make that better. The one-step-at-a-time method doesn't work for every situation, but it's surprisingly flexible.

It depends, ultimately, on being able to break down a shot into components. There's no list of these that's common to all pictures, so you have to exercise some imagination in deciding what elements go into making the picture situation you are observing. What are the important things that you can work on? Take the main one and see how you could improve just that. In the two examples shown in this path, it turned out that the most important components were, respectively, the setting and the light and color.

In the shot of the distiller, the creative problem was to make a visually interesting portrait that would be part of a varied selection of images. It was a straightforward editorial assignment to shoot a sufficient variety of images of this boutique London distillery so that the designer would be able to lay out an entertaining four-page story in a book. This, in turn, called for such pictures as an establishing shot of the distillery, the copper still being prepared, people working, close-ups of the apparatus and the product, and so on. Because of the nature of the photo story, the portrait needed to be in context, not an isolated close shot in limbo. The editor wanted choice, and also a sense of the distillery at work.

The copper still—the first to launch in London for nearly 200 years—was the obvious centerpiece of the entire shoot, and for precisely that reason, it couldn't feature in every shot. I needed to find other settings, and by concentrating on just this element of the picture—the setting or background—I found it easier to push the visual idea toward a more creative, interesting result. Having photographed the distiller in a variety of poses and settings, including with Prudence, the copper still, I searched for other backgrounds, and while I was shooting a delivery being made, discovered that one wall was painted with a swan. This turned out to be the distiller's inside joke, referring to the specially designed "swan's neck" pipe above the still. It had graphic potential, and I asked the distiller to continue a conversation he was

"You've got to push yourself harder. You've got to start looking for pictures nobody else could take. You've got to take the tools you have and probe deeper."

WILLIAM ALBERT ALLARD

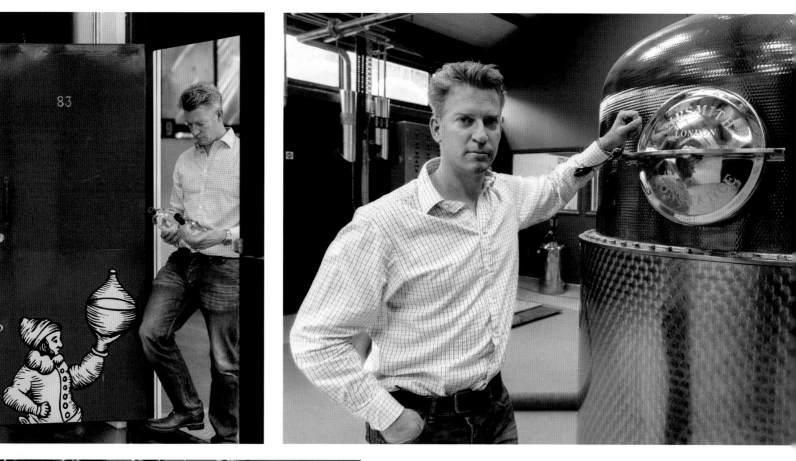

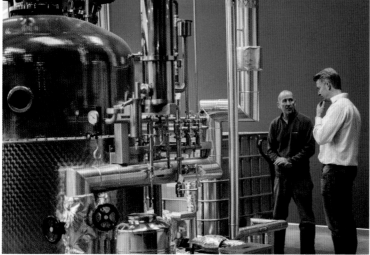

OPPOSITE & THIS PAGE (ALL IMAGES)
Sipsmith Distillery, Chiswick, London. 2014
The final portrait of one of the directors of this relatively new craft distillery (opposite) was the result of a process of search and improvement, all the time looking for an image that would be striking and unexpected. Earlier in the shoot, the three images on this page began in traditional fashion with a "straight" to-camera portrait that included the copper still (above), then moved to a context shot (left), and a search for alternative locations (top left). The ultimate location was a mural of the distillery's logo, a swan.

having in front of it. I then worked on finding the strongest viewpoint and finally captured the most animated moment in the conversation. The step-by-step approach worked.

In a completely different way, going one technical step further proved to be the answer for what could have been a very ordinary shot of a light bulb, though admittedly an interesting light bulb that used LEDs and was being developed by a startup in San José, California. There was definitely a creative problem with the assignment, namely that the lab where the bulb was being developed was extremely uninteresting. It was like a typical engineering lab anywhere in the world, filled with desks and machines. An important picture for the story was what's called a product shot, meaning a close-up of the light bulb, and even though it was well-designed it was not particularly striking, at least not when it was switched off. Switched on, it was just glaringly bright.

The step toward a creative image was simply realizing that light and color were the things to work on. What would it look like if the details visible with the light off were combined somehow with the color from the light switched on? There is a way of doing this, and it involves HDR, or high dynamic range imaging. Many frames and layers were involved, but step by step, as the sequence shows, the potentially boring product shot just got better and better.

> # "The most important lens you have is your legs."
>
> ERNST HAAS

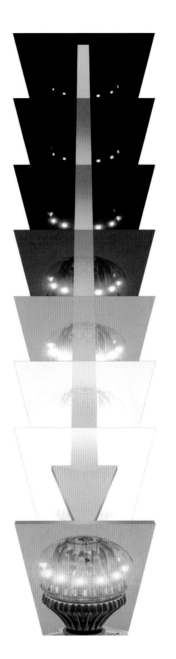

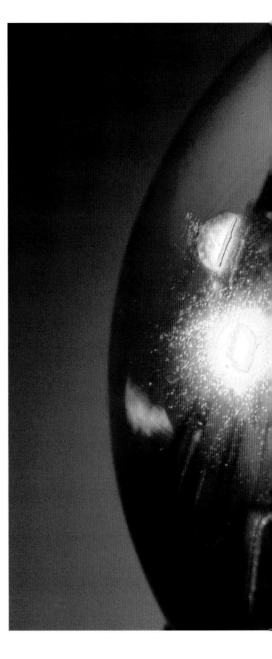

ABOVE & RIGHT
The final stages were a tight crop on the originally vertical framing that showed the entire bulb, and a series of processing enhancements that highlighted contrast, saturation, and vignetting.

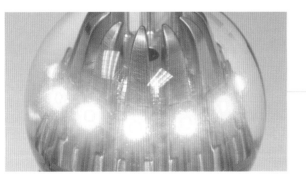

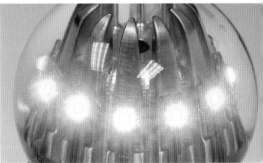

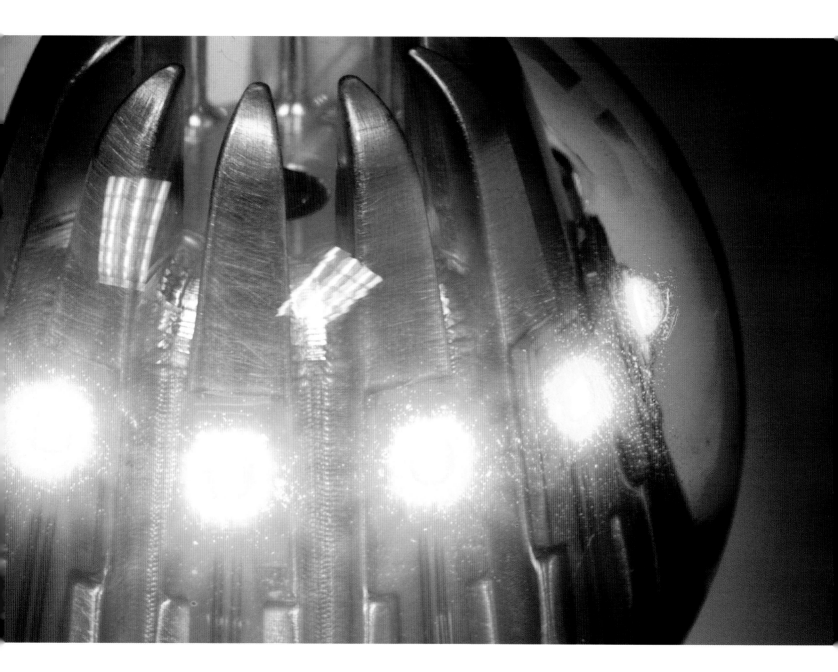

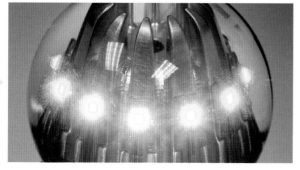

Switch LED light bulb, San José, California. 2011
Up close, the inner details of this light bulb under development in California had a unique engineering esthetic. To show this at the same time as having the lamp illuminated meant using HDR techniques carefully. Six frames shot 2 stops apart were combined into a 32-bit floating-point tiff and processed in ACR to maintain a photographic look.

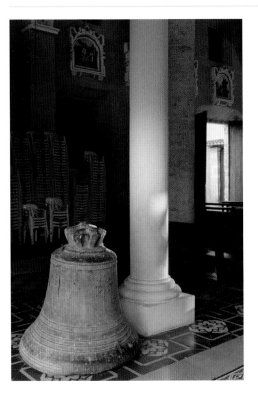

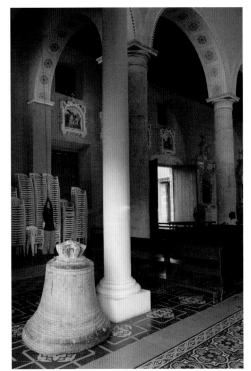

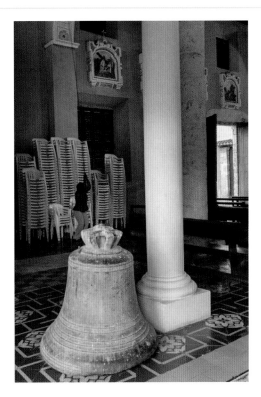

Here's another practical example, the Church of the Trinity in the barrio of Getsemani in Cartagena, Colombia. One fairly reliable way of increasing the creative content of a photograph is to have more than one thing going on inside the frame visually, something I'll come to again under Path 20: Have Things Happen. I was looking for ways to do this here. The church is historic, picturesque, and well used by the community, but I knew I wouldn't be satisfied with just an attractive record shot. My first idea, not very original, was to catch someone walking in or out, but they would need to look special in some way to be worth the picture. I positioned myself by the entrance as the sun started to set. People would be arriving for the evening Mass. But I soon realized that this was highly unlikely to produce anything more than a workaday image—not worth shooting. I needed something different, but had to wait for something—whatever that might be—to happen. In the end, it worked, as the caption oppoiste explains. All of this took place over about five minutes, and the important parts several seconds, and it was a reminder to myself that working a little harder to find a different view often pays off. And yes, the lens can make a big difference. It's admirable to be able to work with a single, standard lens—that's a very pure form of shooting—but the huge range of focal lengths now available multiplies the possible ways of framing a scene by many times. Even creative photography is practical.

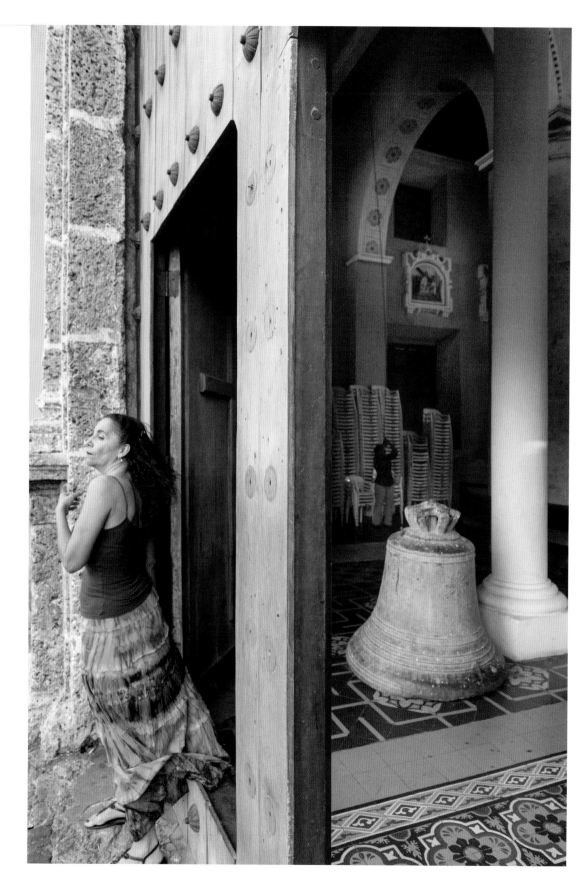

Iglesia de la Trinidad, Getsemani, Cartagena. 2015

There was attractive sunlight falling on a pillar (far left), but it was fading fast (middle left), so I sensed the need to shoot soon. Then three things happened. The first was that a woman prepared to ring the bell with the rope hanging at the back of the church (near left), but her position didn't offer much interest—too far back against the wall. Then, the second thing happened. Another woman came and stood next to the door, waiting, (lower left) and that gave me some human interest. The third thing was that I suddenly realized that if I took a step back and pulled the 24–70mm lens back to full wide angle I could have the two scenes together in the same frame—just. It would need pushing the processing to an extreme, and getting the exposure right, to a fraction below clipping the highlights, but possible. It also needed a good moment for the woman's stance, and there I was lucky.

6. MISTRUST EXPERIENCE

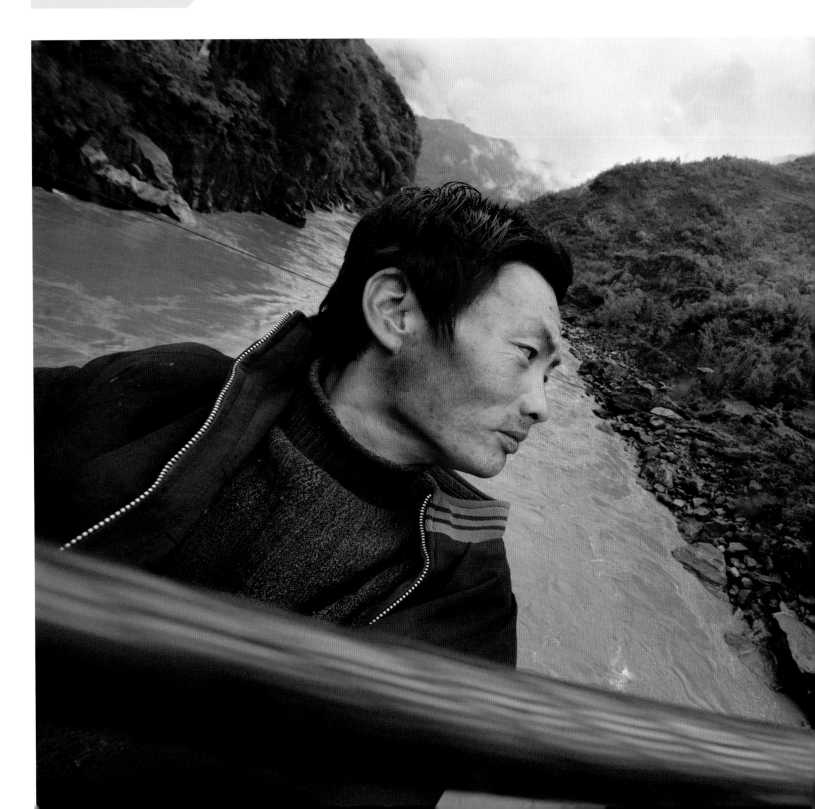

> "I can't tell you how many pictures I've missed, ignored, trampled, or otherwise lost just 'cause I've been so hell bent on getting the shot I think I want."

JOE MCNALLY

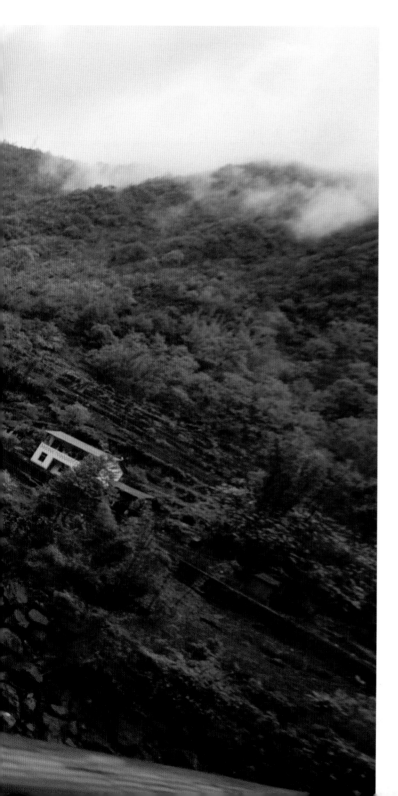

It seems positively essential to learn from experience. Just about everything written on accumulating experience presents it as a good thing to do, and by and large that is true. It is, after all, the professional way to bring knowledge, craft, and skill to the job at hand. Master classes, workshops, and seminars are all about showing people strong professional ways of doing this kind or that kind of assignment or shoot. The more you hone these skills, the better you will be. I don't deny this for one moment, and quite a few of the paths here in this book involve self-improvement by working on some aspect of photography over time.

There's only one thing wrong with this down-to-earth professionalism. It can actually make you lazy and complacent if you rely on it totally. Faced with a new assignment, even if it's one you've given yourself, it's very tempting to review all the ways in which you've tackled this kind of shooting previously and make a list and a plan that you know will work because it worked before. Right about now you might be saying, "What's wrong with that?"

LEFT & ABOVE

Crossing the Nujiang River, Yunnan. 2010
In the upper reaches of the Salween gorge, called the Nujiang in China, locals still use cables to cross the river at high speed, sitting precariously on a loop of rope slung from a pulley. Unless you really need to cross, this is something to avoid, first on health grounds, second because conveying the experience (between exhilarating and terrifying) would need a near-impossible selfie. Except, one way would be to ride with someone else, and hold the camera above and behind you with both hands, shooting with a very wide-angle lens. Ill-advised and unpredictable, but in this instance highly successful.

33

"Discover the recipes you are using and abandon them."

BRIAN ENO AND PETER SCHMIDT

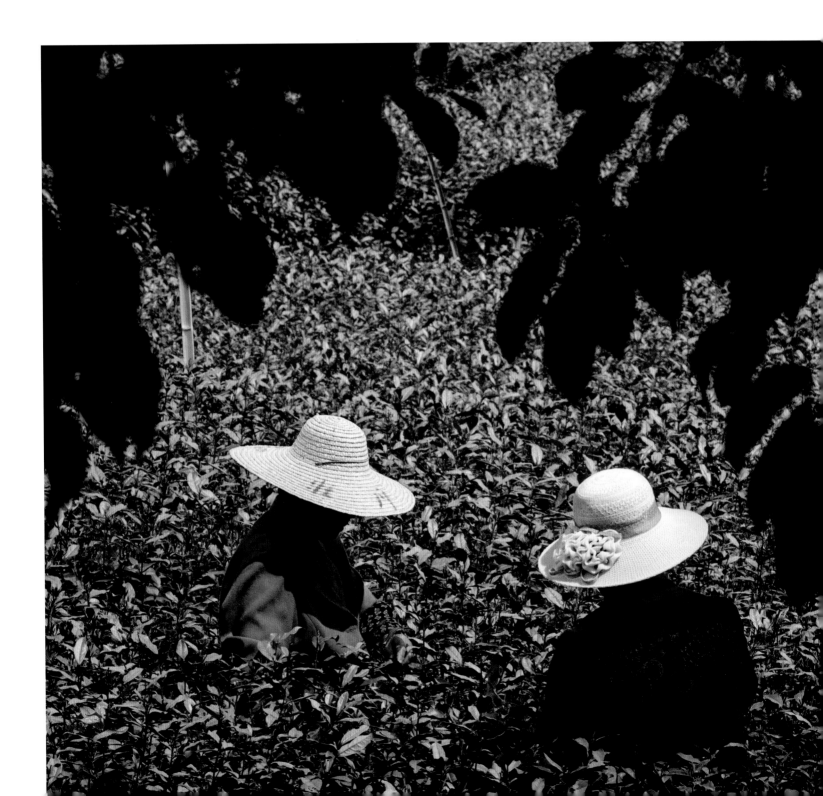

Tea pickers, Hangzhou. 2015

Tea pickers in the middle of the day under a high sun are not likely to make much of an image. The subject isn't all that interesting and the light and color were very ordinary. But I thought how it might look in richly contrasting black and white, and whether I could make something graphic and stark, maybe relating one pair of hats to another.

This is not a trivial point. There really is a potential conflict between professionalism and creativity, but it comes down to how you define photography. If you treat photography as efficiently producing an image tailored to the needs of a client, then creativity has to work within some fairly strict boundaries and experience is definitely your friend. However, if you're looking for creative solutions without boundaries, then it's time to abandon experience. Otherwise, you risk just going through the motions. Habit is safe and reliable, but not exciting. Many photographers have faced up to this one. Dorothea Lange, famous for her photography of rural poverty in the Depression era of the 1930s, wrote that "to know ahead of time what you're looking for means you're then only photographing your own preconceptions, which is very limiting." They may be good preconceptions, but they can stand in the way of new discoveries.

Of the fifty paths in this book, this is one of the toughest because, deep down, it's a path of avoidance. Saying "don't do this" is harder than saying "try this." It means first identifying what your usual successful plan of shooting is, and then cautiously and occasionally reversing or abandoning a part of it. For instance, I'm pretty good at organizing long assignments and I use a shooting script to help me do this. For that very reason, I need to constantly to remind myself to take time away from the script to watch out for anything irrelevant to stantly to that may be happening. This time off-plan often delivers images.

Another related long-project technique is to expect it to evolve and be open to suggestion as you keep shooting. Note when certain kinds of image start to become lifeless and take a step back from those. Pick up on how some of the photographs you're taking are unexpectedly interesting and pursue whatever it was that made them special. Robert Frank said, when he applied for the Guggenheim grant that enabled him to shoot his famous book The Americans, "the project I have in mind is one that will shape itself as it proceeds, and is essentially elastic." In creativity, elastic is useful because it stretches hardened habit. For yet another technique to help with this, read on to the next path on Zen.

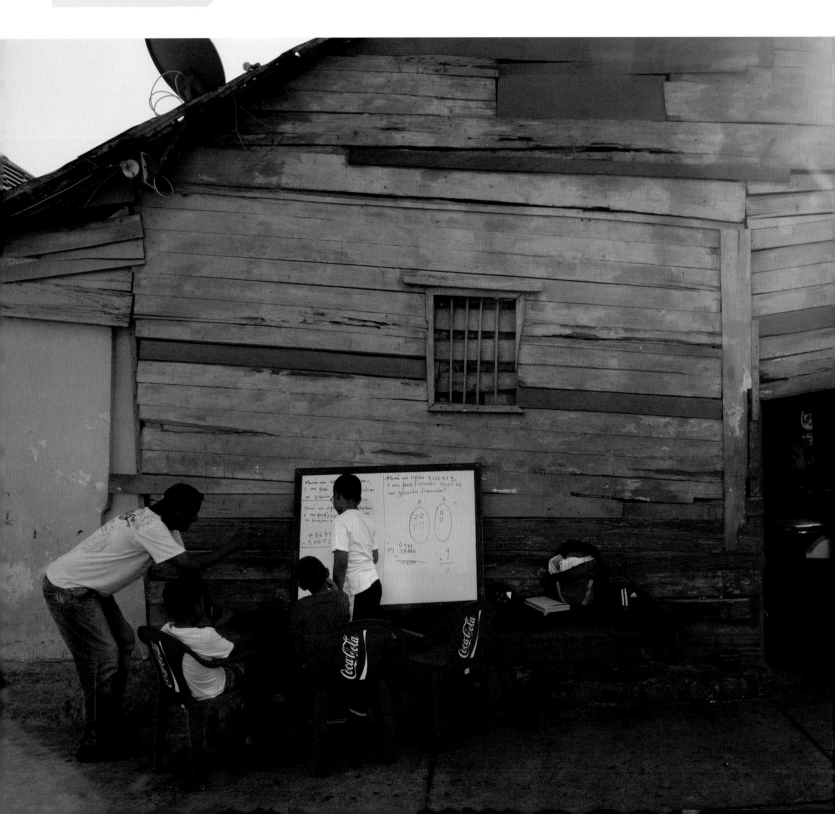

"Thinking should be done before and after, not during photographing."

HENRI CARTIER-BRESSON

Sounds a little pretentious, right, following the old hippie trail of *Zen in the Art of Archery* and *Zen and the Art of Motorcycle Maintenance*? But wait. Zen isn't a religion. It isn't even a philosophy, and you don't have to buy into the whole package to make it useful for shooting. It's a way of thinking that leads to a certain way of action, and it has unique parallels with what we do—in this case, photography. I'm tempted to say that if it worked for Cartier-Bresson, that's reason enough. The painter Georges Braque gave him *Zen and the Art of Archery* by Eugen Herrigel in the 1950s, and after Cartier-Bresson read it he told Braque, "It's a manual of photography." The idea was to become one with the bow. Archery, as its author points out, is just one of the Japanese arts associated with Zen, and all of them, including swordsmanship and flower arrangement, are meant to train the mind. Photography seems a natural fit, and can draw from Zen-like practice as well, as it can help to reveal a lot about life and the photographer. It's in this context that Cartier-Bresson later said, "I don't take photographs. It is the photograph which has to take me."

Practically—and Zen is above all practical—we're talking about useful results, or outcomes if you like modern jargon. Here are three. First is the intuitive flash of awareness, which is right at the heart of Zen. This corresponds in photography to learning how to see the image you're about to take in a flash, anticipating and understanding it viscerally and all at once. Bodhidharma, the First Patriarch of Zen in China, said, "the Way is fundamentally without word," which at first sight doesn't look too promising for me writing this book. However, in order to get to the point where you see that the image is going to work, you still need to prepare and practice, and that's what I'm writing about here. The Buddhist philosopher Daisetz Suzuki wrote in his introduction to *Zen and the Art of Archery* that "if one really wishes to be master of an art, technical mastery is not enough. One has to transcend technique so that the art becomes an 'artless art' growing out of the Unconscious." He didn't say ignore technique, just acquire it and then move beyond it. There's common sense to that. The trick is to practice two things all the time. One is to be constantly looking for potential images with a kind of inbuilt frame vision. The other is to become so adept at using the camera that you can lift it and shoot accurately without thinking about it at all.

OPPOSITE

Street class, Getsemani, Cartagena. 2016
I had walked along this street many times, and loved the old wooden corner shop, but there was never anything special happening. One afternoon I turned the corner and there was an arithmetic class going on. It's a narrow street, easy to stand out as a photographer. The teacher reached toward the board, I saw the picture with the late afternoon sun flaring, and shot within a second without thinking. An intuitive shot.

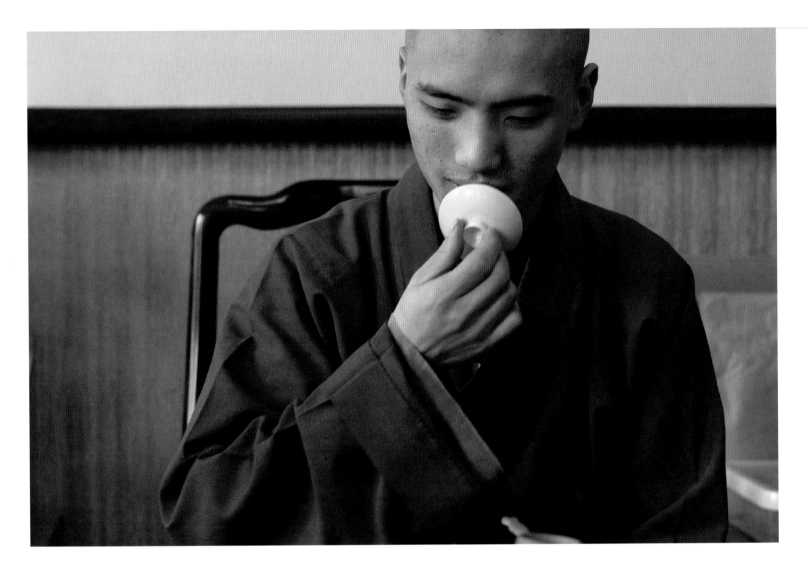

The second useful Zen lesson is being totally in the moment, completely focused on now and nowhere else. Again, this comes down to practice at ignoring every distraction and concentrating completely on the finest nuance of moment in the scene in front of the camera. Capturing the moment is at the core of photography, and there's a huge visual difference between fractions of a second. You don't get to capture the exact moment that's right for you by keeping the shutter on Continuous. You get it by being so aware that time seems to slow down and you can slice the action into the finest microsecond.

Third comes the principle of stripping things bare, down to the bones, and concentrating only on the essentials. It's hard to argue with that, and the way to do it is to think clearly about what it is you're shooting and what's really important. Then, ignore the rest. You force your eye and mind to select only what you need from the unstructured real-life scene in front of the camera. It involves simplifying and eliminating, not adding. It results in a kind of imagery that is uncluttered, rigorous, and lean. This doesn't mean just a few elements in the frame; it means just those few that are essential.

In the photograph of the potter, I had been shooting for more than an hour in his studio, starting with details and close-ups of pots and the workbenches. I then moved on to a portrait, which I needed for the assignment. It was while I was setting up for this that I looked carefully at his hands, which were surprisingly soft for a potter, though ingrained with the red clay. It then occurred to me that this was what pottery was all about, just an individual pair of hands and clay. I asked him to take a massive lump of the special red clay and grip it, while my coordinator held a piece of card near to his hands to throw the background into complete shadow. The shot says all about pottery that I want it to; no more, no less.

Monk making white tea, Guzhu, Zhejiang province. 2015
In the 1700-year-old Shou Sheng temple, this monk was carefully preparing a delicate white tea for us, and I had the opportunity to watch and shoot every action. Both he and I were concentrating completely on our respective tasks, both in the moment—and this was the moment.

"Try to go out empty and let your images fill you up."

JAY MAISEL

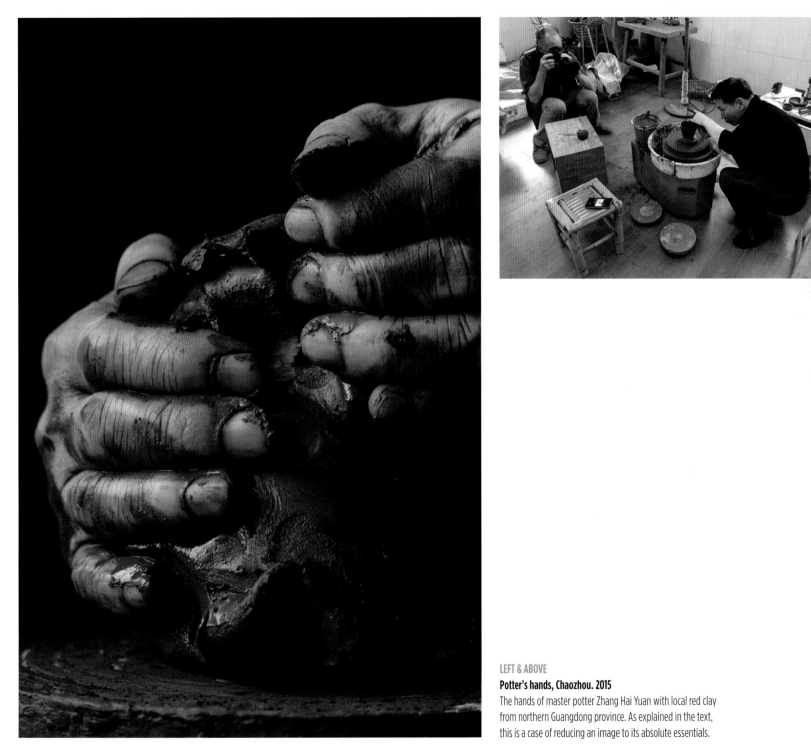

LEFT & ABOVE
Potter's hands, Chaozhou. 2015
The hands of master potter Zhang Hai Yuan with local red clay
from northern Guangdong province. As explained in the text,
this is a case of reducing an image to its absolute essentials.

8. THE ICONIC DETAIL

One tried-and-true creative approach is to whittle down the number of things going on in a photograph, to reduce (which we'll take a closer look at in Path 32: Reduce). When you think about the subject, there are times when the part may be more interesting and focused than the whole. Details of things can be subjects in and of themselves, the telling detail, the one that stands in for the bigger subject. But who's to say what is iconic, or even relevant or typical? As a creative path, this one generally depends a little less on the skill of making an exciting composition and much more on thinking about the subject first.

This technique is especially useful when the larger subject doesn't lend itself easily to an interesting, creative treatment. It might, for instance, be too obvious, too complete. This was the kind of problem I faced with fighting cocks in Colombia. Given that I already had shots of cocks actually fighting, how could I make an interesting portrait-style image that would say something about this quite vicious and often lethal "sport?" They are after all, quite familiar-looking birds, albeit with attitude. One approach might be a studio portrait, relying on good lighting, and hoping to catch an aggressive pose. I did that, but it was still just a portrait. The solution, for me at least, came in the form of the spurs. These are the artificial killer weapons, and yet when they're attached they disturbingly seem to fit the bird all too naturally. I liked that aspect of menace: a warrior bird with its swords.

OPPOSITE

Fighting cock, Cartagena, Colombia. 1985
While the gory reality of a cockfight may be morally abhorrent, this doesn't disqualify it as a photographic subject. In any case, such an approach is firmly bound to reportage, and therefore quite literal, leaving little room for expression. Giving the spur a heroic lighting treatment, however, makes it both compelling visually and allows the viewer's imagination freedom to extrapolate.

"The more specific you are, the more general it'll be."

DIANE ARBUS

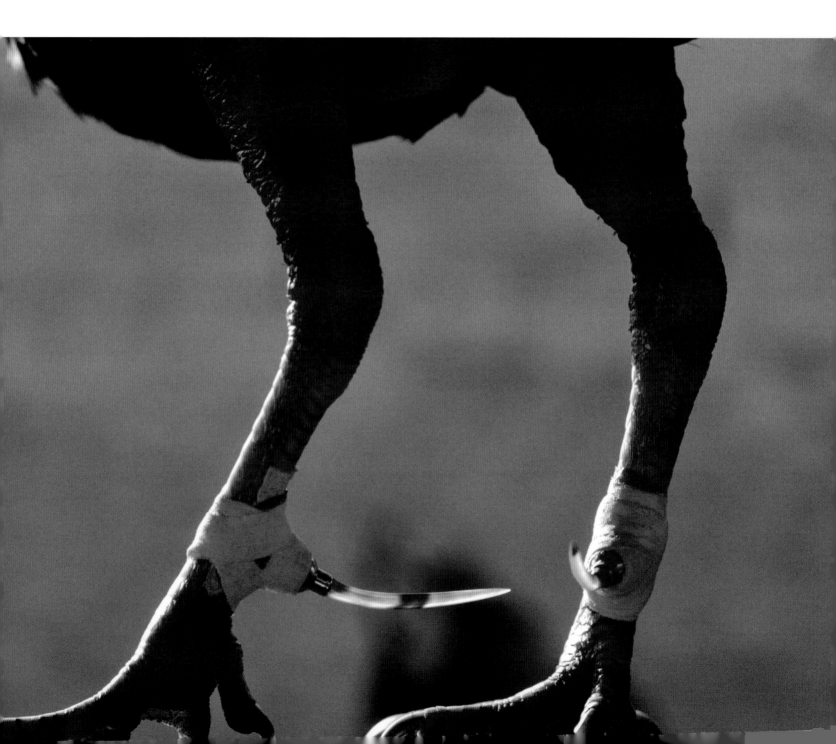

Now, fighting cocks are outside most people's experience, so there's no sense of familiarity to interfere with the clarity of that image. Well-established icons, on the other hand, have a different life of their own. This doesn't mean that you can't use them for fear of cliché, but when you're dealing with an already well-known iconic detail, it helps to know what's gone before. In America, what could be more iconic than a white picket fence? It's the symbol of middle-class, small-town prosperity and stability—or perhaps idealized complacency. In either case, it has a visual history. Oddly, the one artist that everyone associates with white picket fences, Norman Rockwell, hardly bothered with them. It's just that the world thinks he did because he was painting "white-picket-fence values."

Photographer Paul Strand made up for this, however, with his 1916 image "White Fence," which not only made an icon of the fence, but became an icon itself within photography. That one image made it a popular camera subject ever after. W. Eugene Smith made use of it subversively in his famous photo essay for *Life* magazine, "Family Doctor" in 1948, to establish a familiar rural context in the opening shot of the story. David Lynch also made knowing use of it in the film *Blue Velvet*, making it ironic as well as iconic. All this means that an iconic detail like this is freighted. If you're photographing it, you're also hinting at other, earlier images.

The White Fence. 1916

By American photographer Paul Strand, this highly influential image marked an abrupt change in style from dreamy, painterly Pictorialism to abstract modernism. Its stark, high-contrast treatment still packs a punch today, and in 1916 was revolutionary both in style and in its choice of ordinary subject, which appealed to Strand because, he said, "It was very much alive, very American, very much a part of the country . . ."

Paul Strand 1890–1976

Although Strand took up photography professionally because of a fascination with Pictorialism, which at that time, 1912, was fashionable, he soon moved in the opposite direction, looking for a way to bring photography into the same arena of modern art as Picasso, Braque, and Brancusi.

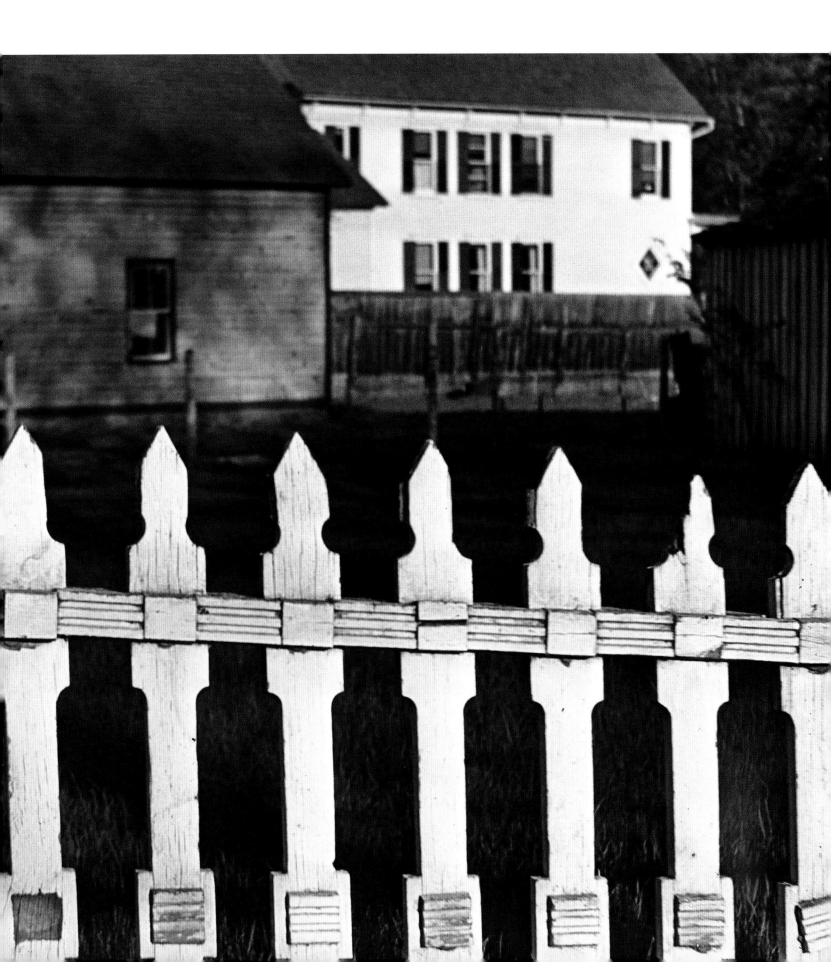

FULL IMMERSION

Richard Avedon's comment (opposite) will sound extreme to most people other than committed photographers, to whom it will sound perfectly normal. Intense, yes, and focused. It's also, for those times when you're being less than full on, a technique to encourage more creative results. Take a deliberate decision to live it and breathe it, and the energy that this generates is likely to start producing results.

Malcolm Gladwell, author of *The Tipping Point* and *Blink*, came up with "the 10,000-Hour Rule" in his third book *Outliers*, which was about success. His argument is that great success needs a huge commitment of time, and one of the creative examples was The Beatles, who played more than 10,000 hours in Hamburg before returning to England and their success. They were ready for it, and as their biographer Philip Norman wrote, "they sounded like no one else. It was the making of them." Now, that amount of time does sound daunting, though it makes sense in an attrition kind of way.

Some people react to this negatively on the grounds that surely drudgery and time can't be the only answer to something as special as being creative. Well, maybe they can. They can at least be a major part. In common with musicians, painters, and all kinds of artists, the most successful and creative photographers have all spent their lives working at it, apart from any other qualities or skills they might possess. How many people who are not committed to a creative life would give that kind of time? To make it sound a little more palatable, it's cumulative. Creativity doesn't suddenly blossom at the magic number of 10,000 hours. It grows—maybe in fits and starts—more and more as you put the time and effort in. If you spent ten hours a day, every day, you'd reach the first thousand in a little over three months. You wouldn't be able to do anything else, but that's what commitment is about.

From the world of reportage photography, which some would argue is the purest form of the medium, there are

RIGHT
Eid al-Fitr, Kado, Pakistan. 1980
Ending the dawn-to-sunset month of fasting known as Ramadan is the festival Eid al-Fitr. Unique to the Pathan of Afghanistan and northwest Pakistan are good-natured egg fights, using hard-boiled eggs.

OPPOSITE
Learning to shoot, Kado, Pakistan. 1980
Weapons are an integral part of male Pathan culture, and here in Momand Pathan territory, the favorite was a British .303 Lee Enfield, some of them pre-war originals, others made locally. The Pathan here were rarely separated from their weapons, and learning to shoot is an essential rite of manhood.

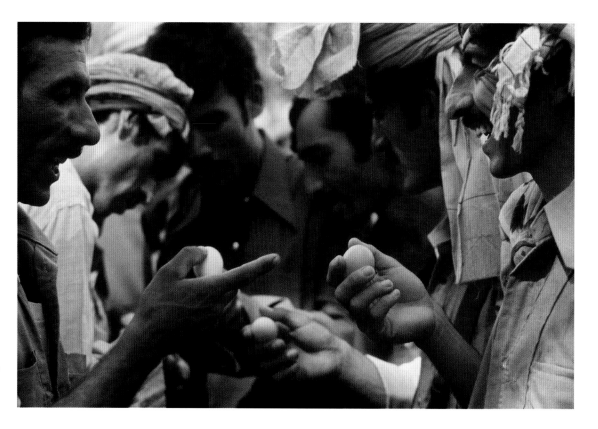

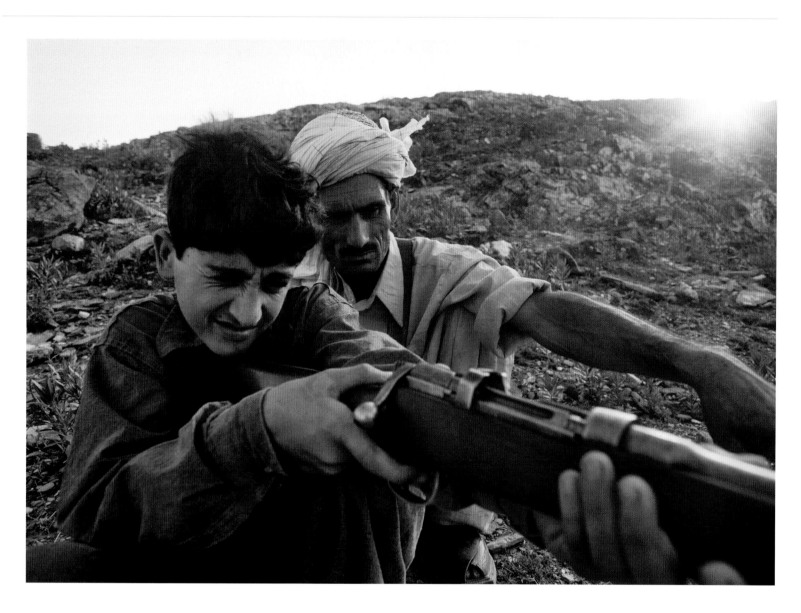

"I believe in maniacs. I believe in type As. I believe that you've got to love your work so much that it is all you want to do. I believe you must betray your mistress for your work, you betray your wife for your work; I believe that she must betray you for her work. I believe that work is the one thing in the world that never betrays you, that lasts. If I were going to be a politician, if I were going to be a scientist, I would do it every day. I wouldn't wait for Monday. I don't believe in weekends."

RICHARD AVEDON

many examples. W. Eugene Smith, creator of the first classic photo essays for *Life* magazine in the postwar years, spent two months in 1950 on his famous "Spanish Village" story, most of it in the small settlement of Deleitosa, shooting over 2,500 negatives. Yet this immersion paled in comparison to his Pittsburgh project begun in 1955. He was supposed to deliver 100 prints from an assignment that should have taken six weeks. His obsession stretched it out for four years and many thousands of negatives.

Smith was extreme, but knowingly so and for the good reason that such obsession was the only way for him to reach greatness in his chosen area of reportage. This is a lesson that any of us can learn from, even in a diluted form. If you're shooting that kind of storytelling photography, find inspiration in learning all about your subject and spending a lot of time with it. It's a practical step towards creativity. Immerse yourself.

The pictures here were from a four-week assignment in this very conservative, strictly Muslim, male-dominated Pathan society governed by a strict social code known as Pakthunwali, based on honor, hospitality, and revenge. Only by living with the community 24 hours a day was it possible to be able to photograph natural interactions between tribal members.

RIGHT, TOP

Friday prayers, Kado, Pakistan. 1980
The men of Kado village embrace each other after the Eid Prayer, which is taken in congregation at the end of Ramadan.

BELOW, LEFT

Buying a rifle, Darra Adam Khel. 1980
The leader of Kado, on the left, negotiating the purchase of a rifle at a gunmakers in the nearby village of Darra Adam Khel, known for its arms manufacturing.

BELOW, CENTER

Hashish shop, Landi Khotal, Khyber Pass. 1980
The border town of Landi Khotal between Afghanistan and Pakistan is in tribal territory, and the use of hashish and opium is permitted.

BELOW, RIGHT

Buffalo feast, Kado. 1980
After Ramadan, the community hosts a feast of freshly slaughtered buffalo meat for relatives and friends from surrounding villages.

OPPOSITE

Midday prayer, Kado, Pakistan. 1980
At the height of summer, a village elder in the Kado community makes his noon prayer (one of five daily) outdoors under the shade of a tree.

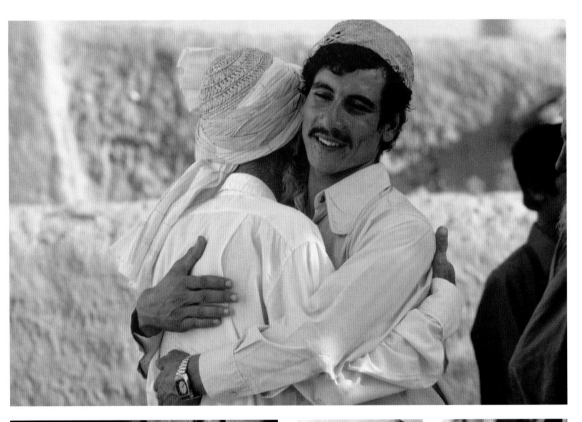

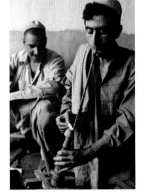
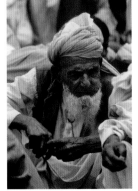

"I think a photograph, of whatever it might be—a landscape, a person—requires personal involvement. That means knowing your subject, not just snapping at what's in front of you."

FRANS LANTING

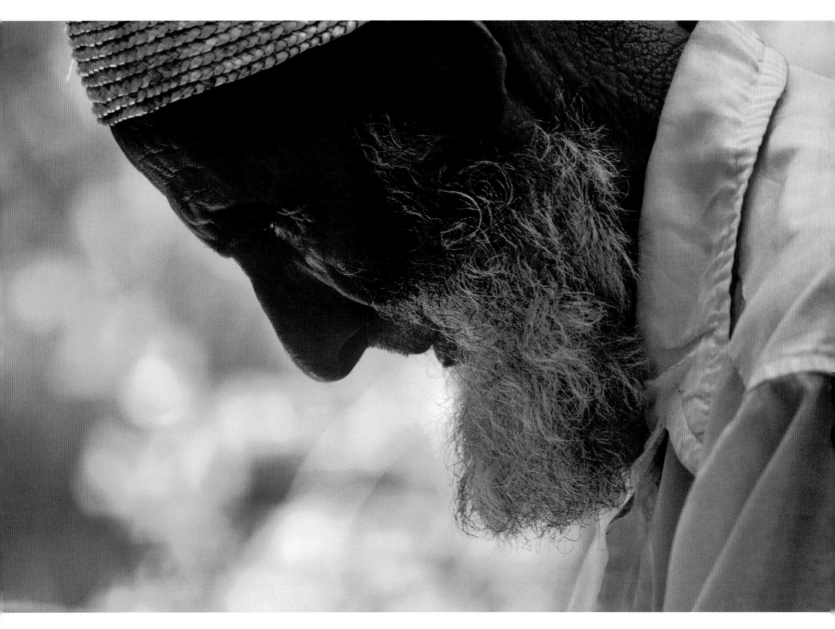

10. SOUL & OPINION

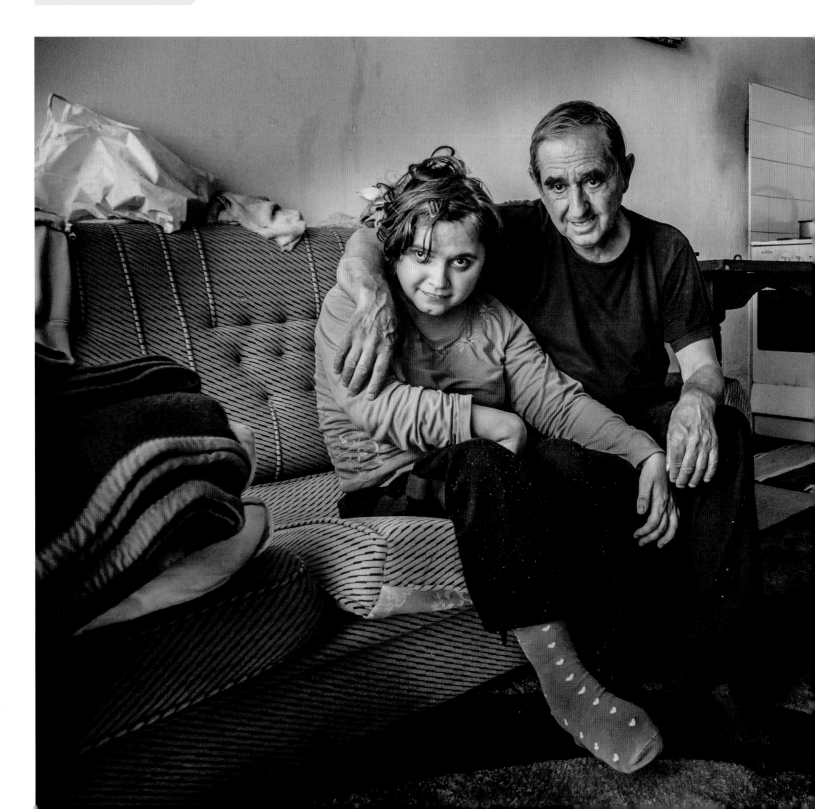

"If you don't have anything to say, your photographs are not going to say much."

GORDON PARKS

borrowed name of this path from my editor in China, who was actually using it negatively to criticize "books with no soul and no opinion," a common enough category. Books are easy for publishers to churn out, so there is a temptation to produce volumes. Photographs are even easier to mass produce, which is why there is so much snapping away. However, viewers easily see through this carelessness. In fact, they see right through the photograph and don't even stop to consider it. Why should they? If it didn't mean very much to the photographer, why should it mean any more to the viewer?

Nurturing those easily lost qualities of soul and opinion is definitely a creative path, and may be more than that. Some people believe it to be a necessary condition. Arguably the greatest practitioner of the photo essay was W. Eugene Smith, who created (not too high-flown a word for what he did) such classics as "Country Doctor," "Spanish Village," and "A Man of Mercy" (about Dr. Albert Schweitzer), all for *Life* magazine. His powerful body of work owes much to his extreme commitment not just to his assignments, but to the causes that they were about. Smith was intense, impassioned, aggrieved, obsessive, and ultimately impossible for even the most appreciative editors to deal with, but that was how he produced piercing imagery. He put his heart and soul into every assignment and suffered knowingly for it. Toward the end of his huge and ultimately unrealized project, "Pittsburgh," he separated from his family to live and work alone, writing that this was "a last ditch stand. The ditch being mental."

That example is one extreme, and it's more of a private tunnel than a path, but it's also convincing proof of one way to stimulate creativity. At a more accessible level, there are many photographers shooting today who commit themselves to the subject they have chosen without a commercial or career-enhancing motive. Most of us have some things that we really believe in. You could make one of them the focus of your photography.

A current example is my friend, photographer Robert Golden, who began his career as a committed photojournalist, left that out of dissatisfaction with the way his pictures were used editorially, switched to a hugely successful career as a food photographer and cinematographer, and then returned to personal photojournalism, focusing his energy on Bosnia and

Robert Golden 1945–

Strongly committed to the social purpose of photography, Detroit photographer Golden left his early editorial reportage work in reaction to the trivialized way it was used in magazines, and, in a volte face, became Europe's leading food photographer and commercial director for 20 years, later returning on his own terms to social documentary and personal work.

OPPOSITE

Father and daughter, Srebrenica, Bosnia. May 2015

An ill man, father to an ill daughter who is wheelchair bound, living on the 4th floor in an apartment block, in Srebrenica. There is no lift. She is trapped inside the flat. The social services are virtually non-existent.

the aftermath of the 1990s war. "I first went to Bosnia to document the production of an opera by the English company Opera Circus who were working with the composer Nigel Osborne," Golden wrote. His wife Tina Ellen Lee is the artistic director of the company, and she was then asked to go to Srebrenica to work with children using music and theater practices. "I went again," continued Golden, "and after more then twenty trips there I have made four films and many photographs, often on a voluntary basis. These two were shot in May 2015 as part of a series to reveal the ways in which the agencies of the state and the medical profession ignore the suffering and needs of these children and their families. They are to be used in a report by a local university to help substantiate their case."

"How does the individual image or the sequence help the rest of us to understand the world and the complexities of life?" Golden asks. "I know this is not everyone's intention with their pictures, but for me it is the most important thing to pursue. I always ask if my life's work has any relevance to other people's lives. Will it provide a flash of self-knowledge, empathy, human understanding, and care? For me, that is why I must tell stories; that is my purpose."

SOCIAL DOCUMENTARY

Social-documentary photography has a long and established history, and goes back much further than the Great Depression years of the 1930s, when the term was coined. It began in the late 19th century, notably with the work of Jacob Riis, who recorded the desperate poverty of New York slums, then continued into the first decade of the 20th century with coverage of child labor in the US by Lewis Hine. Other landmarks of social documentary are the works commissioned by the FSA during the American Depression of the 1930's from Walker Evans, Dorothea Lange, and others; Eugene Smith's photographs in the early 1970s, documenting the long-term effects of mercury poisoning in Minamata, Japan; Cornell Capa's anthology *The Concerned Photographer* in 1968; and global working conditions and mass migration by Sebastião Salgado in the 1990s. The photography of the downtrodden areas of society is one of the most powerful and commanding uses of the camera, as a means of showing a wider public conditions and situations they would otherwise not see.

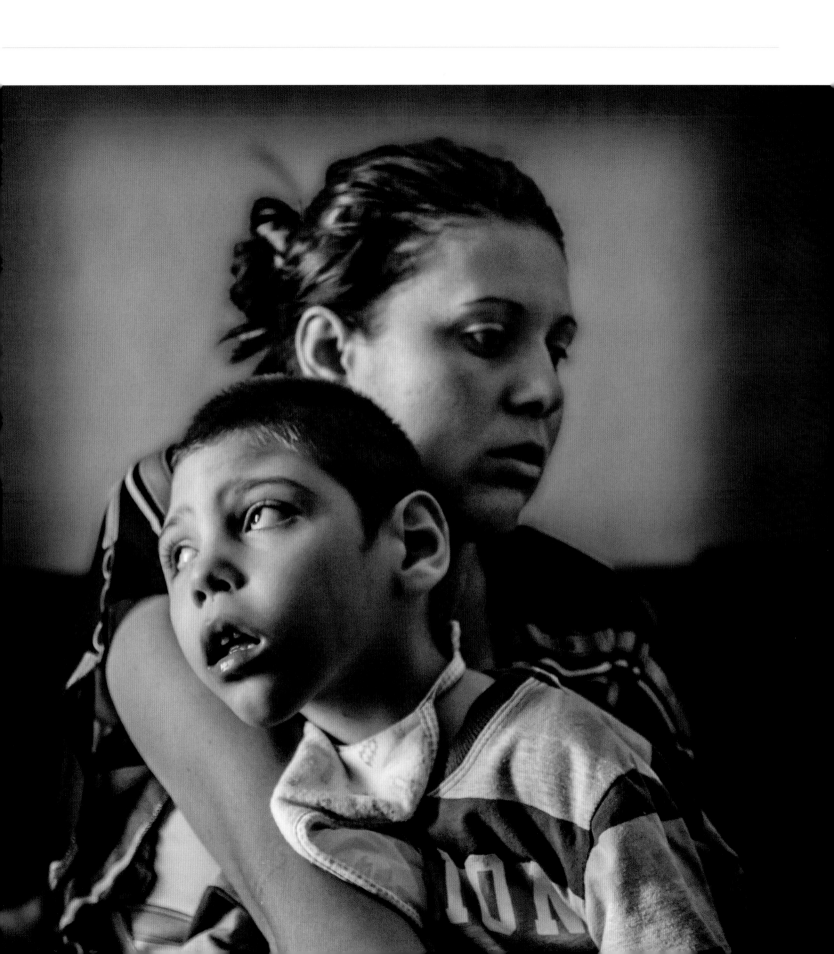

11. BE CURIOUS

One of the interesting things about curiosity is that everyone agrees it's good for you (and especially good for children and creative types), but without being prompted, not so many people actually list it as important, or so research tells us. It's also notoriously difficult to pin down, both for what produces it and how you measure it. Are you curious? Of course you are. We all believe we're curious, and it's a real criticism to be accused of lacking curiosity. Realistically, though, people vary in how curious they are, and in what use they make of their curiosity.

Creative people seem to have a higher level of curiosity than most, though that's difficult to measure—doubly so because creativity doesn't lend itself to being put on a scale. Leonardo da Vinci, always good for a quote, wrote, "I roamed the countryside searching for answers to things I did not understand. Why shells existed on the tops of mountains along with the imprints of coral and plants and seaweed usually found in the sea. Why the thunder lasts a longer time than that which causes it, and why immediately on its creation the lightning becomes visible to the eye while thunder requires time to travel. How the various circles of water form around the spot which has been struck by a stone, and why a bird sustains itself in the air. These questions and other strange phenomena engage my thought throughout my life."

There are some certainties. Curiosity is impulsive but intense, and it works in many ways like an internal drive. Psychologist George Loewenstein in wrote in 1994 in his classic paper, *The Psychology of Curiosity*, that not only was it motivated by gaps in what we know about things, but that it actually increases with knowledge and our individual interests. The more we know, the more we want to know.

RIGHT

Calle Cartucho, Cartagena. 2015
Street shooting with a very long focal length lens—here 500mm—often suffers from out-of-focus passers-by crossing in front of the scene. But what about using that to enliven the composition and push the viewer's eye to move between in-focus distance and blurred, bright, and colorful foreground?

OPPOSITE

Wristwatch Polaroid. c. 1990
The curiosity here was to see what a wristwatch would look like if allowed to photograph itself by its own luminous dial. Placed face down on an unexposed sheet of Polaroid SX 70 film in a darkened room, it created this image, a form of photogram.

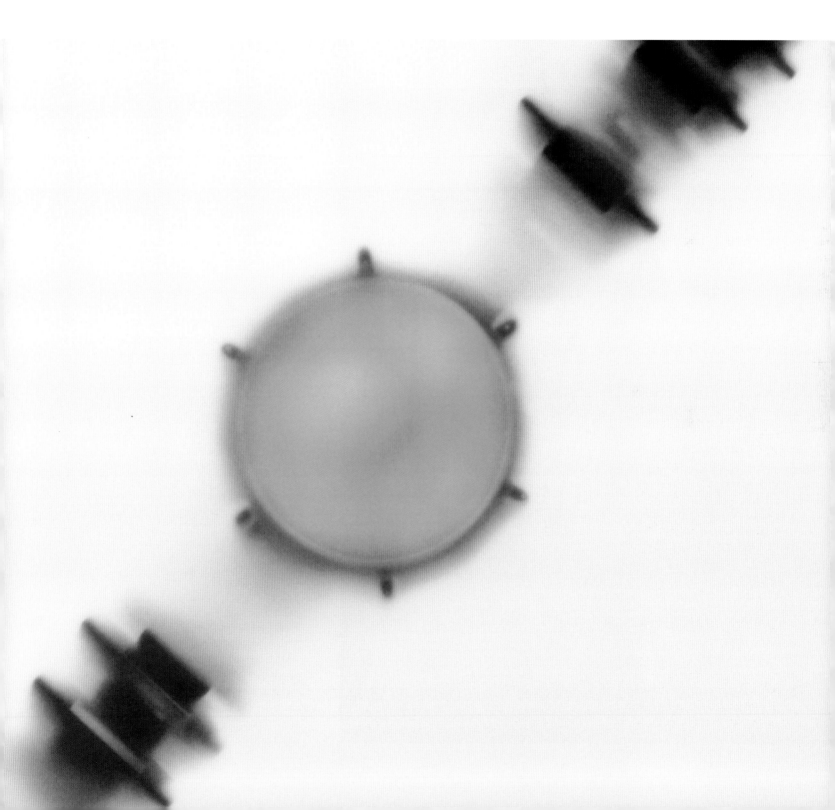

> "My favorite words are possibilities, opportunities and curiosity. I think if you are curious, you create opportunities, and then if you open the doors, you create possibilities."
>
> MARIO TESTINO

"Interest, in effect, primes the pump of curiosity," Loewenstein said. Leonardo was interested in all kinds of things all at the same time, and so he could draw on a huge range of seemingly unrelated facts and ideas. Put it in the terms of bisociation (see page 22) and we realize that he enabled himself to see connections and invent.

Curiosity is practical. It draws you down pathways that you can't predict, so it's a sort of discovery engine. In photography, you can apply curiosity to any of three skill sets—technical, visual, and conceptual—but it always produces the basic question "What would it look like if…?" That is why the Garry Winogrand quote at the opening of this path is so universal. Simply applying camera skills to a subject isn't quite enough. The desire to know how things will appear once you've shot them is a powerful creative impulse. This can stretch from how places and events that are difficult to access will look once you get there, to how things will look in different circumstances. Reflections in moving water, for example, are difficult to capture because of rapid motion and the difference in focus needed for ripples versus what's reflected in them. In the Polaroid shot on the previous page, I was curious to see what a watch would look like recorded by its own light—the glowing dial.

LEFT

Polarized artificial fibers. 1980
Many plastics contain stress patterns that appear as interference colors in completely polarized light, and these artificial fibres from a petrochemical company were candidate. Photographed backlit on a polarizing sheet with a polarizing filter over the lens, their normal appearance was transformed.

Nga Pha Chaung monastery, Shan State, Myanmar. 2014

We see water reflections in full focused depth, but capturing that effect is difficult in a photograph, calling for reasonable shutter speed and extreme depth of field. And the distortions are unpredictable. Here, sunlit temple decorations at ISO 2000, 1/125 second and *f*/22.

THE DISCOVERY ENGINE

Chemistry may seem to have little to do with photography, but 2015 Nobel prize winner Paul Modrich made the point that "curiosity-based research is so important; you never know where it is going to lead." Accepted in many areas of research and education, curiosity comes from NOT knowing, and using that ignorance and mystery is a proven way to explore photographic subjects and ideas that you never thought about before. Just ask the question.

THE OVERLOOKED

One creative shortcut is to find a subject that most other people wouldn't think of or wouldn't think was suitable, worthy, or polite. Art history is full of instances of the establishment deeming what is a fit subject and what isn't, and equally full of rebel artists disagreeing. You don't even have to stray into the realm of shocking people (though we will soon in Path 17 on page 76). At some point in time, anything of any interest has been considered unfit for photography, but the big divide that has persisted for decades is between the important, exemplary, and handsome subjects on the one hand, and the banal, common, rejected, and discarded on the other. That second group may sound like a lot of unspecialness to bring together, but what they have in common is that they are all things and scenes that for most people are simply not worth much, if anything.

One of the most famous rejections of subject matter on the grounds of being considered unseemly were Robert Frank's mid-1950s pictures of the United States that appeared in his book *The Americans*. This was a generally unhappy, unwholesome, and *noir* America. Almost all the reviews were terrible, and Frank recalls that "people said, 'That's too sad. We don't want to look at that.'" The book went on to be hugely influential. One lesson from this is that it doesn't matter what most people think is good subject material. If it interests you, photograph it. There will always be at least some people who agree with you.

You don't have to go quite as high-concept as Frank if you're searching for overlooked subjects. Anything that runs against normal standards of beauty has possibilities—folds of fat, for example. Also consider decay, things that have been

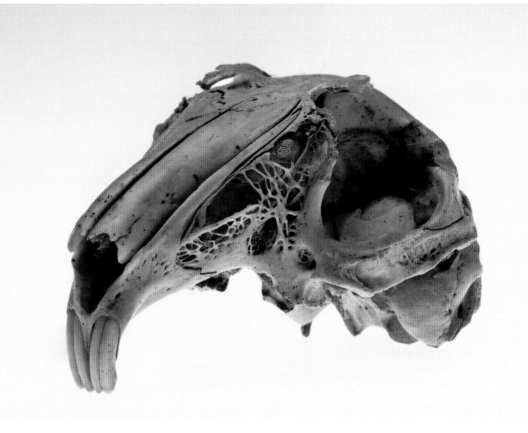

Rabbit skull. 2013
Fragile and small, the upper part of the skull of a rabbit found in a field takes on more weight and presence when given a full studio treatment. For sharp focus throughout, a digital camera body was attached to the back of a 4x5-inch view camera, with the lens panel tilted left so as to angle the plane of focus to the orientation of the skull.

OPPOSITE
Toilet wall, Chennai. 2009
An outdoor toilet in a Chennai slum in southern India would normally be determinedly overlooked, but the rusted and eroded corrugated iron papered over with a Hindu motif makes an unexpectedly compelling graphic image.

"Everything has its beauty, but not everyone sees it."
CONFUCIUS

"Already now I am searching for the most boring and irrelevant photo material that I can find. And I would like to get to the point soon where this determined irrelevance could be retained, in favor of something that would be covered up otherwise by artifice."

GERHARD RICHTER

BELOW
Abalone shell. 2009
The inner polished surface of an abalone shell is a well known beach subject, enjoyed for the play of iridescent colors, but closing right in and maintaining full depth of field de-familiarizes it, removing any sense of scale and orientation.

OPPOSITE
Udon noodles. 1994
Dried Japanese noodles from the supermarket, straight out of the packet, take on a sculptural appearance. As with other still-life images in this Path, applying the hero treatment adds one kind of bisociation, as in Path 4.

thrown away, are destined for the garbage truck, and are unwanted by most people. It's unlikely that you'll be the first to shoot a particular subject (Irving Penn, for example, photographed fat bodies, and also discarded cigarette butts and wilted flowers), but you are likely to have a clearer field than usual. And it can be interesting to bring your photographic skills to bear on such subjects, treating them as if they were beautiful. You might even succeed in making them beautiful through your photography.

THINGS YOU MIGHT OTHERWISE OVERLOOK

- ▶ The banal
- ▶ The trivial
- ▶ Things discarded
- ▶ By-products and waste
- ▶ Wrapping and container materials
- ▶ Decomposed stuff
- ▶ Damaged and broken goods
- ▶ Abandoned spaces
- ▶ Details out of context
- ▶ Anything out of fashion

13.

YOUR OWN LIFE & WORLD

Young couple, Tiniteqilaaq, Greenland. 2000

As Sobol remarks, "The young people in the settlement are very open about their sexuality and relationships." Moreover, the lack of private space in houses gives young couples little choice but to conduct relationships in the full gaze of at least the family.

OPPOSITE

Sabine Maqe, Tiniteqilaaq, Greenland. 2000

Sobol's intimate relationship with the young woman who became the subject of his book *Sabine* gave him a way to work photographically that reflected the open and accepting mores of Greenlandic family life.

M ost people take their inspirations from what's new and different, looking outward, beyond their experience and familiar surroundings. This is completely natural. We're conditioned to find stimulation in the unfamiliar. Exotic is the catchword, and it's a word that is always used positively, almost an advertising slogan in itself. It's standard vocabulary in, among others, the travel industry.

However, as in all things creative, it's good to look in the opposite direction as well, beyond the exotic to the mundane. While this might seem counterintuitive, your own home, world, and life can provide much interesting material. It's totally available and at hand, and even though you see a great deal of it, most other people have not, so there's the benefit of exclusivity.

Yes, there are pitfalls and issues. If the result of shooting scenes from your home life ends up looking like simple family snaps like millions of others, that would not be so good. One way to overcome this is to work at all the visual skills here in this book—composition, lighting, timing, and so on—to lift the imagery beyond the snapshot. Another is to make a story out of your shooting, or to assemble it around a theme of some kind. In other words, conceptualize it.

The main issue for most of us (myself included) is a natural reluctance to expose our private lives to public gaze. Embarrassment leads the list here, both for ourselves and for friends and family. Just think of examples from the world of literature, of authors who bare all, even when fictionalizing. It may come across as brave, foolish, or just plain thick-skinned, and inconsiderate. Making your life into art is a big step, not least because the whole thing may fall flat artistically. Tracey Emin's bed isn't for everyone (actually it seems to have been for quite a lot of people), nor is the classic here's-my-strange-life-in-photographs, Nan Goldin's *Ballad of Sexual Dependency*. If you're okay with those examples, you probably don't need this path to encourage you. If not, there's the option of going oblique: Just photograph traces and mementos. Still life and detail, for example, can sometimes tell as much, in a quieter way, as full-on family encounters of the exposed kind.

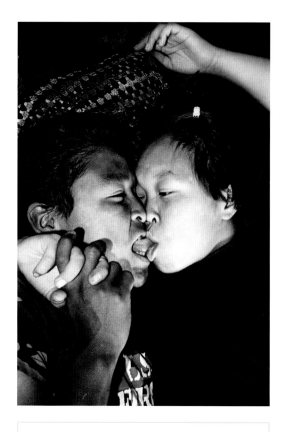

Jacob Aue Sobol 1976–

From Denmark, Sobol began not as a photographer but by recording Inuit life in East Greenland on a grant. Dissatisfied with the documentary results from his first season, he returned, fell in love with a young Inuit woman, Sabine, and recast his approach to photograph in intimate detail his life with the family. This intimacy has become the hallmark of his work.

"Many photographers are now working with their private understandings, observations, and sensibilities."

JOHN SZARKOWKSI

"Photographers are suckers for this kind of narcotic."

EDITOR HAROLD EVANS (ON SZARKOWSKI QUOTE ABOVE)

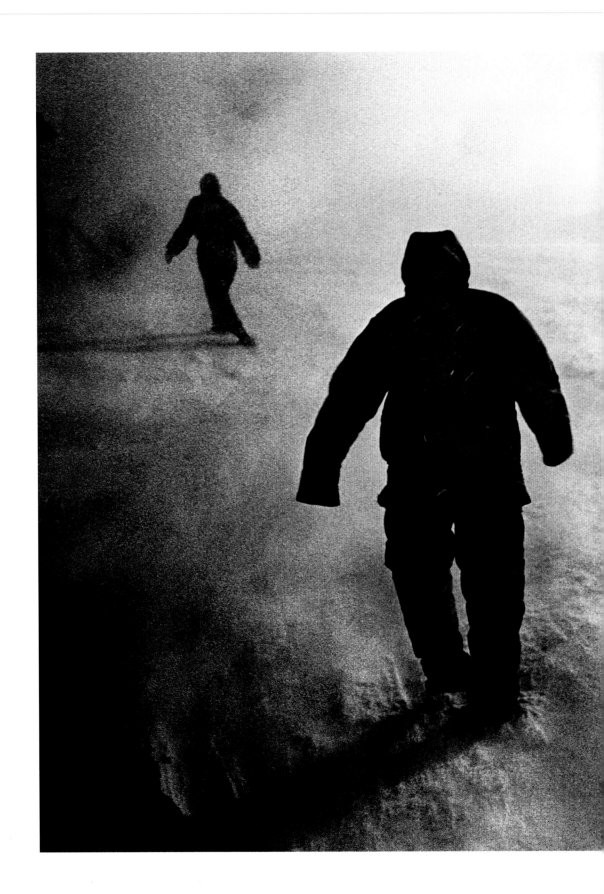

Sabine Maqe, Tiniteqilaaq, Greenland. 2002
Sabine and her mother on their way
home from the supermarket in the face
of a Piteraq—a violent snow storm that
is created on the ice that covers 90% of
Greenland. It accelerates and reaches the
settlements by the coast with terrifying
strength.

14. CROSSOVER

Cross-fertilization is a mainspring of creativity. Exploring ways to interpret other art forms, such as poetry, music, and painting, runs no risk of imitation yet allows photography to tap into creative minds working in other areas. Take a poem that you like and attempt to illustrate it in one or several photographs. Or, take a short piece of music—or any other work of art other than photography—that makes you feel something. You're not copying, so no guilt there, and yet you've been given a strong creative idea to work with.

Poetry has a lot going for it in this respect. Quite a number of poems aim to create visual imagery in the mind of the reader, and they tend to do it in a condensed and succinct way. The techniques are poetry's own—simile, metaphor, synechdoche, and so on—and the imagery is suggested rather than baldly explained, but all this makes poetry a very useful inspiration. There have been a number of books that combine poems and photographs, one of the most celebrated being poet Ted Hughes' collaboration with

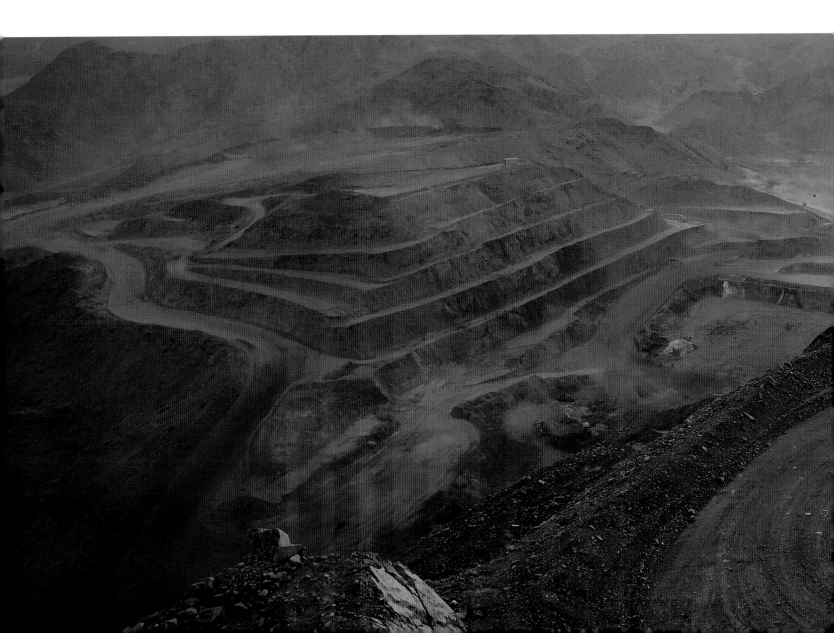

"Photography's closest cousin is poetry because of the way it sparks your imagination and leaves gaps for the viewer to fill in."

ALEC SOTH

BELOW

Open cast gold mine, Red Sea Hills, Sudan. 2004
The end-of-day lighting, dust and scale of this mine make a natural fit with the quote on the following page from Dante's *Inferno*—a case of searching for a match that evokes yet is not too literal.

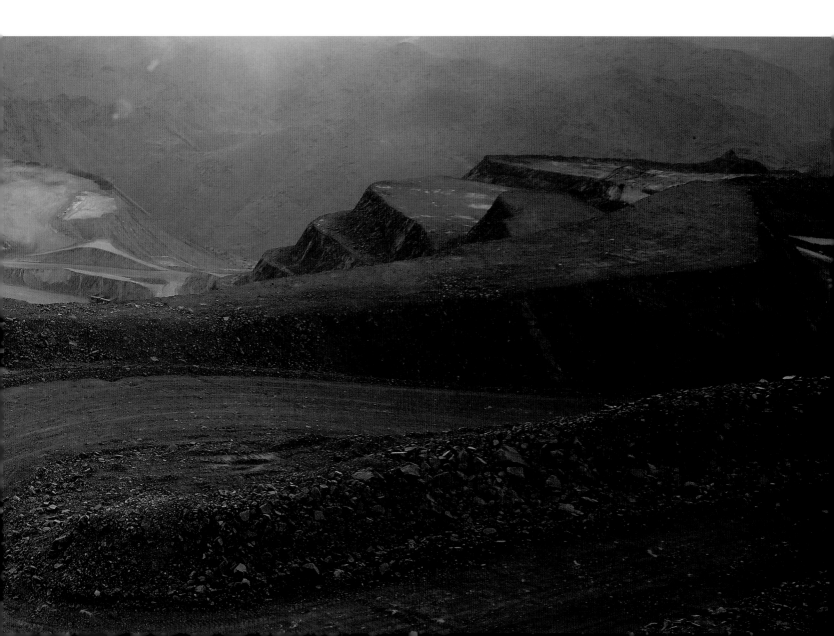

landscape photographer Fay Godwin to produce a joint work on the Calder Valley in Yorkshire, titled *Remains of Elmet* (1979), and later retitled simply *Elmet* (an ancient name for the region): "...Blackstone Edge—A huddle of wet stones and damp smokes, Decrepit under sunsets."

It's interesting to see how literary studies look at these collaborations. One academic research project called "Poetry Beyond Text" recognized three approaches: direct interpretation with the photographs matching what is in the poem, oblique with poem and photograph connected at the level of mood or association, and simply "a joint presence" with the photography sharing elements of atmosphere, setting, and theme.

You can make an easy start by taking poems, or lines in poems, that are visually evocative. Take Dante's *Inferno*, for example, which contains quite a number of lines that could have been aimed at art directors:

> "There is in hell a place called vge
> entirely formed of iron-colored stone
> as is the circling cliff that walls it in.
> Dead center of this baleful waste there gapes
> a chasm of enormous width and depth
> whose structure, when the time comes, I'll describe."

This is the eighth circle of Hell, and roughly translated from Italian, Malebolge means "evil ditches." The illustration here is actually of an open-pit gold mine in the Red Sea Hills, and generally speaking it's more satisfying to step slightly to one side like this rather than be totally literal. On the other hand, back to Ted Hughes, who did countryside and wildlife very well, and who first came to critical attention with a collection called *Hawk in the Rain*. One poem was *And the Falcon Came*. Its imagery, with lines such as "The gunmetal feathers...the bullet-brow...into the target…With the tooled bill" portrays the falcon as a "delicate boned" weapon, and in combination with a documentary image might offer a different view from most people's.

This, together with Romantic poets Wordsworth, John Keats, and Walt Whitman, is obviously good potential material, but there are also easy-to-visualize lines in unlikely places, such as T. S. Eliot's modernist poem *The Wasteland*. Good luck to anyone trying to illustrate all of it, but these lines, for instance, could inspire:

> "Unreal City,
> Under the brown fog of a winter dawn,
> A crowd flowed over London Bridge, so many,
> I had not thought death had undone so many…"

Not to mention the very simple "At the violet hour…"

Music is also a rich source to mine, beginning with program music and tone poems, which also started in the Romantic period. Think Beethoven's *Pastoral Symphony*, Smetana's *Má vlast*, and later, Vaughan Williams' *Sinfonia Antarctica*. That last one was a film score, and these obviously work the other way around, matching music to visuals, but as the two can work so well together, there's nothing to stop you from conjuring up imagery when you listen to a piece of music then translating that into a photograph.

RIGHT
Brokers, City of London. 1977
The Wasteland, mentioned here,
is notoriously difficult to match
in imagery, with its wide-ranging
modernist references, but the line
about a crowd flowing over London
Bridge has a correspondence here in
the visual flow of a long exposure
shot of old-fashioned top-hatted
City brokers.

15. CROSS-CULTURAL INSPIRATION

Not only are other art forms a rich source of inspiration, but the art of different cultures can also be inspiring. Picasso and his contemporaries were fascinated by African tribal masks, and he used their designs in paintings such as *Les Demoiselles d'Avignon*, saying he wanted "to liberate an utterly original artistic style of compelling, even savage force." Of course, that's the way many people use the word "original," meaning "original to what I'm doing."

Another such fertile idea is the Japanese yugen, which came directly from the similar early Chinese concept you xuan, dating back to the 2nd century. As with many Japanese and traditional Chinese esthetic concepts, this is not easy to grasp, even for many Japanese and Chinese. For Westerners, it is more difficult still because of the differences in cultural mindset, and that is precisely why it is a valuable source for sparking new ideas.

Here is how yugen has been described: "the profound, remote, and mysterious, those things which cannot easily be grasped or expressed in words" and "a profound, mysterious sense of the beauty of the universe" that embraces "the sad beauty of human suffering… making visible the invisible mysteries of nature and man." So, it is self-defined as elusive. The following may, or may not, be of some help. It's an example given by a 13th-century Japanese writer, Kamo no Chomei: "It is like an autumn evening under a colorless expanse of silent sky. Somehow, as if for some reason that we should be able to recall, tears well uncontrollably." Yugen works by allusion, by suggestion and being oblique, not through the directly obvious.

Photography can do all of this. In fact, these descriptions of yugen conjure up a sense of a Western esthetic idea in the arts, the sublime. This is a romantic idea, but a dark one, to do with conditions and scenes bigger than man that inspire awe. So, what would a yugen-inspired photograph look like? Dark and somber, perhaps. Maybe like that autumn landscape Kamo no Chomei describes. More visual clues come from a small book by Japanese writer Junichiro Tanizaki, called very descriptively *In Praise of Shadows*. This is really all about yugen esthetics, which he describes like this: "Such is our way of thinking—we find beauty not in the thing itself but in the patterns of shadows, the light and the darkness, that one thing against another creates." Shadows and darkness help create an aura of mystery and depth. Perfectly fertile ground for photography, to "create a kind of beauty of the shadows that we have created in out-of-the-way places." Yugen is just one example of a concept that can inspire imagery, but which comes from a different set of esthetic values, even slightly alien ones. There are many others. Look into other world cultures for inspiration.

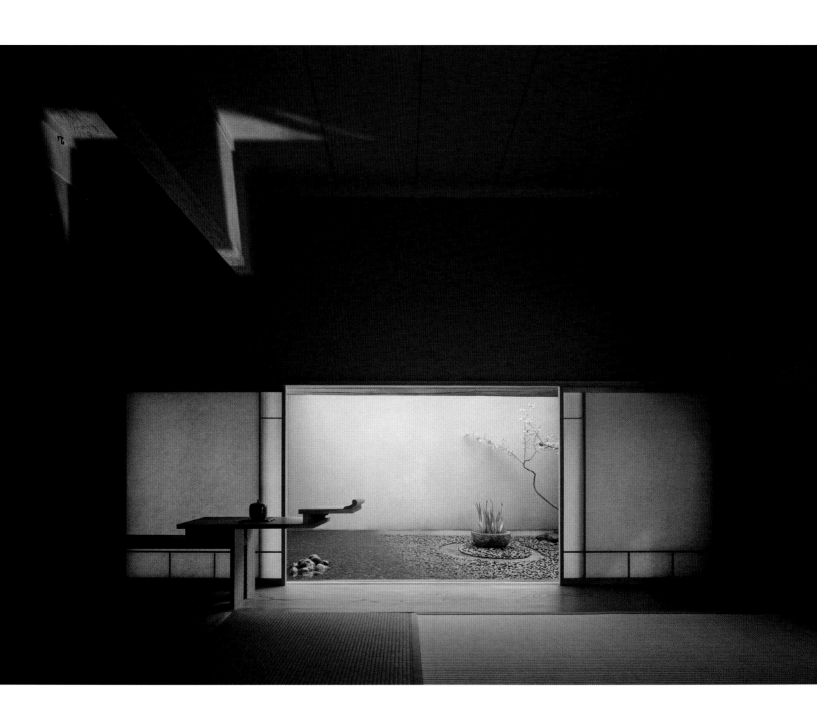

Ipswich, Massachusetts, winter. 1989
A dim winter's day on the Massachusetts
coast, rendered in black and white, alludes
to emptiness, mystery, and being "under
a colorless expanse of silent sky."

16. HOMAGE

In art, the French word "homage" means creating a work that bears resemblance to another, usually great work, and it is done in honor of that earlier artist. This is tricky territory, partly because you don't want to give the impression that you're passing something off as entirely your own idea, and also because a direct imitation is boring. It works best when you reinterpret the original.

Once you understand that there's no such thing as a truly original idea (we're all standing on the shoulders of someone who has gone before), you can certainly do worse than take an idea or a style that you admire, or even an actual image, and take it further. This may be easier said than done if you're thinking of developing beyond what seems like perfection—say, Ansel Adams' best landscape work—but it's not impossible, and has some hidden benefits.

There are two sides to this. One is the semi-ironic and the other is as a way of learning. Let's look at the tongue-in-cheek approach first, in which the photographer puts a twist on a well-known original, thereby adding something. It may not be a better something, but it's at least an attempt. Sandro Miller, an established Chicago portrait photographer, did this by taking 41 well-known images by photographers who had influenced him and recreated them as closely as possible—with one important difference. He used his friend John Malkovich as the model for every one of them, even when it posed some difficulties, as with Bert Stern's shots of Marilyn Monroe. That was quite a high-profile homage, but you get the idea.

OPPOSITE

Corrida, Cartagena, Colombia. 1979
In the late 1950s, photographer Ernst Haas experimented with long exposures on Kodachrome while moving the camera in different directions, to achieve a swirling, impressionistic effect. Finding Haas influential, and wanting to discover for myself how this might work, I tried the same technique, shifting the camera in a swirling movement.

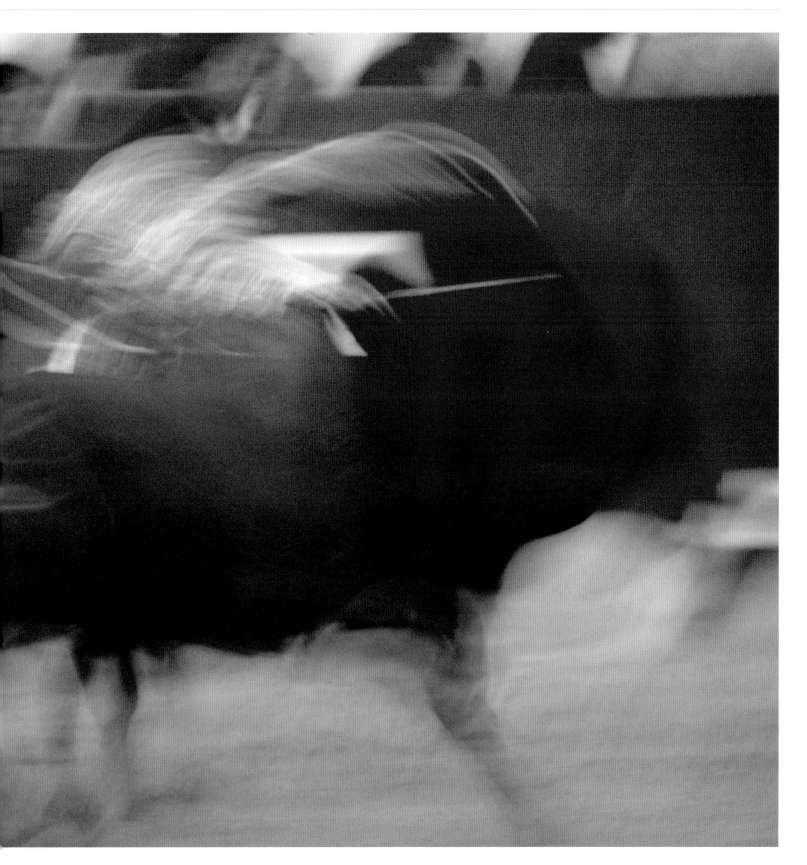

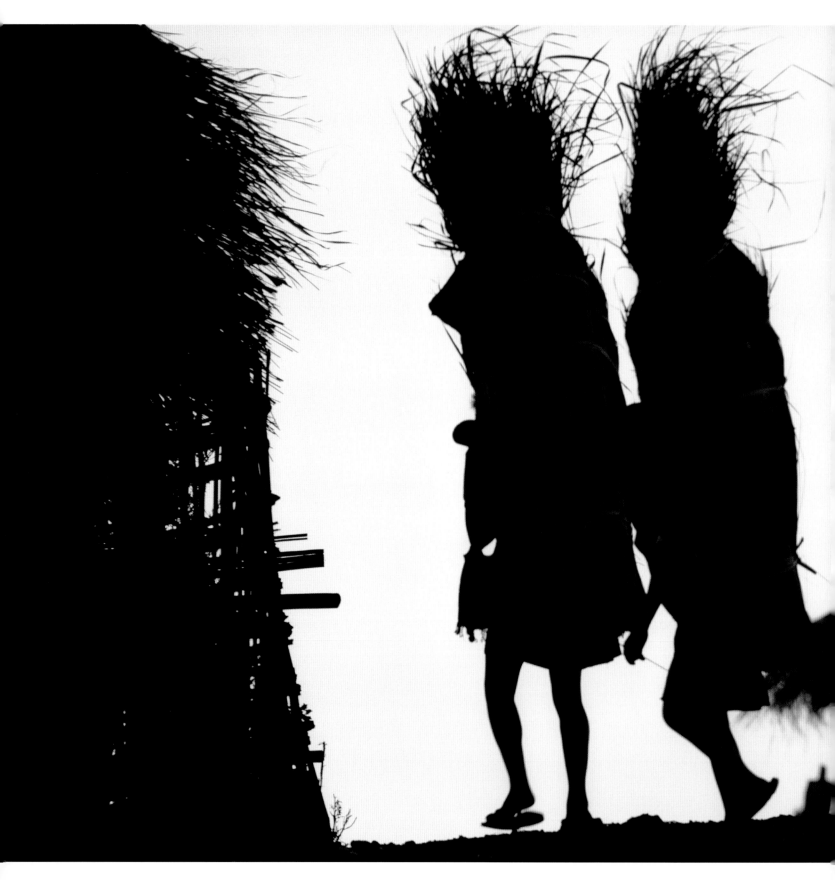

The other homage mode is for learning, and has a long and honorable tradition in painting. It's the way many classical painters educated themselves. Even Degas said "You have to copy and recopy the masters, and it's only after having proved oneself as a good copyist that you can reasonably try to do a still life of a radish." Today, the Louvre still encourages this, and 100–200 painters a year copy great paintings there. The point is to learn by practice and by close inspection of the masters. The photographic equivalent involves learning how admired shots were lit or composed or managed in various ways. This obviously works better with staged imagery, such as fashion shoots or studio setups. The British photographer Rankin did this with seven iconic fashion images and made a television program about it, which showed better than any gallery notes could what actually went into making these successful photographs.

At the end of all this, you might harbor doubts over plagiarism. If you copy too well, are you just borrowing another photographer's creativity? Under controlled circumstances like a studio still life, that might be possible, but the saving grace is that photography, unlike painting, has to work with real time and space, and you have to handle all of the elements, including lighting, yourself from scratch (discounting Photoshop-assisted images). Plagiarism, in any case, involves deceit and bad intentions. As long as you are aiming to pay homage, deceit is off the table.

"Good artists copy, great artists steal."

PABLO PICASSO

OPPOSITE

Akha girls carrying thatching, Chiang Rai, Thailand. 1981
For some reason, two or three images by Jay Maisel stuck in my mind, all very much of his telephoto style—dense silhouettes against a color. Silhouettes work best for me when the outlines are both distinct and ambiguous, so that you wonder a little at what's going on. I thought of Maisel's pictures when I saw this scene in a hill village where I was staying.

17. SHOCK

One fairly certain way of getting audience attention—you could even call it a guaranteed way—is to shock. Artists have been at it for ages, sometimes deliberately (see Marcel Duchamp's quote, opposite), but sometimes surprised to find that their work upset people (like Manet with his 1865 painting of a prostitute, *Olympia*). Like it or not, good, creative solutions will never please everyone. The only way to do that is to follow the lowest common denominator, and that's creative suicide; you'll just end up with bland and pleasant. With this home truth in mind, one slightly aggressive technique is to set out to challenge whatever's established. Creativity is rarely safe in any event, but journeys to the outer edge of acceptability are among the most uncertain. Whether brave, knowing, or simply showmanship, these attempts are usually controversial.

Efforts at stimulating the audience abound in art and popular media, from Gustave Courbert's 1886 painting *L'Origine du monde* (a woman's genitals), through Chris Ofili's 1996 artwork *The Holy Virgin Mary* (using, among other materials, dried elephant dung), to the first appearance of the shark in Jaws (known as the "You're Gonna Need a Bigger Boat" scene). What they have in common—and this applies to all works designed to shock—is that they either tread on taboos or confound expectations. Use either of these strategies and you'll succeed in causing some amount of shock among some people. Whether or not it will be creatively worthwhile is another matter.

Bruce Gilden 1946–

Brooklyn-born photographer Bruce Gilden has developed a distinctive style of shooting that is quite abrasive and extremely close, a literally in-your-face technique, using a 28mm lens from about a meter with off-camera flash held to one side. He says, "the viewer will always feel like he's a participant," and "flash helps me visualize my feelings of the city… the energy, the stress, the anxiety that you find here."

"Unless a picture shocks, it is nothing."

MARCEL DUCHAMP

Donna, Las Vegas, Nevada, USA. 2014
Sherry, Romford, Essex, UK. 2013
Bruce Gilden's street photography is decidedly confrontational (although his engagement with his subjects is by no means as aggressive as it may seem on the surface). His portrait series is an extension of this unflinching style, yet with full cooperation from his subjects. Hard flash and a wide-angle lens used so close as to fill the frame forces viewers to look at all the details we might normally turn away from.

Taboos are fairly straightforward to line up in order to knock down. Naturally they vary over time and across cultures. Manet's *Olympia* offended because the nude was obviously a prostitute, which wasn't acceptable in late-19th-century Europe. Any pictures of women are unacceptable in Islamic society today. A basic rule of thumb is that you can most easily find taboos somewhere within sex, bodily functions, food, decay, and religion, and for the first three or four of these it simplifies to things going into or coming out of the body. There are more obscure taboos, but these areas are reliable.

As for expectations, people tend to get rattled or at least activated when things don't go the way they think they should. Moviegoers didn't expect the white shark to leap out suddenly toward the camera and at Roy Scheider, but then visitors to the Paris Salon in 1865 didn't expect a nude to be painted flat and sketch-like. Photography, however, has a slight problem with being truly shocking. It shows the real thing. It's one thing to hint at or describe shockingly unpleasant events of cruelty and violence, but entirely another to show them.

I can't imagine any war photographer claiming creativity. Documenting the horrors of conflict is entirely too raw and, well, serious. Artists, of course, can claim seriousness, but that's of rather a different order from actual killings, bombings, and the like. Someone somewhere will say that I'm missing the point here and just chickening out,

but remember that this is about creative paths. I can think of some shocking Philip Jones Griffiths' photographs from the Vietnam War, but they were angry, campaigning images, not an attempt to be creative. One of the founding members of Magnum, George Rodger, discovered the contradiction of creativity and horror for himself when he photographed the liberation of the Belsen concentration camp: "When I discovered that I could look at the horror of Belsen—4,000 dead and starving lying around—and think only of a nice photographic composition, I knew something had happened to me and it had to stop."

Ways to shock creatively in photography still involve taboos and expectations, but remember that the very realism of a photograph makes a little go a long way. An interesting aside is that, when it comes to sex, bodily functions, food, and decay, wet is generally more shocking than dry. People don't like slime. Three well-known examples from photography's history are Frederick Sommer's still-life photographs of arrangements of chicken parts and other dead and decaying creatures in the 1940s, Andres Serrano's 1987 *Piss Christ* (a crucifix in urine), and Robert Mapplethorpe's explicit homosexual imagery from the 1970s and 1980s. However, Mapplethorpe said, "I don't like that particular word 'shocking.' I'm looking for the unexpected. I'm looking for things I've never seen before. …I was in a position to take those pictures. I felt an obligation to do them."

OPPOSITE

Mummified Cat Casting a Shadow. 2003
There's more than one way to skin a cat, and this harshly lit and roughly cropped shot of a mummified cat, by Dave Schiefelbein, relies as much for its shock value on reversing our normal expectations of cute and furry as on the naked lighting. The shadow in fierce profile also triggers memories of a clichéd early horror film device.

18. KNOWN SUBJECT, DIFFERENT VIEW

Take a subject or scene that has been photographed by others, even heavily photographed. Look at the history of its imagery and do something different. The common ground of how a subject is typically photographed in a certain way is a really useful starting point because you can then have an idea of what an alternative might be.

If you're confronted with an over-photographed scene, perhaps the most obvious reaction is one of blankness, of having no idea where to start in order to take anything resembling an original picture. Take the Lincoln Memorial in Washington D.C., for example, or the Eiffel Tower, the Leaning Tower of Pisa, and so on. You already know these scenes so well from endless photographs and videos that it's often anticlimactic to even be there in person. It's the fate of famous views and famous sayings to become cliché. What value they once had has been worn away by over use.

Paradoxically, though, by being so thoroughly over-done, the well-known subject carries the secret seeds of inspiration. Think of it this way: If you're remotely interested in using your camera on it, you know right from the start that the obvious treatments aren't even worth attempting. You already know the gamut of imagery, so that automatically narrows the field of what you might do, beginning with viewpoint and moving on to concept. You don't have to waste a moment trying the obvious.

One example is the world's most famous city crossing, in Shibuya, Tokyo. This is the one by the railway station that everyone has seen on television, where five busy streets converge and the traffic lights are arranged so that all the pedestrians cross all at once. On a busy day, a thousand or more people cross within a couple of minutes. The white lines that mark the crossing are also graphically striking. The endlessly repeated views are elevated, often taken from one of the surrounding buildings. That poses a slight problem for originality as the shot from overhead really is a good bet by almost any standard. So, how about taking it from even more overhead?

The hotel I was staying at has the steepest vertical view down, especially from the 25th floor. Choosing that wasn't creative, but it did refine the view. What made the difference was that I knew I didn't want just a standard semi-aerial shot. I wanted somehow to abstract the already graphic possibilities and make it less realistic. Tighter framing would help, and that suggested a 200mm focal length. I still needed an imaginative breakthrough, and making my way back to the hotel one day in the rain I suddenly realized what that could be as I joined the crowds on the crossing itself with my umbrella. Hundreds of umbrellas hiding all the people! Colored dots and stripes and flat light. What's more, from that height looking through rain and through reinforced glass, I had a slightly strange optical filter. The final touch was a slow shutter speed of 1/20 second, fast enough to avoid camera shake, but slow enough to put a little motion streaking into the umbrellas.

Trooping of the Color, Horse Guards, London. 2010
The endlessly photographed and filmed annual parade of Guards regiments for the Queen's birthday cried out for some new treatment that went beyond the standard massed-and-wheeling ranks of soldiers. While a regiment was marking time, I made a very tight crop with a 200mm lens, framed so that the officer just fits the upper right corner, and timed for when one leg is fully raised and the boot clears the heads of the troops behind him. Essentially, I was looking for maximum graphic treatment.

19. **JUXTAPOSE**

One of the most elemental ideas in photography is juxtaposition: two things in the same frame that the photographer chooses to relate to each other. Juxtaposition can be a powerful tool that works better in photography than in any other visual medium. Use it well and you are guaranteed a strong audience reaction. Use it poorly and you expose yourself to looking very silly. It's all about seeing a connection that other people would miss, but which they get once you have captured it skillfully. The skill part is crucial, as we'll see in a minute, but making the creative connection is the key. Why do the two things go together? Why are they interesting together? It could be as simple as two matching shapes, or it could be conceptual, where you want the viewer to see some hidden meaning. Most good photography is about showing connections, and juxtaposition is a special tool for revealing connections.

Juxtaposition works so well for photography because you cannot easily invent a juxtaposed situation without going to lot of trouble or moving into the studio. The surprise element that a good juxtaposition needs is that two things were unexpectedly in the same space at the same time. It's also a proof that you are functioning well as a photographer: alert and creative enough to be open to the possibilities. If you were painting or illustrating, there would be no great trick to putting two subjects together. The idea of the combination might be good, but there would be nothing special about it visually as it's just too easy to do. As a photographer, however,

you have to work with what you can find, and it's only occasionally that you have the opportunity to shoot two subjects in order to make a point, assuming you're alert enough to spot it. Being tied to reality makes strange and unimagined juxtapositions all the more powerful and valuable.

Imagine asking a friend to cup their hand and hold it so that it appears to be holding the setting sun from one angle. Well, you don't have to imagine that because you can see countless people doing it on beaches every sunset. That's juxtaposition, but it's also embarrassingly silly. The quality and the freshness of the idea really do count. Potential juxtapositions are all over the place, so you do need to make sure that yours is worthwhile. (If you sense some familiar undertones in this path, look back to Path 4 on page 22. Quite a lot of bisociation goes on with juxtaposition.)

Getting juxtaposition to work practically is not always easy or straightforward. If you just happen to come across a juxtaposition that triggers a satisfying reaction in your mind and eye, that's a stroke of luck and you need no more than a quick reaction to shoot it. If, however, you have the idea that two things might work well together, but they're separated in space, the problem then is to find the magic combination of viewpoint, lens, and composition that will make it work. Often it turns out to be impossible; you imagine that, from somewhere, they would line up, but physically they just don't. It happens.

OPPOSITE

Bethlehem graveyard and steel mill, Pennsylvania. 1935
The details of this shot by Walker Evans are lost, but it was probably St Michael's Cemetery in the steel town of Bethlehem, and most certainly a very carefully composed juxtaposition, using a long focal length, between the brightly sunlit cross in the hillside cemetery and the repetitive dark factories beyond. The viewpoint is exact, making maximum contrast between the cross and the shadows of the building in the middle distance, and the aperture very small for full depth of field.

Walker Evans 1903–1975

The founder of the documentary tradition in American photography, Evans combined precision and clarity in technique with what has been called the poetic resonance of ordinary subjects. His preferred subjects were vernacular, something he put to memorable use in his work for the Farm Securities Administration during the Depression of the 1930s.

The viewpoint is the obvious first step if you're working at a juxtaposition instead of just coming across one, but focal length is also critical. Changing focal length helps you adjust the size relationship between two subjects. A long lens enlarges backgrounds and distant things, while a wide-angle lens enlarges foreground objects. Which focal length works best depends on the particular juxtaposition. In any case, large depth of field from a small aperture always helps.

The third skill for juxtaposition is how you compose, and that might be as simple a choice as placing one subject in front of the other or to one side. Always pay attention to the framing, especially in terms of what you exclude. Keep attention on the juxtaposition itself by avoiding distractions. Reasonably tight framing is one strategy, but at least be aware that other elements near the edges of the frame tend to pull the viewer's attention away.

ABOVE
Swimsuit, Cartagena. 2015
Ideal and reality make an unkind association
in both advertising and photography.

McDrink, Hoxton, London. 2008
Graffiti on a wall in the East End of London and a casually discarded drink match each other in colorful banality.

20. HAVE THINGS HAPPEN

Monks, Songzanlin Monastery, Yunnan, China. 2009

There was plenty of time in this situation, drinking tea in a relaxed fashion with the monks, but although the setting and light were both good, just drinking tea was ordinary and obvious. Yet at one point, the slightly flamboyant senior monk raised his hand unexpectedly—I was never sure exactly why—and the commonplace action suddenly became a unique moment and far more engaging.

This is, to be sure, a street or reporting photographer's credo, so it will not suit every situation by any means. You may prefer stillness, or your subject may deserve it. However, in the wider world, there are many scenes and situations that can be charged up and inspired by having something happen within them. Static scenes are easy. They don't change much and they don't talk back to you. That's why landscapes, buildings, and close-ups are so, so popular. And, they often turn up as pretty boring images. Consider enlivening your image by animating it with action.

That's easy enough to say and it makes sense, but of course it isn't always as simple as turning on a tap marked "action." In commercial shooting, however, where the photographer is art-directing the scene and has control, adding action is a good move to consider. With a little effort, it's also fairly easy to put into practice. It gets trickier, though, when you're not in control. Then what can you do? You're on the street, and there are the makings of a shot taking shape in front of you.

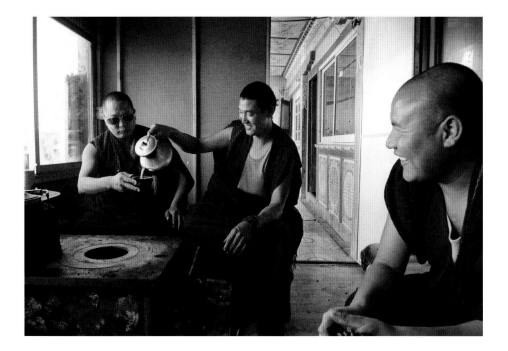

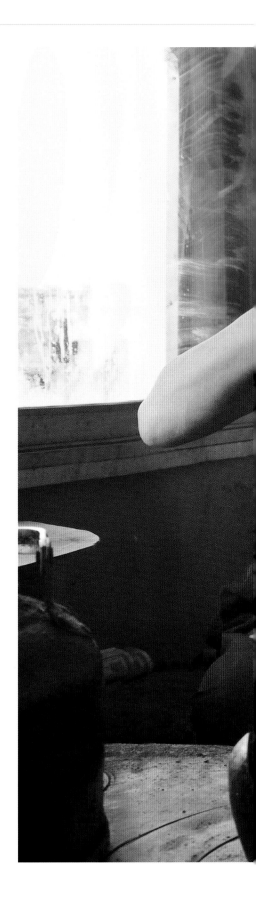

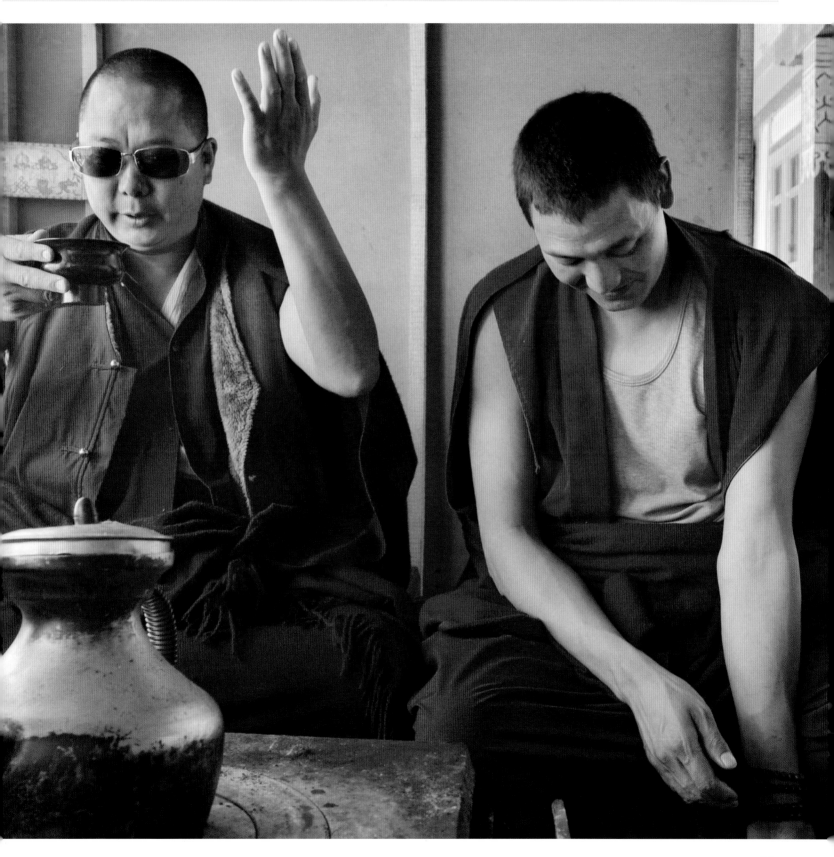

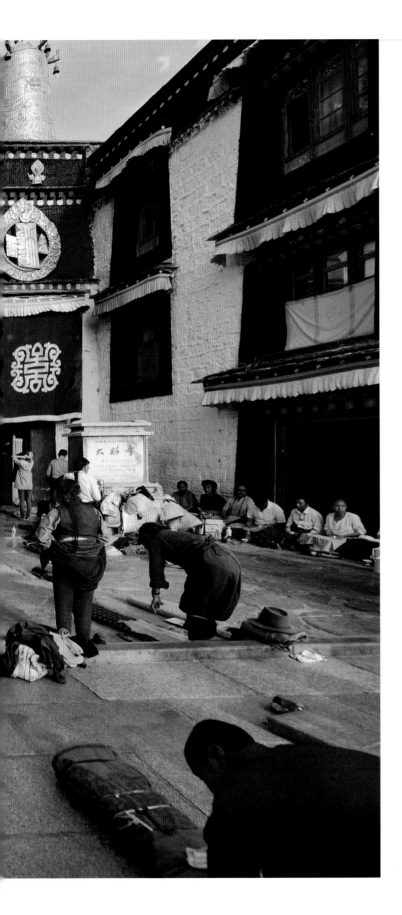

That's often the way it happens, partly because you see its possibilities and partly because you're willing it to happen, to become something good. You've got a scene and a framing for it. You're in place with the right lens and the light's good and there are people passing through. Let's say, then, that you've got about 70 percent of an image in front of you. What you need to take it up to its full potential is something happening inside that situation—and, more importantly, inside your frame.

It's not so much what anyone actually does, but how you capture that in your frame. In practice, this means putting in the time and the energy to move around and pay constant attention while also being prepared to accept that it may not happen at all for you. This is why these perfect captured moments are relatively rare. If it happened all the time, it wouldn't be valuable. Moreover, if you're rather more discriminating, you might have judged that the starting point wasn't 70 percent but more like 20 percent, on the grounds that the action and coincidences were totally necessary for any kind of success.

OPPOSITE & BELOW

The Jokhang, Lhasa, China. 2009
The entrance to this Buddhist temple, where people constantly pray, is heavily over-photographed, which makes a standard view unremarkable. Nevertheless, for an assignment the entrance had to be shown, and the solution was to shoot from very close to one woman praying and frame her to the left at the moment when her hands were fully raised above her head (and incidentally, outlined clearly against the white wall at left).

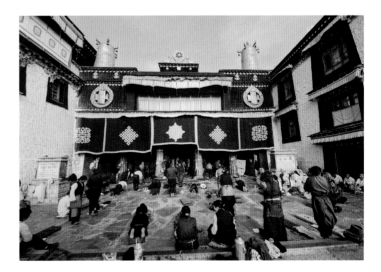

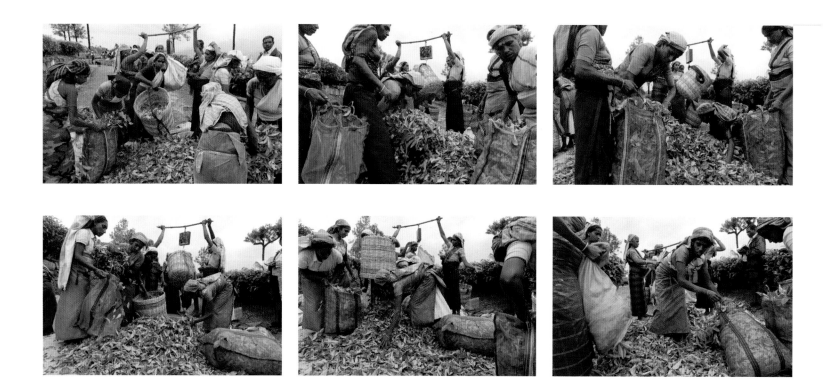

ABOVE
A small selection of six images from an entire take of over 70 shots taken over seven minutes from basically the same viewpoint, trying to coordinate the different visual elements in this scene of washing and bagging tea leaves. The different variables, shown in the illustration right, were all operating independently, and in a situation like this almost the only solution is to keep shooting in the hope that one frame will have all of them in a satisfying relationship to each other.

RIGHT
Here shown schematically, there were four individual events happening at the same time, and although they were linked as actions, there was no visual coordination. At times they would merge, or one would obscure another, and shooting meant staying aware of the four "units" and how they moved relatively within the frame.

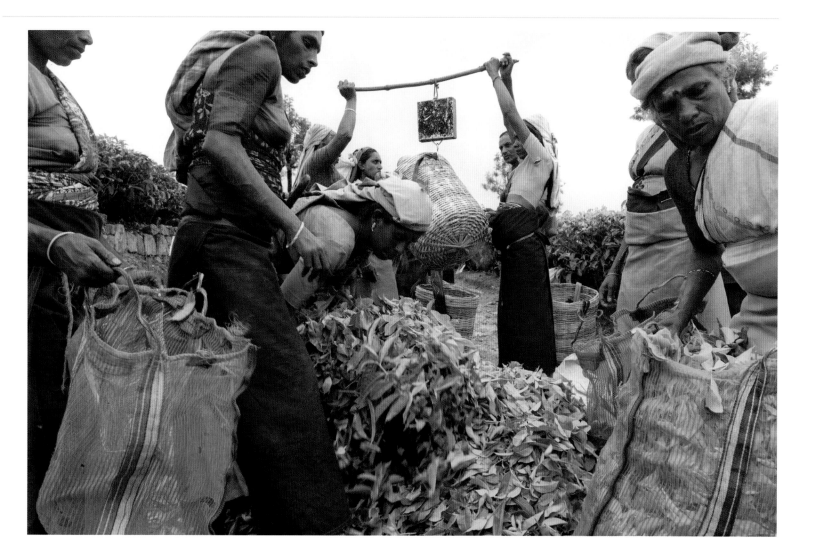

ABOVE

ABOVE

Tea pickers, Mount Vernon Estate, Sri Lanka. 2014

The frame finally chosen after careful editing has for me the best combination of activity. The prime target was the weighing action in the background, and it had to read clearly. After that, I looked for a good tea-pouring action in the middle ground, and two strong figures close to the camera last and right.

It doesn't have to end with just one well-caught piece of action, either. Seasoned street photographers look at higher stakes, hoping to juggle more than one piece of action in the same frame. When you have two or three "active units" in the frame, the chances of them all working together as a composition are not high, so it calls on a rare combination of luck and skill. When it works and things come together, this multiple action is all the more satisfying.

In the example of the Sri Lankan tea-pickers at the end of their shift, there's a chance to look at a multi-action shot in detail. This isn't street photography so the situation is easier in that there was time and space to move and wait. The number of "active units" did, however, make it difficult to manage visually as my only controls were viewpoint, focal length, and timing. The wide-angle focal length of 24mm was an early, deliberate choice because it allowed a deep view when used up close. It also allowed an extra foreground plane of sharp activity that longer lenses don't permit.

The sequence of work controlled the action: One at a time, the pickers put their baskets on the weighing hook and the two women operating the scale raised their arms. This done, the picker steps forward with her basket and empties it onto the pile of leaves. Meanwhile, closer to the camera, women scoop up leaves from the pile and cram them into bags that will be loaded onto a truck. There were two women doing this on the left, with another nearer on the right. All in all, that meant four "active units" to capture in one moment, and ideally each action ought to be special or interesting or even elegant. From the take shown here, the best of each of the four did not all coincide, which is normal.

21. UNGUARDED EXPRESSION

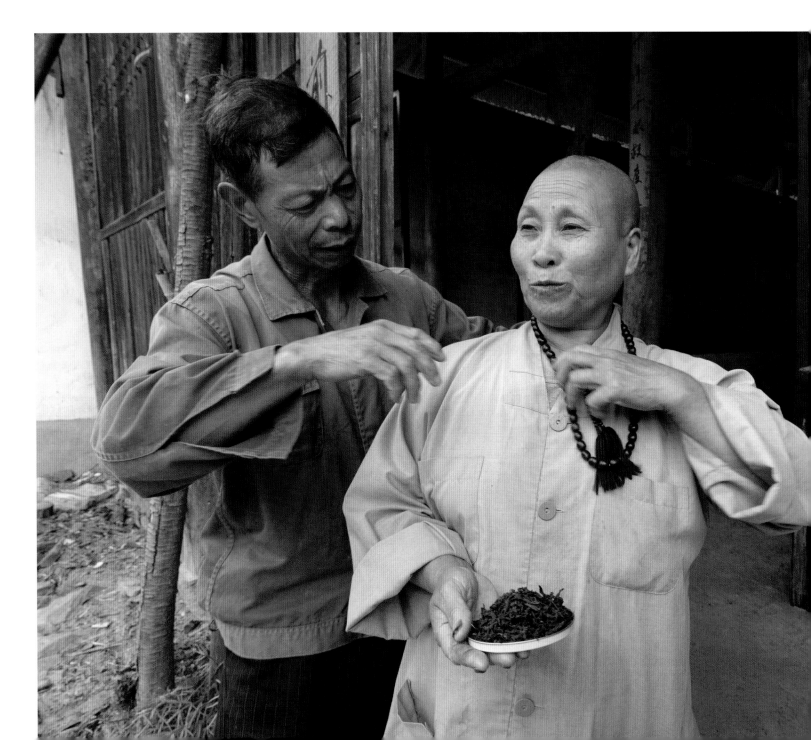

This is a path specifically for photographing people, for portraits of one kind or another. By portrait, I mean a photograph that concentrates on showing some kind of likeness of someone, but within that there are many different approaches, from formal to informal, planned to unplanned, usually with the cooperation of the subject but occasionally without. When you combine the idea of "likeness" and the cooperation of the sitter, it shouldn't be any surprise that most portraits are conventional and unadventurous. Almost everyone wants to look good in a photograph, and if they are actually asking the photographer to do the job, and even paying for it, they expect to look at least as attractive as they think they are, and hopefully better.

In other words, there's usually a pact between the photographer and the person being photographed that the result is going to be something that the sitter would be happy to show others and say, in effect, "That's what I'm like," or at least, "That's what I'm like on a good day." This doesn't leave much room for creativity, but if you're prepared to step away from the happy smiling face, calm trustworthy gaze, and seductive twinkling eyes, there are many good creative opportunities. This does not mean looking for an expression, gesture, or pose that is necessarily awkward, ungainly, or unattractive, but rather for something that is not posed. Almost all conscious portraits are posed because the person being photographed is creating a kind of mask that they know, or hope, makes them look good. The creative path means somehow getting that guard down.

Fu Lin monastery, Wuyishan, Fujian. 2014
This Chinese nun in charge of a small, old Zen monastery was being photographed with some of the tea that she grows for the monastery's own use. The situation was straightforward and not particularly interesting. Then one of the workers doing reconstruction stopped by and tried to re-adjust the way she was wearing her beads, which caused some argument. It turned out that they had once been married.

No photographer has worked harder at pulling the mask away, and talking about it, than Richard Avedon, who said, "The fact that there are qualities a subject doesn't want me to observe is an interesting fact (interesting enough for a portrait). It then becomes a portrait of someone who doesn't want something to show. That is interesting." It is also the starting point for breaking away, if you want to be creative. As Avedon explained, "My portraits are much more about me than they are about the people I photograph. I used to think that it was a collaboration, that it was something that happened as a result of what the subject wanted to project and what the photographer wanted to photograph. I no longer think it is that at all."

Put like this, it means extracting the expression that you want, or at least having the choice of a more unguarded expression. In an agreed portrait session, you have to set up a relationship for at least as long as the photography lasts, so the method for getting an unguarded moment is usually deliberate on the part of the photographer. There are a number of famous case histories. One was Canadian photographer Yousuf Karsh's iconic image of a scowling Winston Churchill, widely regarded as embodying wartime "bulldog spirit." In fact, as Karsh said, "He was in no mood for portraiture and two minutes were all that he would allow me as he passed from the House of Commons chamber to an anteroom. Instinctively, I removed the cigar. At this the Churchillian scowl deepened, the head was thrust forward belligerently, and the hand placed on the hip in an attitude of anger."

Perhaps less well known is the story behind Avedon's portrait of the Duke and Duchess of Windsor, whom he clearly didn't like. "I wanted to bring out the loss of humanity in them. Not the meanness, and there was a lot of meanness and narcissism. So I knew exactly what I had to try to accomplish during the sitting. I photographed them in their hotel suite in New York. And they had their pug dogs, and they had their 'ladies home journal' faces on—they were posing, royally. And nothing (if not for a second)—anything I had observed when they were gambling, presented to me. And I did a kind of 'living by your wits.' I knew they loved their dogs. and I told them, 'If I seem a bit hesitant or disturbed—it's because my taxi ran over a dog,' and both of their faces dropped, because they loved dogs, a lot more than they loved Jews. The expression on their faces is true—because you can't evoke an expression that doesn't come out of the life of a person."

A studio is the rawest, most exposed situation possible for photographing people, and Avedon was really at the forefront of using it mercilessly. However, the unguarded moment works perfectly well in other situations: people's homes, workplaces, on the street. There may be less opportunity to talk, and waiting unobtrusively is often the best strategy. Ultimately, the moment you choose to photograph is what you prefer, and you might want to be cautious about attributing any deeper truth to an unguarded moment. Even Avedon, despite what he said above, also had this general comment: "This really did happen in front of this camera…at a given moment. But it's no more truth… the given moment is part of what I'm feeling that day, what they're feeling that day, and what I want to accomplish as an artist."

The Duke and Duchess of Windsor, Waldorf Astoria, suite 28A, New York, April 16, 1957
As described fully in the text, the strength of this penetrating portrait by Richard Avedon of the Duke and Duchess of Windsor comes from the emotionally charged moment. These are not the managed public faces that the couple preferred to offer the public as their personae, but a more genuine glimpse—albeit of distress.

Richard Avedon 1923–2004

Without doubt one of the greatest photographers of the 20th century and the most influential in fashion and portraiture, Avedon is best known for his minimalist but intense portraits, using stark lighting and a plain setting which concentrates the attention on the expression of his subjects. He worked hard at revealing expression, although ultimately he saw this portraiture as perhaps more revealing of the photographer than the sitter, saying, "Sometimes I think all my pictures are just pictures of me."

22. OUT OF PLACE

The order of these paths is deliberate, really. In one way of looking at things, this path and the one that follows might seem to have naturally followed Path 19: Juxtapose (see page 84) because all three are about positioning things next to each other. However, things are more often than not moments as well, and it's not necessarily useful to try and separate position and timing. Path 20: Capturing Happening was very much about having things happen in a certain place in the frame so that the entire image comes alive. Following that, Path 21: Unguarded Expression was about different things happening in place, but now let's look at things happening in a way that looks and feels "out of place." As the main image here shows, being out of the expected order of things is often as much about when as it is about what.

So what is going on here? And practically speaking, what has it got to do with a creative path? Parts of Calcutta, where this image was taken, used to be the exemplar of abject urban poverty and squalor, though now it has more competition. This picture was shot close to the nadir of Calcutta's international low ranking, in 1984, and I'll ask you to trust me that I wasn't carefully framing to make it look like that. I was by the Hooghly River, and you can see part of the wonderful Howrah Bridge in the background (which means that I was shooting illegally—under Indian law, all bridges are off limits for photography on account of national security).

Everything in the photo is a mottled, ugly gray, from the buildings and pavements to the clothes, as if an art director had had everything sprayed in the same tones. Then, look what happens along. Here is an exquisitely polished, pristine car. If you're into Indian culture and history, it's more than that: This is an Ambassador, which for decades was the car of government and an Indian icon. What is it doing here, in the rock-bottom end of town? I don't know the answer. In any case, this is an image that, if it attracts at all, suggests looking deeper into the circumstances that it's showing. That incentive to enter the image and wonder about it is at the heart of this creative path.

In other words, as a path, this is very much subject-based—which means either that you put a lot of effort into research or you stay sharply aware of inconsistencies as you walk around. However, this being photography, having found a situation in which something is intriguingly out of place, you must then make the contrast work visually. Juxtaposition

OPPOSITE

Ambassador car, Calcutta. 1984
A spotless and gleaming Ambassador car, until recently the vehicle of choice for Indian officials and one of the sub-continent's icons, seems to have strayed into the wrong and very grubby part of Calcutta.

"The marvels of daily life are exciting; no movie director can arrange the unexpected that you find in the street."

ROBERT DOISNEAU

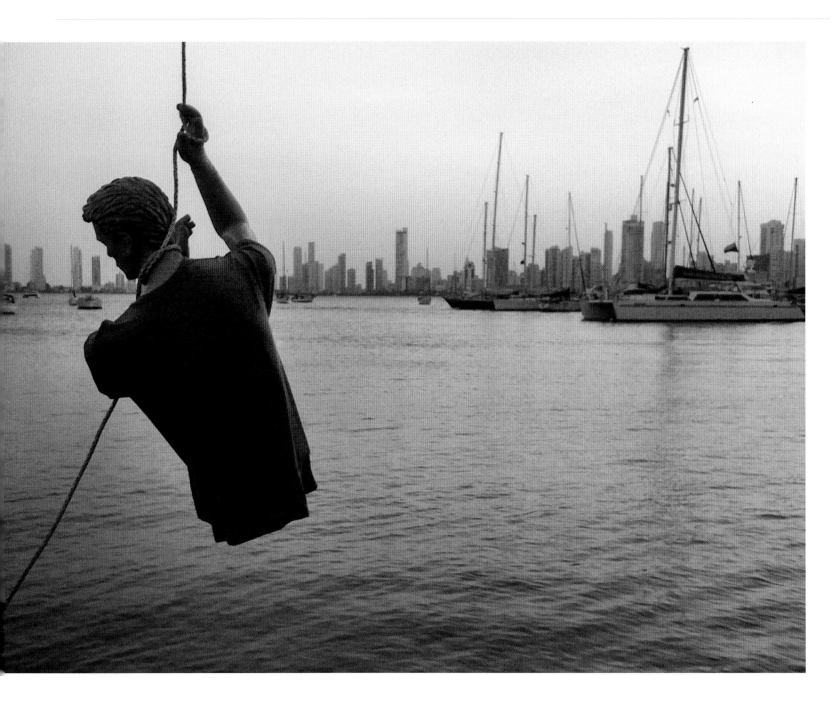

ABOVE

Cartagena Bay, Colombia. 2013
Completely without explanation, the torso of
a shop window dummy hangs from the neck
by a jetty on the Bay in this South American
city. Any explanation would surely be more
prosaic than anything imagined.

is at work here, so the suggestions at the end of Path 19
(see page 84) apply here also. In addition, and in principle,
there are two opposed visual strategies. One is to make the
contrast clear and striking, as in the Calcutta street scene on
the previous page, where color plays a major role. The other is
to keep the visual contrast subdued and under control so that
the image reads more slowly. The hand of the Buddha is one
such example. There is obviously something immediately
unusual in the hand being isolated from a body, but it takes
a little time to see that it is sitting among bags of cement.

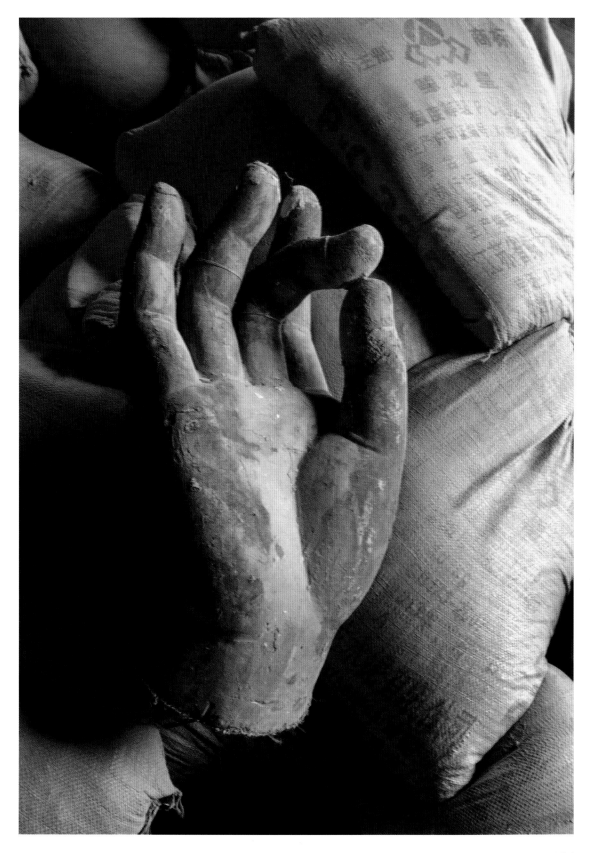

White Crane Temple, Suzhou. 2013
The hand of a Buddha statue, along wth other dismantled parts, lies temporarily among cement bags during the re-building of a temple in the Chinese city of Suzhou.

23. COINCIDENCE

Juxtaposition comes in many flavors, and coincidence is one of the more interesting. As an idea and word, it began life meaning simply happening or being in the same place or at the same time. Nowadays, it means strangely so, unexpectedly so. Any kind of coincidence has a universal appeal, because it seems special. "What are the odds of that?," we ask, usually pleasurably. With a visual coincidence, we seem to be privileged in some way to have been just there at just that time when it happened. Better still, to catch it with a camera shows skill and fast reaction, and then it's captured forever. We have the evidence in a permanent image. Some people take coincidence even further, as a suggestion that there may be more to life and the world than meets the eye, some sort of underlying connection we don't really know about.

So if it's all chance, how can it be made into a useful path? Well, strange to say, it's not entirely about chance. A lot of coincidence, when subjected to probability theory, turns out to be not quite so unusual as we imagined. What counts is how the audience sees it, and they are often simply prepared to be entertained by it. So, given this, can you actually manufacture a coincidence? Can you deliberately find something that other people, your audience, will find more remarkable than it actually is?

Richard Kalvar 1944–

A member of Magnum for 40 years, Kalvar practices street photography (though he doesn't use that term) in a determinedly personal way, searching for the disconnects between banality, reality, and strangeness. Results like this come from putting in a lot of time and shoe leather—he says, "every once in a while something unexpected happens"— and from ruthless editing.

OPPOSITE
Rome. Piazza della Rotonda. 1982
Similar to the handling of humor in the next Path, captions can do more harm than good. Pointing out a coincidence that the viewer has already seen simply irritates.

"How long can a coincidence extend before it ceases to be one?"
GEOFF DYER

ABOVE

Palenquera, Cartagena. 2014

An established feature of this Caribbean Colombian city is fruit sellers from the nearby town of Palenque, and water melons are their most typical ware.

To a degree, yes you can, and it depends on using the extra knowledge about juxtaposition that most photographers have. Since most of us, at least in street photography, are constantly on the look out for visual juxtaposition, we tend not only to have a heightened sense of awareness about it, but we can sometimes improve the odds by getting into a particular camera position and by waiting. This involves what I call the "passerby syndrome," which most photographers suffer from, and it brings back echoes of Path 20: Have Things Happen (see page 88). You're in front of a scene that would be animated by a passerby, and you know that sooner or later, someone will come along. You can anticipate where exactly in the frame you would like them to be, so you're prepared to wait a certain amount of time, depending on how good you think the shot will be.

As you wait, you have time to think how much better it would be if the passerby were dressed in a certain way, or carrying something, or maybe even were dressed in a color that matches something in the scene. Maybe if you wait long enough, that will happen. This is how the passerby syndrome works, and it's one way of improving the odds of what will look like a coincidence of sorts. True, the image becomes a little less valuable for having been worked at in this way, but it can still be effective.

"There are only coincidences."

ABOVE

Mural, Getsemani, Cartagena. 2014
Street graffiti, very popular in urban Latin America, inevitably
invites some sort of visual relationship with other things that
go on in the streets.

24. COMEDY

To make someone laugh or bring a smile to their face is one of the purest forms of entertainment. Successful comedy relies totally on creativity; just think of the last good joke you heard, what you liked about it, and why you laughed. Going back to the idea of bisociation (see page 22), Arthur Koestler actually used jokes as the perfect example of this kind of creativity—joining two normally separate contexts. So why not look for humor with your camera? Succeed and you cut straight through the usual minefield of taste that has post-modernists turning their noses up at attractive landscape photographs and practical-minded sports photographers sneering at conceptual images. Everyone likes to laugh and smile.

All right, it's not as simple as that. Jokes can fall flat. What may seem hilarious to some people comes across as crude to others, and if a joke is too clever for an audience, it's an embarrassing disaster. The same goes for visual jokes, and there's probably no such thing as a universally funny photograph. Only one or two photographers in the history of the art have succeeded in consistently producing an actual body of amusing work (Robert Doisneau and Elliott Erwitt come to mind), but the fact that they were able to succeed should be an inspiration.

Humorous photography isn't complicated and it doesn't depend on any special technique. One simply needs to possess a very good sense of humor and be able to spot it happening in real life. Probably the safest option is to go for wry or gentle humor, nothing too flashy or outrageous.

OPPOSITE

Rome. Piazza della Rotonda. 1980
Just as you'll damage a joke by explaining anything about it, photographer Richard Kalvar says all that he needs in the title. His general view is "If you kill the magic and the mystery, what's left but humdrum reality?"

So, how exactly can you set about being amusing with your camera? Firstly, unless you're brimming with self-confidence, please avoid even the idea of setting up a "funny" situation. I can't think of a single instance in which this has worked, but I've seen many excruciating failed attempts. The best visual humor—judged on general approval ratings—is of unintended events and moments. What this means practically if you want to do the same is:

You need a sense of humor that meshes with most other people's. If you can already make people laugh by telling jokes, you've probably got it. If not, forget the whole thing and move on to the other 49 paths in this book. Don't force it.

You have to be constantly looking for amusing things.

You must be able to shoot anytime, anywhere at a second's notice. This is what makes a smartphone an excellent tool.

Give your picture the stress test of showing it to some friends. If most of them laugh or smile, publish. If not, keep it to yourself.

RIGHT

Sculpture by Fernando Botero, Plaza Santo Domingo, Cartagena. 2015
You probably wouldn't pose this way for a friend's camera if you could see the view from here.

OPPOSITE

Xinle Road, Shanghai. 2015
Really asleep and really not posed. The latter is an essential condition for any street photography, as that is the audience's expectation.

25. THE UNEXPECTED GUEST

BELOW

Still Life with Fruit and Flowers. 1620–21
A Dutch still life in the vanitas tradition, with a number of insects crawling around, signifying mortality and the inevitable corruption of living matter. As symbols, they turned an otherwise comfortable still life into a moral reminder to their audience.

Photography is good at surprises. In fact, it thrives on them. With the undisciplined world in front of your camera, it doesn't take very long for something unexpected to walk into your frame, but if you've already decided what your shot is and are about to take it, what do you do when the unexpected occurs? Do you wait until it's gone away, or get rid of it if you can so that is doesn't spoil your preconceived idea? Do you change your idea? Treat the unexpected as a kind of gift, something you wouldn't have thought of but which potentially makes the shot more interesting, more thought-provoking.

Here's a sort of food still life, and I say "sort of" because it's clearly not the kind intended to grace the mouth-watering pages of a glossy cookbook. There's something slightly unexpected about it: the fly. Of course,

it didn't just happen to wander in. It was deliberate and I introduced it. Most people would swat it, but here's a studio photographer actually adding an insect to a food shot. Why on earth would I do that?

Well, it was partly because I was experimenting with Path 16: Homage (see page 72), honoring a series of still-life shots by Irving Penn, in which insects are crawling on the food. This would be enough for many people to throw the food away, but he actually celebrated it. Path 14: Crossover (see page 64) also comes into play here, as Penn was well-versed in the history of still-life painting, which began as a poor cousin to the more typical grand religious and historical scenes and portraits of the day. A number of artists used still life to remind the viewers of mortality and the transience of life. The Dutch Golden Age painters were well versed in this,

Paella. 2015

The huge popularity of food and cooking as a subject, in magazine articles, cookery books, and websites, reinforced by endless phone pictures, has established food porn as the norm of imagery. As a result, the presence of just a single fly is enough to make most people mentally switch in an instant to less pleasurable thoughts— but at least, thoughts.

and artists such as Balthasar van der Ast introduced decay into their food still-life works as well as an insect or two crawling around.

That was a deliberate introduction of something strange but small, with an effect predictably unexpected on the audience. Occasionally, though, if you stay open to the possibilities, you come across similarly unexpected details in unplanned photography. There's no strategy involved here, but to take advantage it's essential to stay alert. If you spot an odd, unexplained detail, other people are likely to have the same reaction when they see the image. When we come to the power of the unexplained in imagery in Path 35: Disquiet (see page 152) and Path 36: Mystery and Intrigue (see page 154), the unexpected element can serve as a potent extra layer in the viewing of a picture.

In the case of the Dinka cattle camp photograph shown here, the misty cattle and squatting man are interesting enough, but what is that cross doing? It is part of something the woman is holding, but we can't see what it is to give us context. All we see is the cross. I still wonder what it was.

OPPOSITE

Dinka cattle camp near Rumbek, South Sudan. 2003
Boran cattle, the wealth and pride of their owners, stroll through a cattle camp, passing smouldering cow dung burnt to drive away insects. Cattle play such a large role in Dinka economy and culture that camps such as this may hold thousands of animals.

26. THE REVEAL

This is an idea taken from the movies, where it works more easily. Nevertheless, when you get it right in a photograph, it lengthens the viewing time of the image and gives it more depth. The cinematographic version has a long history and, in principle, is straightforward. The camera starts on one subject, or even not much of a subject, and then moves to reveal a completely different subject—the real one, as it were. The move could be a tracking shot or a pan, or occasionally a zoom, and the general idea is to surprise the audience. One memorable and well-known reveal is the final shot of *Planet of the Apes* (1968), when a buried Statue of Lady Liberty is revealed on the beach.

The reveal has a lot going for it in a movie because of the intrigue and surprise it creates. Wouldn't it be nice to do the same in a photograph? The problem is that you can use the camera in a movie or video to take charge of what the audience looks at. When the camera moves, the audience doesn't have much choice but to go with it. The still version needs to find another way to make the viewer see one thing first and then eventually find the point that makes the picture. Generally, this means that the final point of the shot needs to be small and not really in an expected place. The trick is to construct the composition (and maybe the processing) so that there are visual encouragements to lead the eye.

OPPOSITE

Hutong hotel, Beijing. 2010
In the interior of a secluded hotel in one of the old lane districts of Beijing known as hutongs, bright red peonies on an etched-glass pair of sliding doors made such a striking backlit image the they worked well as a first distraction to the eye before the room beyond comes to the attention. The doors were left just slightly ajar to slow down the way in which the picture would be seen. Full depth of field from a small aperture was important, otherwise a difference in focus would have interfered with this reveal technique.

There is never any guarantee that you can pull this kind of thing off, the obvious danger being that the audience doesn't get that far, or can't be bothered, and looks away. Well, it wouldn't be fun if it worked every time, would it? The two examples illustrated here explain the technique better than words and theories can.

The photograph of the spectacular ruined mosque at Kassala in eastern Sudan begins as an architectural image, naturally enough. It has a formal feel to it, making the most of the rows of huge arches, and is shot in an architectural manner with parallel verticals and lighting that shows depth and height. It asks to be read like this yet also explored. The very regularity of the arches and columns sooner or later reveals the two men sitting in the distance. It might take from a second to several seconds, but the eye nearly always gets there in the end. The strange openness, by the way, is because the mosque was partially destroyed by Mahdist troops in 1887 just after it was completed, but then the Khatmiyya sect, whose mosque it is, decreed that it should not be rebuilt.

Khatmiyya mosque, Kassala, eastern Sudan. 2003
These huge arches, seemingly in endless ranks and open to the sky because of destruction wrought in the 19th century, have the kind of scale and ruination made famous by the Italian artist Piranesi in his engravings. Scale needs reference, and in a Piranesi-like treatment, the view was chosen so that the small figures would only gradually reveal themselves.

27. ORNAMENTAL ACTION

This kind of action sits in a strange limbo area between important and insignificant. Unlike the action that animates the entire image (as examined in Path 20: Have Things Happen on page 88), these tiny scenes within the scene are almost incidental—almost, but not quite. Without them, the setting has no sense of moment. You might reasonably ask where the borderline exactly lies, as on the surface it looks to be simply a matter of degree, |or rather scale. On the ground, however, when you're in the street shooting (this is very much a street circumstance), the difference is normally very clear, because it has to do with your priorities.

In a have-things-happen scenario, you would generally have the viewpoint and framing already set, with the theater that Robert Doisneau described all in place and waiting. You're hoping for it to come alive, for someone or something to set it all in motion. With ornamental action on the other hand, you have a broader setting that you simply want to enliven. "Ornamental" may sound trivial or lacking in significance, but that might be because clean, modernist simplicity still tends to hold sway in a lot of photography. Ornaments nevertheless give pleasure, in photography as well as in jewelry and architecture. Don't dismiss it as too incidental, as it is often the deciding factor that tips the balance between reasonable and good.

In my estimation, there are two kinds of photograph that can use this strategy. One is a scene that is okay, more or less fine, but what you really want is to take it to the next level by means of some animation in a small slot in the frame. The other is a framing that is really only going to work if it includes a small action within it. It may seem like splitting hairs if you're doing a postmortem on a picture, but when you're there behind the camera it's completely essential. Realistically, in either case, and at whatever moment you choose to shoot, only the one with the action happening is going to stand a chance of making it into your portfolio.

Is the scene you've framed really able to make a worthwhile photograph without this ornamental action? Could some different way of framing compensate for the lack of action? In the case of the photograph of the street in Lucca on the next spread, where for some unknown reason I made one other pointless exposure of it empty, the answer is no. Your expectations may be more or less realistic according to how busy a place you are trying to photograph. A constant flow of passersby promises plenty of choices, while an almost deserted Italian town during a hot afternoon may be no more than wishful thinking. After that, it's down to waiting and luck, or more practically speaking, how patient you are.

Memorial arches, Chaozhou old town, Guangdong. 2015
A dense street scene compressed by the long (500mm) focal length, in the southern Chinese city of Chaozhou. The series of ancestral arches in the old city seems to call naturally for this stacked treatment. Unusual though the street is, it still needed something to enliven it, and there was a constant flow of pedestrians and traffic. From 15 frames, this man half-standing on his bicycle proved to be the best grace note.

Rooftops, Lucca, Tuscany. 1991
Seen from the city ramparts of Lucca in Tuscany, the late afternoon sun cut this bright slice through the old tiled roofs. Such a shining narrow street cried out for action, preferably neatly contained and better still multiple. It took a longer wait than expected, but eventually two figures appeared at the same time, one of them happily on a bicycle, which made for a stronger silhouette.

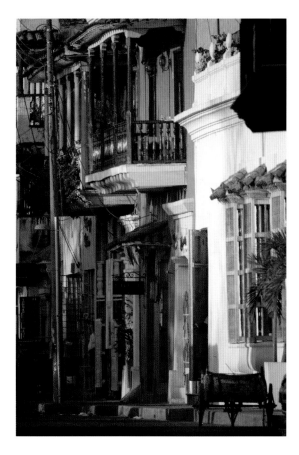

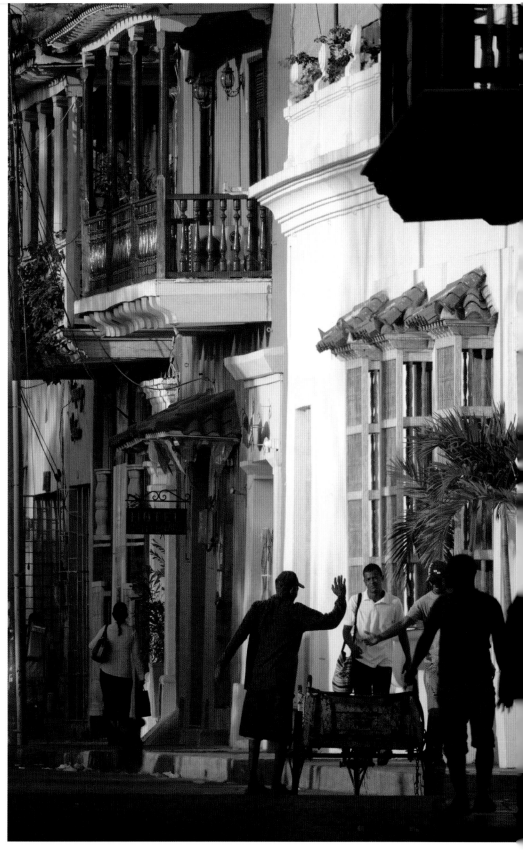

Avenida del Centenario, Cartagena, Colombia. 2015

The third in this trilogy of street scenes illustrates the nuances of incidental action in the frame. Would this shot of attractive old Spanish colonial house fronts with their balconies have worked without any people? Possibly, as a purely architectural image, but surely better with at least a passerby, of which several came along in the ten minutes or so of waiting. This moment, however, was an unexpected bonus, as the man with his handcart greets an acquaintance in such a typical and flamboyant South American gesture. Small in the frame, but beautifully outlined against a section of white wall, it lifts the image to another level.

28. MAKE IT FIT YOUR GEOMETRY

Composition is an entire field of its own for developing creativity. If you do it imaginatively, you can even make a good image out of no particular subject at all. Also, the way you compose can become the basis of a style, and having your own identifiable style can go a long way toward being more creative. As a working method, take charge of your own style of composition. Develop it and make the scene in front of you fit to what you want. In fact, making things fit is the cornerstone of composing an image, and things can be made to fit in any number of ways.

Through habit we each tend to frame shots and compose them in certain ways that appeal to us, even without thinking very much about it. When we do think about it and study it, we stand a chance of really developing a personal style of fitting things together in the frame—what Cartier-Bresson called "geometry." If you're not feeling very certain about this, you might wonder whether you do have your own style at all. That's a natural reaction if you're not accustomed to thinking formally about images and how they are arranged. Once you do start thinking about this, however, it's a near certainty that you will be able to articulate ways of composing that you are drawn to.

OPPOSITE, LEFT, & ABOVE

Imperial Palace Moat, Tokyo. 2015
This corner of the moat of the Imperial Palace, Tokyo, has character, but how to strengthen it by composition and viewpoint? The trio of images at the top show how it looked. The core solution is to know your own compositional preferences and then apply them consciously. I wanted to simplify, and also to make as clean and graphic as possible, even as far as trying to abstract the view. Fine details of camera position and a severe crop made the difference. In particular, the reflection in the clear area of water shifted with every step, as did the way in which the elegant curves of the pine trunk cut into and intersected with the lines of the moat. This is all a matter of taste.

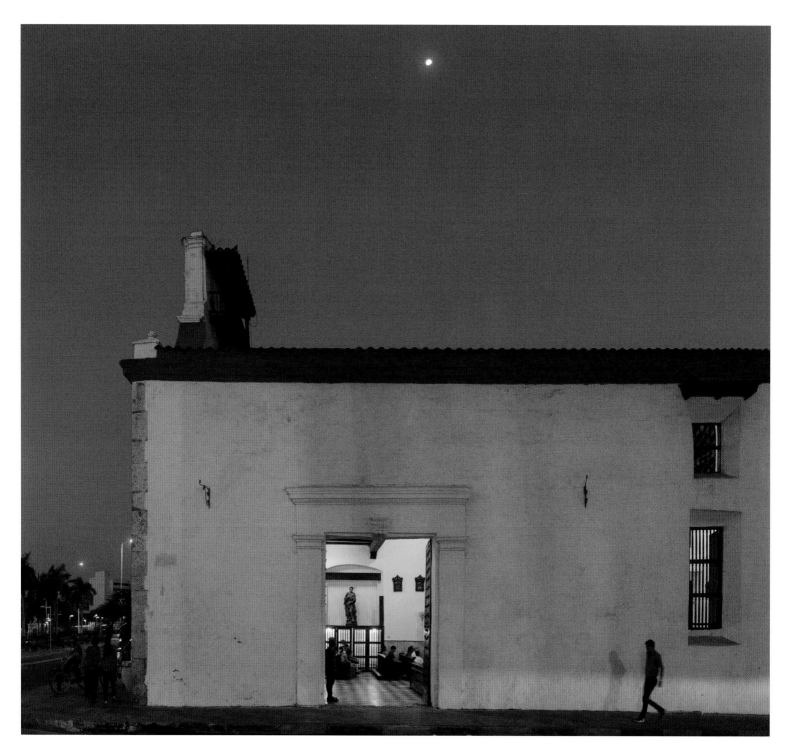

Here is a list of quite common, but nevertheless thoughtful ways of composing a shot. See which of these you identify with, recognizing that the list is certainly not exhaustive:

COMMON COMPOSITION STYLES

- ▶ A sense of depth with a strong foreground
- ▶ Flattened perspective
- ▶ Straight lines neatly aligned to edges of the frame
- ▶ Neat fitting, with nothing breaking through the frame's edges
- ▶ Energetic diagonals
- ▶ Face-on views with no diagonals
- ▶ Clear, distinct shapes
- ▶ Natural-looking untidiness
- ▶ Unexpected elements poking into the frame
- ▶ Clean, simple backgrounds
- ▶ Busyness
- ▶ Square frames
- ▶ Panoramas
- ▶ Clear, simple divisions

It's important to remember that the only way to impose your will on a scene and make it fit the way you want it to is by moving. Change your viewpoint. Move closer, farther away, to one side, lower, higher. Change the direction of your view, maybe swinging to one side, angling up or down, tilting. Change your focal length. Wait for things in the scene to move and change. You might even move things in the scene, or encourage them to move. Above all, execute the movements you employ in relation to each other, such as moving closer while zooming out.

Making a composition is a fluid, active process. Here's Joel Meyerowitz talking about being inspired by watching Robert Frank shoot in New York: "This photographer was moving around the room, snapping—click, click, click—and he was cajoling the subjects, these two young girls, to keep moving, too. I was mesmerized. I knew nothing about photography except that it had to be still, but there was this guy moving constantly as he was shooting movement." And here's Paul Strand in 1916, the same year that he made his *The White Fence* picture (see page 43), talking about learning "how you build a picture, what a picture consists of, how shapes are related to each other, how spaces are filled, how the whole thing must have a kind of unity."

OPPOSITE
Church of the Third Order, Cartagena, Colombia. 2014
Very different from the angular geometry of the previous pages is this style of squared-up, full-frontal imagery that makes building and street views appear flattened, controlled, and restrained. The bare simplicity of the side of this old church, isolated on a street corner and with a dusk sky as backdrop, encouraged this treatment, which called for a precise camera position and waiting for just the right moment with no traffic but a single figure walking.

29. ALIGNMENTS

One thing that almost all photographers agree on is that you must have a position on composition. How things are arranged in the frame is the evidence of how a photographer sees; it's the mark of individuality, of who we think we are. It is massively important for photography, even more so than for other visual arts, for the reason that there's never any foregone conclusion about it. Painters, illustrators, architects, and others can choose exactly where to put things. Photographers (outside of the studio and other controlled situations) cannot. Stuff is already there, so if you want to make it work your way, you're the one who has to move. This path expands upon the last path; I'm continuing now with an entire multi-lane system of paths that involve composition. Some of them work against each other, offering clashing strategies. A few are more universal, like this one: alignment.

Every photographer who does strong, distinctive composition, whatever the style, does alignment of one kind or another. They even use the same language. Both Arnold Newman and Lee Friedlander, very different in style, both talked about "lining things up" whenever they surveyed a scene. This is a very photographic technique because the lining up has less to do with what's in the real scene and much more to do with where the photographer stands and how he or she frames the shot. Generally speaking, you can line two or more things up by repositioning yourself so that they look as if they fit. Or, you can line things up with one or more of the edges of your frame. If you're lucky, you might even be able to do both at once.

Even wonky camera angles often have their basis in alignment. Garry Winogrand was known for tilting his

BELOW, RIGHT

Construction workers, Calcutta. 1976
All alignments are best when coincidental, and even more so when short-lived, allowing you just a tiny window of opportunity before they're gone forever. This angle of view of street girders on a construction site in Calcutta was from the window of a neighboring building, and clearly had good possibilities as a rigidly geometric setting for anything at all happening on them, namely workers. However, this brief and unexpected alignment as laborers waited at attention at the beginning of the day to start carrying building materials in baskets made it much more special. Even more satisfying visually was the descending size order of the three men.

OPPOSITE

Basilica of St. Peter, Vatican, Rome. 2009
The shadow of the arm of a sculpture in the Basilica of St. Peter moved so quickly across the wall that it took a second day to prepare for it from the right viewpoint. The ideal moment was clearly when the finger of the shadow just touched the left edge of the wall, and the framing needed to include the sunlit hand at upper right. The two smaller images, shot three minutes and eight minutes later respectively show how critical timing can be.

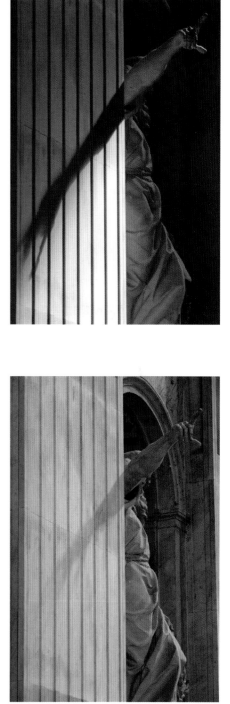

US Navy mothballed fleet, San Francisco. 1978
An aerial view of mothballed naval vessels in San Francisco Bay. Their alignment to each other comes as no surprise, but assigning them to the edges of the frame and fitting them neatly inside meant getting the light aircraft into the right position—not always easy to communicate to a pilot. The small boat passing the second row was a lucky coincidence.

camera this way and that, but delighted in telling people, "they're not tilted, you see?" He went on to say, "I never do it without a reason. …I have a picture of a beggar, where there's an arm coming into the frame from the side. And the arm is parallel to the horizontal edge and it makes it work."

Lining things up with the frame edges has an element of accuracy to it, but more than that, a sense of conventional correctness. It's what architectural photographers do with shift lenses and spirit levels, and that is not particularly creative. For an alignment to be creative, there needs to be some unexpectedness, some evidence that the photographer's imaginative eye was at work. Think carefully about exactly what things you are going to line up.

Within alignment as a general strategy, there is an even more special kind of coincidental alignment that borders on comedy (see page 106). This is where you line things up that truly have nothing whatsoever to do with each other, but by doing it you force them to relate. It's a trick that, when it works neatly, can be amusing or even thought provoking.

> "I am always lining things up, measuring angles, even during this interview. I'm observing the way you sit and the way you fit into the composition of the space around you."
>
> ARNOLD NEWMAN

Hold the Line, London. 2007
Worthy of a place in Path 4: Bisociate, this delightfully ridiculous alignment of white tape on a tree trunk and the stripe on a road is part of a series observed by Hamburg-based photographer Siegfried Hansen. Distance, focal length, and camera position are combined with painstaking precision—this is not a casual snapshot—so that not only does the curve of the tape flow from the angle of the stripe, but their widths are an exact match.

Siegfried Hansen 1961–

Hamburg photographer Hansen began as an amateur in 2008, pursuing a kind of street photography in which the subjects are not people, but graphic connections and formal visual relationships. He says, "I am looking for the little absurdities of life. Trying to catch special moments, either funny things, graphical or even light and shadow situations."

The row of Sri Lankan tea pickers waiting in line to deliver their baskets of picked tea is interesting enough as a scene, but is transformed the moment the young woman near the middle leans forward. She breaks the line yet stays part of it, and the eye goes directly to her in an instant. Creatively, the breakout, of which this is just one example, is almost always satisfying, not only because it gives the viewer a point of attention, but because it sets up a contrast.

The odd man out has a sort of cult appeal, perhaps partly because the eye finds it refreshing to see a single break in a pattern, but also partly because it invokes the idea of the rebel. That second thought might be hard to swallow when you're looking at the breakout example in the form of a box of eggs, but it worked wonders in an advertising photograph devised by the British agency Bartle Bogle Hegarty for Levi jeans. The American company was launching black jeans in 1982 when the color was unusual, and the agency proposed an image of a herd of white sheep moving in one direction with a single black sheep in the midst heading in the opposite direction. The headline read, "When the world zigs, zag." Not a pair of jeans in sight, and a great success. More than 30 years later, the agency still uses the image for its own branding.

Visually, as Jay Maisel says, we like patterns (called "field images" in art-speak because they extend to the frame edges and resemble a field). It is oh so much more interesting, however, when the pattern is broken by one unit behaving differently. It's an idea with traction with the added attraction as a creative path in photography of not being easy to pull off in real life. The line of guardsmen at the UK's annual Trooping of the Color is highly trained not to break their pattern and give you a great photograph. How about masses of sunflowers all facing the sun, as they do, but with one facing in the opposite direction? I'm not sure what that could advertise, though there must be a number of possibilities. Executing such a shot? That would be a challenge (and no, not Photoshop, please).

Yes, you can set up a pattern-breaking photograph (that black sheep image didn't just happen by itself), but that removes part of the fun. That said, a strong idea will often make a strong image. Certainly, make it if you can. If you come across it in the real world, however, even if less tidily, it gets you extra points. The basic technique is to first find and frame the pattern. Telephoto lenses are usually good for this because they hone in on details while compressing perspective. Then wait, anticipate, and be lucky.

OPPOSITE

Tea pickers at collection point, Mount Vernon Estate, Sri Lanka. 2014
Despite there being 21 women closely packed within the frame, that just one leans forward to look out changes the image immediately from being a row of figures to one with a sharp break. Even with all the confusion of colors and faces, our eyes go straight to hers.

"As people, we love pattern. But interrupted pattern is more interesting."
JAY MAISEL

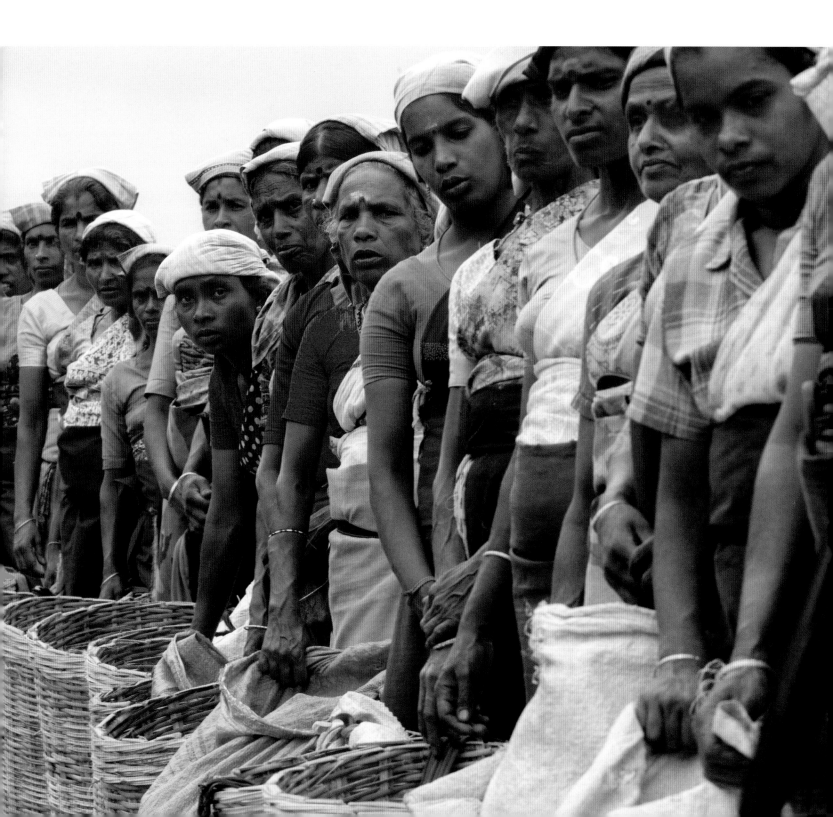

ABOVE
When the world zigs, zag. 1982
An award-winning advertising photograph by Alan Brooking that significantly had nothing
whatsoever to do with the product it was selling (jeans), and succeeded purely on the power
of imagery and by being different. The agency responsible, Bartle Bogle Hegarty, continues
to use it as its brand statement more than three decades on.

ADVERTISING'S ISSUES WITH CREATIVITY

Since the late 1960s, an important niche in the advertising world has dealt in entertainment, humor, and surprise rather than mainstream product presentation. Always controversial among clients, who tend to want to see their carefully worked-out marketing strategies followed closely, a new breed of agencies in New York and London confidently flouted all the established rules. The results were often successful for sales, but always successful for promoting hot boutique agencies. One of the longest running of these determinedly creative agencies is Bartle Bogle Hegarty in London, founded in 1982.

31. PUSH THE COMPOSITION

> "To compose a subject well means no more than to see and present it in the strongest manner possible."

EDWARD WESTON

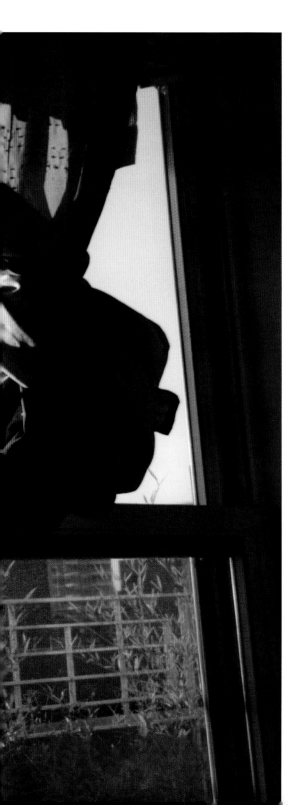

It may be unusual to think of it in this way, but you can apply composition in degrees. You can treat it as an ingredient in creating the total image, and that means you can put less or more of it in. There is a danger of over-simplifying things, but it's an interesting exercise to look at what basic qualities went into the making of a successful photograph. It's entirely up to you to decide what these qualities are, but without getting too fanciful, the half dozen shown here (see the pie charts on the following spread) cover most of the bases.

I normally use these charts to show people how little the actual equipment matters (unless you're doing sports or wildlife photography, for example), but the idea here is to suggest expanding the role of composition. Look at a few of your favorite images and decide which of the qualities listed in the pie charts played the greatest part. Then look at some of your less successful images and think how they might have been improved if the composition had been more forceful, more energetic.

Much depends on how you already treat composition in your shooting. Some people hardly bother at all, and they're the ones likely to get the most out of this sequence of composition-related paths (Paths 28–31, pages 122–137). At the other end of the scale are photographers who make it a major feature whenever they shoot, such as Guy Bourdin, Alex Webb, and GueorguI Pinkhassov. In between are a majority of serious photographers who have their own preferred ways and apply them with more or less rigor according to how they feel that day.

OPPOSITE

New York City, 2010

Magnum photographer Gueorgui Pinkhassov frequently plays disorientation games through carefully disjointed compositions and by searching for natural lighting effects that confuse the eye yet make strange connections. Here, this works by means of a frame divided strongly into rectangles and a double cast of shadows—the knot of a curtain onto a man's head and the head onto a wall—with the surreal suggestion that the knotted curtain and the man are somehow inverted versions of each other. None of it makes any formal sense, which is why it compels the viewer to try and work out some meaning.

Gueorgui Pinkhassov
1952–

Russian-born photographer Pinkhassov's distinctive style of strongly lit and colored ambiguous moments, with a hint of the surreal, was first influenced by the films of Andrei Tarkovsky, and then by Henri Cartier-Bresson, whom he credits with the idea of working "in the moment" and shooting by intuition. He says, "I'm like a bird sitting on a tree looking around; I'm not on anybody's side. I'm just trying to capture unique moments."

135

This creative path involves not just applying your composition thinking with more energy, but making it more forceful, more extreme. This is not a universal solution by any means, just one possible path. Most of us use composition reasonably, efficiently, even subtly. Extremes, as in any creative medium, tend to be flashy, striking, and not much suited for everyday use. However, extreme composition is always eye-catching, and if you use it just occasionally, it can be a big creative help to an image that is not quite working otherwise.

There's a matter of taste involved, and if you're not into flamboyant composition, the suggestions here may not appeal to you, but at least consider that they offer a direction that could be used once or twice. This is deliberately the opposite of a conventional, "perfected" composition, and can sometimes act as a stimulus. Joel Meyerowitz, for example, spoke about how much he is "willing to throw things off the perfect composition." Practically, you could look at the various techniques listed on the right, pick one that appeals to you, and try it. At worst, you won't like the results. At best, though, you will have pushed yourself out of your comfort zone to reveal a new way of composing that could positively impact your photography.

EXTREME COMPOSITION EXPERIMENTATION TECHNIQUES

Extreme placement
(near a corner or edge)

Minimalist framing to include the least number of elements

Frame breaks (subjects severely truncated or cut off by the edge of the frame)

Parts of things, like hands and feet, poking into the frame

Empty centers

Disjointed, disconnected, discrete elements

Reflections that put subjects in unexpected places

Any kind of disorientation

ABOVE RIGHT
Pride of place to composition
A legitimate though rough-and-ready way of looking at the recipe for a successful photograph is to think in terms of the necessary basic ingredients. Here's one suggestion in the form of a pie chart: a mix of subject, timing, equipment, color, composition, and light, shown as equal in importance at top, but with composition deliberately favored below.

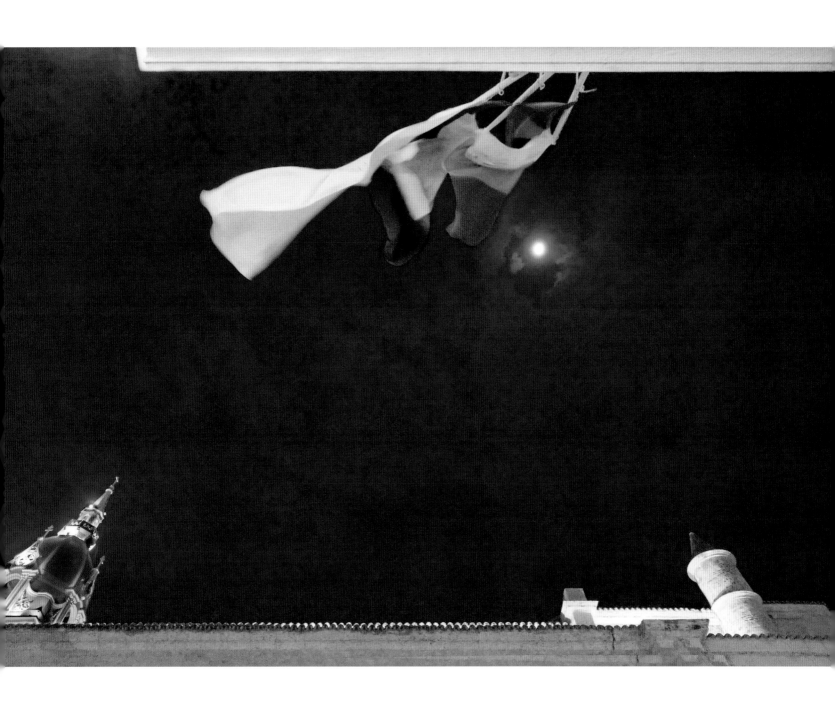

Plaza de la Proclamación, Cartagena, Colombia. 2008
The two sides of an old Spanish colonial plaza in the Caribbean
city of Cartagena—the Cathedral above and the Governor's Palace
below—are forced into an unnatural triangular relationship by
shooting directly upward with a wide-angle lens at night. The
moon and the flag in the wind complete the triangle.

32. REDUCE

Reducing. Chefs do it to intensify flavor. Composers do it to simplify a score for fewer instruments. The Bauhaus artists did it for a purer design esthetic of functionality and simplicity, and it works beautifully in photography as a way of clearing the clutter. More than that, it makes a powerful statement that the photographer is very much in control of the subject or scene. The control comes from framing and composing so precisely and tightly that chaos is removed and just a few elements remain, maybe just one or two against a clean background.

"Less is more" became the minimalist mantra, first articulated by Mies van der Rohe, but happily adopted by creative types everywhere. The idea of distilling the essence of a scene visually is very appealing, both philosophically and esthetically, and the special appeal for photography is that it demands skill. Most scenes in front of us are busy and messy, so one way to stand out as a photographer is being able to reduce the clutter. It is definitely a challenge, and success is highly regarded for its own sake, not just for the minimalist result.

Still, let's not get distracted by peer respect. Lean and pared-down imagery appeals to contemporary taste in two ways: short attention spans and the contemplative ideal. Popular lifestyle philosophy leans heavily on space: personal space, space to move around in, space for various Zen-inspired thoughts (see Path 7 on page 36), and this applies to imagery as well. Minimalist photographs allow viewers to fill them with their own ideas, which may explain why this style is so popular as wall art.

The strategies for reducing or minimalizing usually begin with choosing a plain setting. On a large scale, a featureless sky, large bodies of calm water, and blank walls are probably the three backdrops that are easiest to find, although when this backdrop is very obvious, like a blue sky, it also risks a lack of specialness and originality. Moving water like the sea can be further reduced by using a long exposure with a strong neutral density filter for a "slow-mo," misty effect.

Two weather-related possibilities are a covering of snow and fog. At a smaller scale, there is more choice of surfaces and frame-filling patterns. Careful framing is, in any case, key to backdrop selection in order to keep it as even and field-like as possible. The shot of the horses crossing a suspension bridge shows the process of finding a viewpoint and a frame that eliminated all but green foliage.

The second part of a typically reduced image is one, two or a very few small subject elements. Where they sit in the plain setting is important, and there's some advantage in eccentric placement because of the extra emphasis it gives to the backdrop. One visually strong strategy is to have part of a larger subject breaking into the frame (so becoming a small subject).

If there's one creative problem with reduction, it's the largely unquestioning popularity that it enjoys. There is an almost knee-jerk reaction of approval when you say "reduce," but in reality, it can get tiresome in sustained doses. That's why there are 50 paths in this book; creativity needs variety. For an antidote, read on.

OPPOSITE (ALL IMAGES)

Tea picking by machine, Yame, Kyushu, Japan. 2015
Tea plantations throughout Japan are characterized by immaculate neatness, reflecting both one aspect of the national character and almost total mechanization. Japanese harvesting machines are highly sophisticated, and leave perfectly sculpted rows behind them. The shot began by concentrating on the one-man-operated harvester, but it soon seemed a much better idea to subordinate that to the strictly ordered rows of tea bushes. In order two reach a near-minimalist reduction from a crowded landscape, the scene was severely cropped to cut out the tree line above and a road at left, and then the shot was timed for when the harvester appeared smallest. The color contrast ensured that it would stay easily visible, however small and off-centered.

"Ultimately, simplicity is the goal in every art, and achieving simplicity is one of the hardest things to do. Yet, it's easily the most essential."

PETE TURNER

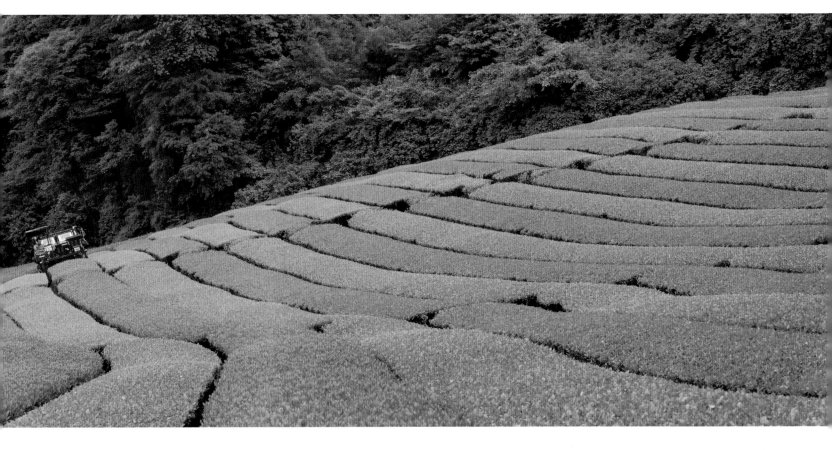

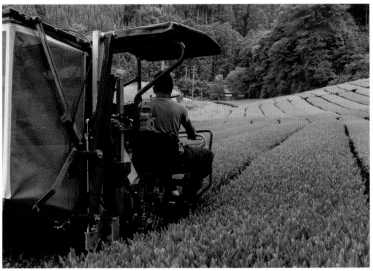

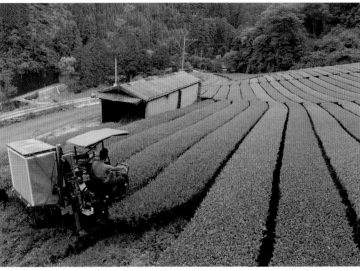

"The essence of great photography is economy and it's all to do with confidence. Crap photographers don't have any confidence and therefore they don't have economy."

BOB CARLOS CLARKE

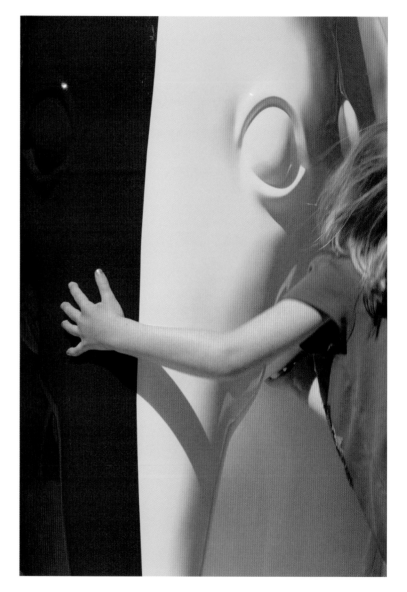

OPPOSITE & LEFT (ALL IMAGES)
Elephant sculpture, Green Park, London. 2010
There was an unpromising start to this image of a brightly colored fiberglass baby elephant, one of many painted by different artists and installed across London one summer. The sunlight was high and harsh, and the park predictably and messily crowded. Reduction seemed the solution, and closing in the way of executing it. Ultimately, it needed just a graphic crop of the head of the elephant, and a child's hand reaching in. That was enough.

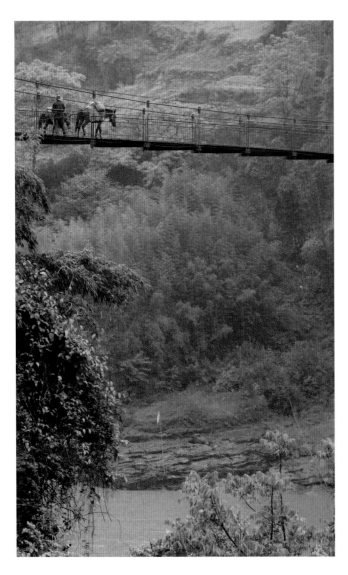

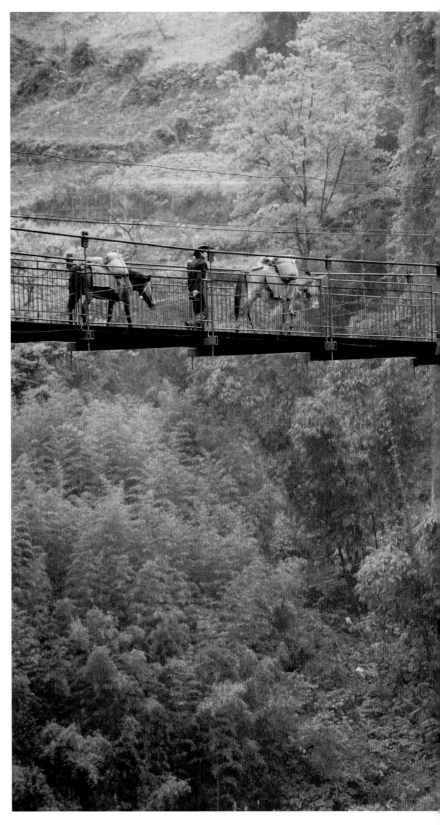

Horse crossing bridge, Nujiang Bridge, Yunnan. 2010

The subject of interest here is the slender suspension bridge carrying a pack train of horses across a forested river gorge. The ponies provided and controlled the moment, but apart from that, how much do we need to see, or even want to see? The two smaller pictures show the lead-in to the final framing, and it quickly became obvious that simpler would be more interesting. We're better off not seeing either the tree line above or the river below. Just the unsupported central span against a continuous vertical carpet of green looks more suspended than if we could see the bridge supports or anything else of the context.

33. ELABORATE

The opposite of the minimally visual is bringing many subjects and coincidences together in a single frame. This, however, is not a practice that you hear discussed very much. Just as modernism ruined any chance of the Baroque coming back into fashion, so too has simplification in photography grown to become an almost undisputed ideal. The arguments for simplicity are convincing, as we just saw in the previous path. Plus, reducing the elements in a photograph is simpler than adding them.

If you're trying to bring order in the viewfinder to a chaotic scene by moving and framing to get rid of clutter you may find this hard to contemplate, but imagine what would happen if instead of finding strategies to eliminate stuff from your frame, you waded in and tried to make everything work together. It's not so easy, and it usually demands a virtuoso performance from the photographer, just as interweaving several strong flavors is a challenge for a chef.

One photographer who is well known for elaborative street images is Alex Webb. Much of his work has been in tropical countries like Haiti, where light is often highly contrasting and colors are strong. Both of these qualities help, and perhaps even inspire, crowding a frame. Naturally, though, this technique carries risks. Webb writes, "It's not just that that and that exists. It's that that, that, that, and that all exist in the same frame. I'm always looking for something

more. You take in too much; perhaps it becomes total chaos." The challenge is to pack things into a single frame while keeping each element separate and somehow distinct. In a studio or planned shot this is easier to manage, although a big shot with many components can take hours to arrange. In the street, it is very difficult, so when success comes it is all the more applauded.

As for lenses, each focal length has useful, though different, qualities. A telephoto's stacking effect lends itself to fitting things together. Normal focal lengths work for the kind of street scales that many of Alex Webb's images have. Lee Friedlander, on the other hand, likes doing this with a wide-angle lens, saying "it allows you to have more stuff, maybe in the foreground or in the background, whichever way you want to think about it. Even if something is a little but out of focus, it has a tendency to feel as if it was married to the other stuff."

The eight techniques listed opposite can help you to get started, and you can see many of them at work in the images shown in this path. The colors and strong shadows help explain the success of Alex Webb's style. With the image that includes the silhouette of a photographer, the diagram helps to explain the clear sense of interlocking geometrical shapes and an overlay of colors from reflections.

RIGHT & OPPOSITE
One New Change, City of London. 2012
Elaborating a shot uses much the same way of thinking as does reducing (on the previous pages), but the techniques are more complicated, not far removed from fitting jigsaw puzzles together. This image in a shopping mall in the City of London takes in three planes: the silhouetted figure, the reflective metal ceiling, and the building across the street. The angular geometrical elements, created by color and tonal contrast, suggested the treatment, and as the illustration shows, involved a combination of lens focal length and viewpoint that would "fit" the elements together in a coherent way.

"I'm always playing along that line: adding something more,
 yet keeping it short of chaos."

ALEX WEBB

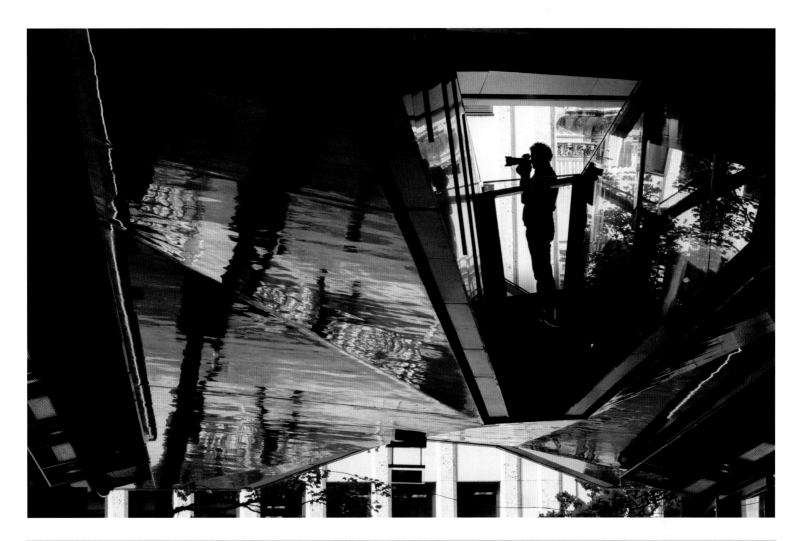

TIPS FOR PHOTOGRAPHING ELABORATE SCENES

- ▶ Fill up the frame and don't leave empty spaces.
- ▶ Try and divide the frame into geometric shapes that interlock.
- ▶ Fit things neatly together and into spaces.
- ▶ Multiple colors help elaboration by increasing the visual content.

- ▶ Strong blocks of shadow help by creating distinct shapes that fit together.
- ▶ Use frame breaks, where a subject like a person is cut by an edge or corner.
- ▶ Use a small aperture for sharpness throughout.
- ▶ Reflections, shadows, and silhouettes help increase the appearance of content.

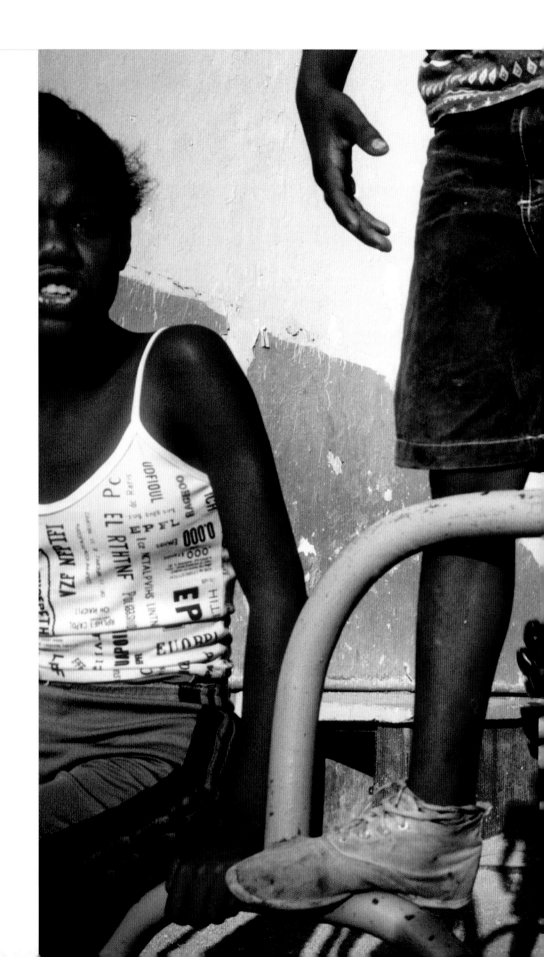

Alex Webb 1952–

Webb deliberately restarted his career and style in 1975, when he felt he had reached a dead end, shooting black-and-white social documentary in ways that he felt only mimicked the work of others before him. His success came with Haiti, where he developed his frame-filling style of engineered disorder, which partly depends on strong color and low sunlight. He says, "I work in color, where light is really important in a very special way, so I work certain hours much more than others. I am always out at the latter half of the afternoon and in the evening."

RIGHT
Children playing in a playground, Havana, Cuba. 2000
Alex Webb's colorful and high-contrast street photography honed to precision mainly during his work in Haiti, is at its best a virtuoso performance of very rapidly assessing the number of crowded elements in a scene like this. They have to be timed and framed in such a way that they lock together visually—and no one moment like this lasts for more than a part of a second.

34. DON'T SHOW EVERYTHING

The default mode for photography is to "show and tell," to reveal and explain, and it's easy to think that this is what photography does best. Many of us were trained, or trained ourselves, to follow this direct approach as an ideal. News photojournalism, for example, has to be clear and all-inclusive, getting as much information as possible into one image. Harold Evans, former editor of both *The Sunday Times* and *The Times* explained the virtues of a powerful news photograph as "the sensation of being there, and for an image the mind can hold." Much the same holds true for sports photography, wildlife, architecture, and product shots. When a clearly defined subject or event needs definition, photography follows. In any of the above genres, skill and knowledge are needed to achieve this, and they are the kinds normally taught, involving lighting, timing, composition, and so on—the full range. This aim of being direct, however, pays a price on the creative side. It ignores the dramatic potential.

Look to other creative forms of media that rely on narrative—like plays, movies, and novels—for an alternative path. They nearly always keep the audience guessing in order to hold attention and to give a pleasurable discovery later in the experience. In photography, you can do the same by holding something back and making the viewer wonder a bit. Robert Doisneau, author of our leading quote for this path and a warm-hearted Parisian street photographer with a sharp eye for humor, said "I can't remember who said that 'to describe is to kill, to suggest is to give life.' This, I think, is the key."

Practically, don't be afraid to let off-target lighting, off-kilter framing, foreground obfuscations, and other kinds of indirectness make your photograph slower to read. There's a creative risk involved (the viewer may lose interest after a second or two and move on), but if you carry it off successfully, your reward is that you draw your audience

RIGHT

Rolling Monkey King green tea, Houkeng village, Anhui, China. 2015

Used here as a solution to an assignment problem, cutting off a large part of the view raised the level of interest in what would otherwise have been a workaday shot of freshly picked tea leaves being rolled. There was no choice but to show this activity, as it was a part of an assignment for a book titled **The Life of Tea**, and these particular and famous leaves are specially hand-rolled. Stepping back and above brought the decorated doors into frame without detracting from the focus of attention, glimpsed through the door slightly ajar. This incidentally added to the narrative, showing the rolling continuing late into the night during the short picking season.

more personally into your photographic world. This is almost a prerequisite of art—if, that is, you want your photographs to be treated as art, which not everyone does. You let the audience do something. You could even try throwing viewers off the scent by showing something related to the subject rather than the thing itself.

If there's a problem with this creative path, it's that you can be too calculating, too planned, to the point where the attempt at manipulating the viewer response becomes clumsy. No one likes being manipulated, least of all when it appears that they're being invited to step into the picture and find things out for themselves, so the act of suggestion as a strategy always works better when it comes quickly and naturally. A timely reminder at this point comes from Cartier-Bresson, whose mission statement at the beginning of his small book *The Mind's Eye* includes, "There are those who take photographs arranged beforehand and those who go out to discover the image and seize it. For me the camera is a sketchbook, an instrument of intuition and spontaneity." Ideally then, hold something back spontaneously.

News rack, Cartagena, Colombia. 2015
Holding back can apply to content and meaning as well as to the more obvious visual concealment. What on earth is this man doing in front of newspapers in a street? We'll never know, and this failure of the photograph to explain is what makes it intriguing. Or annoying, depending on your point of view.

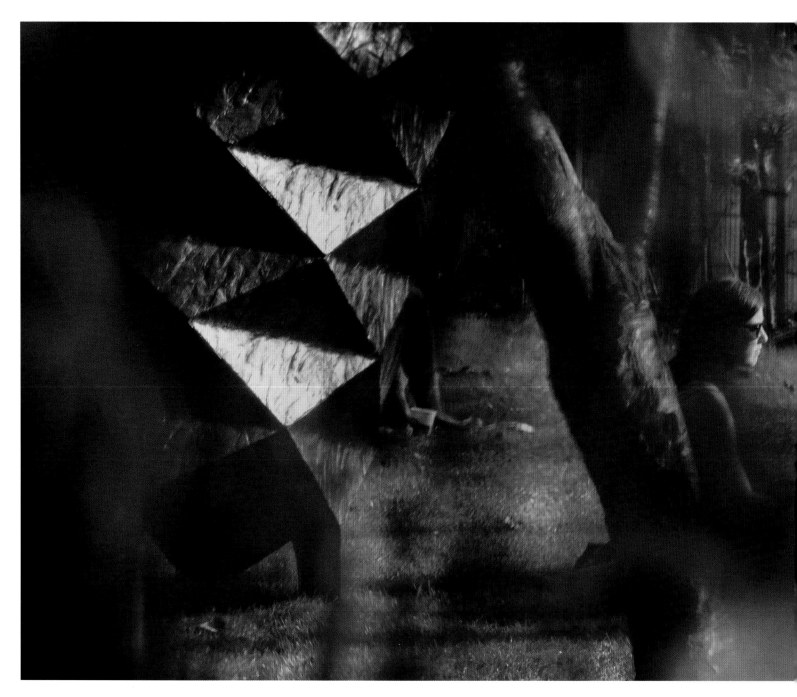

"I don't usually give out advice or recipes, but you must let the person looking at the photograph go some of the way to finishing it. You should offer them a seed that will grow and open up their minds."

ROBERT DOISNEAU

OPPOSITE

Holland Park, London. 2014

Here in a London park is a literal case of not showing everything by shooting through foliage. The long focal length smears the foreground leaves into a blurred screen that revels random areas of the scene beyond— a not-too-obvious angular sculpture and a group of friends sitting on the grass. Disjointing a scene with nearer obstructions can can be as confusing as it can be successful, and calls for some experiment with position and distance.

35. DISQUIET

Photography is such a definite medium, so good at nailing things precisely, that it may seem to be heading in the opposite direction to look for uncertainty. It sounds vague, but there's a value in not being obvious, in being a little difficult to pin down. That is because many of the paths to creativity have to do with trying to engage the audience's attention for longer than usual, and for longer than they themselves would expect. We want them to wonder what's going on and to get involved with their own imagination. It's why, for example, a good portrait catches a look in the subject's eyes that allows the viewer to believe they have some insight into the thoughts or emotions going on behind the face (see Path 21: Unguarded Expression on page 94).

These invitations to discover things in an image don't have to be obvious. In fact, it's often better if they aren't. Also, creativity doesn't always have to be upbeat. The default for photography is to be attractive and pleasing. This is one of its burdens, but it also allows a doorway in the opposite direction. This is a subtle path, and it relies on conveying a mood, a feeling, that's hard to put a finger on. It's about getting across a sense of unease, of uncertainty. As a path it's a tricky one. You can work harder to be really mysterious, as we'll see in the next path. Here, however, let's look at being more nuanced, at qualities in the photograph that don't slap the viewer in the face, but just are mildly unsettling.

BELOW

Muzzled dog, Xuhui, Shanghai. 2014
A young girl stands with her hand on the head of the family dog, in a street in Shanghai's French Concession district.

"Everything that is visible hides something that is invisible."

RENÉ MAGRITTE

The principle at work is that viewers will put more into looking at a photograph if there's an opportunity for them to think, and for them to add some of their own questions to the experience. Since it needs to be just on the edge of being recognizable, it can be a hit or miss venture. The very uncertainty that you try to convey can be just as uncertain to pull off. It even has a tenuous relationship with surrealist photography (see Path 39 on page 168), because that, too, depends on a dislocated shift in reality—hence the name.

What is this dog planning behind its clear and perhaps too-bright eyes? It's a breed trained for attack. We know that from its powerful muscular structure, the clipped ears, and the muzzle. There's some danger here, and yet a young girl's hand rests casually on its head. Is that the way you see it? Or is it just another picture of a dog? That's the inevitable uncertainty in this kind of photograph. You as the photographer may think one thing. The viewer may think another. That's ultimately what creativity is about— uncertainty. If it clicks, it works. If not, you've lost. What I've just done is to argue the case, like a lawyer, and try to convince you that this image does to you what it did to me when I took it. In reality when someone views your image, you are unlikely to have the opportunity to support it with clever words of explanation.

BELOW

Deserted park, Chaka Salt Lake, Qinghai, China. 2010
An unused public park with a single artificial palm tree in a remote part of northern China. It was built for workers extracting potash; this is China's largest source of the mineral.

MYSTERY & INTRIGUE

Photographing clearly, precisely, and cleanly is a skill set that you need if you have a straightforward purpose, like telling a story or showing an interesting action. A sports photographer at a football match wants the goal, and a wildlife photographer strives to catch everything that can be seen as a lion pounces on a zebra and sinks its teeth into the neck. Outside of recording things though, photography isn't that simple. In fact, simple is often exactly what isn't wanted. Instead, some complication is called for.

The previous path, Disquiet, was at the shadow edges of mystery and intrigue, and has much in common with this path. However much people say that they want to know what's going on if you ask them outright, when it comes to entertainment they do not. We all enjoy being puzzled as long as it's something we're looking at or reading about and not something that is actually affecting us directly. That's why there are crime novels and tales and movies of mystery and intrigue. The idea is to entice the audience and give them something to think about.

This technique is a whole lot easier in a novel, short story, or television script where there is time to build things up. We're back to the old problem of how much of a story can be told in a single photograph. Very little is the short answer, but what you can always do is to set up the possibility of a story. You can get the audience hooked by showing them something that they want resolved and want to know more about. If you can trigger a sense of intrigue in the viewer's mind, they will get involved in the image, making use of what's called a narrative hook.

This is usually a literary term, but it works just as well visually. The idea is to "hook" the audience right from the start with something that makes people want to know more. It is standard practice in novels. (Think of George Orwell's compelling first line of *1984*: "It was a bright cold day in April, and the clocks were striking thirteen.") It also works in movies, but in still imagery there's no dialog possible, so we need to use different techniques. These fall into two groups: content and visual style. Either can work on its own, but ideally, a mysterious still image combines both intriguing content and an atmospheric treatment.

Spirit Gate, northern Thailand. 1980
The explanatory caption to this image reads "A young Akha girl runs past the carved phallic guardian figures near one of the symbolic gateways to the tribal village, in northern Thailand." That's clear enough once explained, but purely as an image, the mist and strange shapes, with the just-readable small figure moving away uphill suggest a story or a place of mystery, and just possibly better left uncaptioned.

"Mysteries lie all around us, even in the most familiar things, waiting only to be perceived."
WYNN BULLOCK

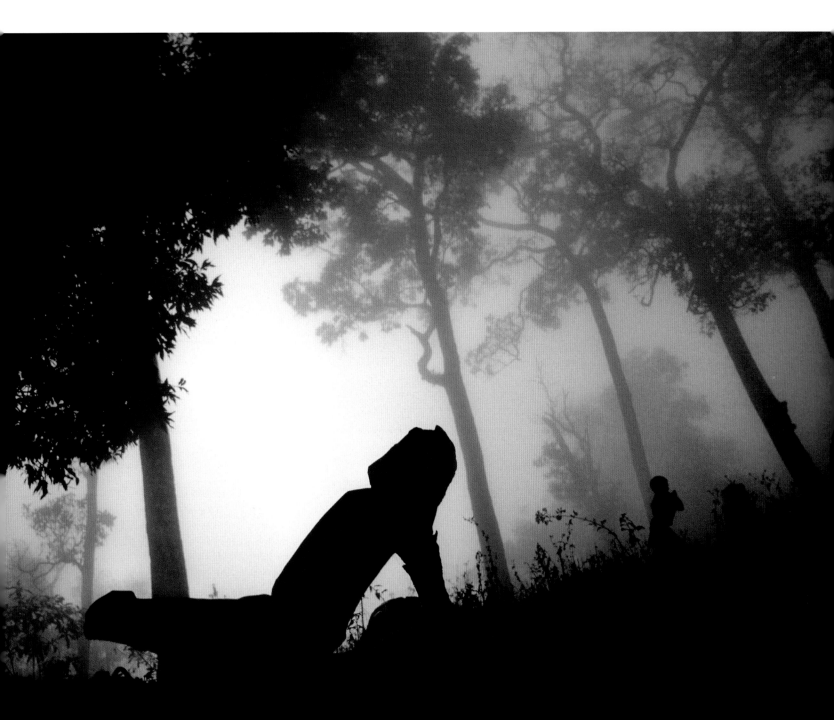

ABOVE

Møre og Romsdal, Norway. 2013

In 2009, Stuart Franklin moved to a small cabin on a Norwegian island to develop "a more personal, subjective, and phenomenological approach to landscape." Rather than dealing in scenic views, he explored the experience of place, looking for "the unexpected: the random and yet mysteriously purposeful order of things." Mystery here comes from focusing on the unexplained.

With content, the key is to show something that is difficult, perhaps impossible to explain, and which at the same time triggers interest. The viewer needs to care about what he or she is looking at. One great standby of all mystery is apprehension of something wrong and even scary. Imagine a few drops of blood in the snow. Handled well in the camera, that ought to trigger apprehensive interest. The same is true of something that's unexpectedly out of place, hinting at an event that just took place. Traces of happenings are another staple of mystery fiction. Never mind the frustration that anyone feels at not being told enough; that's one of the signs of it working. If your viewer thinks, "Why doesn't the caption tell me what's going on here?," you've succeeded creatively, albeit at the price of some mild irritation.

Stuart Franklin 1956–

After years in news photojournalism (civil war in Lebanon, famine in Sudan, Tiananmen Square, for which he gained a World Press Photo Award), Franklin has concentrated on documentary photography, much of it on ecological issues. He explores the role of photography and the limitations in what it can reveal: "The rest we have to imagine and the ambiguity of black-and-white photographs requires we imagine even more. This imagining is, for me, part of the pleasure of looking at photographs."

MYSTERY THROUGH CONTENT

▶ Something very much out of place and unexpected
▶ Anything that triggers menace, fear, apprehension
▶ Traces of something unexplained that happened

MYSTERY THROUGH VISUAL STYLE

▶ Low key, exploiting darkness, maybe even black and white
▶ Spot lighting on just part of the subject
▶ Fog and mist
▶ Silhouette
▶ Contrast

ABOVE
Kopachi kindergarten, Chernobyl, Ukraine. 2015
There's something clearly wrong here, a scene of absolute and long abandonment, bathed in an apprehensive shade of green, with a stuffed rabbit doll—in fact, all the makings of a cinematic cliché. What kind of apocalypse could have caused this? The answer comes clearly in just one word in the caption: Chernobyl. This is the abandoned kindergarten of Kopachi village located inside the Chernobyl Exclusion Zone, where a 1986 explosion of number four reactor created the worst nuclear accident in history. Photographer Sean Gallup made the pilgrimage at the risk of radiation levels that will make the area uninhabitable for thousands of years to come. Curiously, though, the explanation, while sobering, diminishes the initial mysterious power of the image.

DIG INTO YOUR REPERTOIRE

Every photographer, whether aware or not, gradually acquires a set of favorite ways of shooting. I call it a repertoire. It's a kind of private bank of stylistic choices. Notable photographers tend to have quite a strongly developed repertoire, and this is what makes their imagery distinctive. For example, Alex Webb's habit of filling the frame with a complicated jigsaw of shapes and subjects that somehow neatly fit together (see page 147) is a stylistic idea that he deliberately works at. Trent Parke's games with unusual and brief patterns of sunlight in city streets are another (see pages 16 and 192). What they have in common,

and what actually makes this a workable creative path, is that they are both fully aware of these kinds of effects and they go looking for them.

There's a trick here, and there's no reason to automatically despise tricks. It's being able to sit back and look at your own images—the whole body of work—objectively and coolly, and analyze what things give you visual satisfaction. If you have never done this before, break the analysis down into the following categories (see following spread) and search your favorite images for what they might have in common. In other words, ask yourself "Why exactly do I like this image?"

RIGHT & OPPOSITE

Suq Libya, north of Omdurman, Sudan. 2003
Calle de la Factoria, Cartagena, Colombia. 2014
A habit from my own personal stylesheet and which, once I was aware of it, I continued to cultivate, is the idea of "just," as in just about to touch or just about to happen. It can be real in the sense of a foot just about to connect with the ground, or purely visual in the sense of a figure or shadow coinciding with the edge of something unrelated beyond. The latter is something we already explored in Path 19: Juxtapose, where elements connect in the frame only from the photographer's point of view. Photographically, however, they're essentially the same.

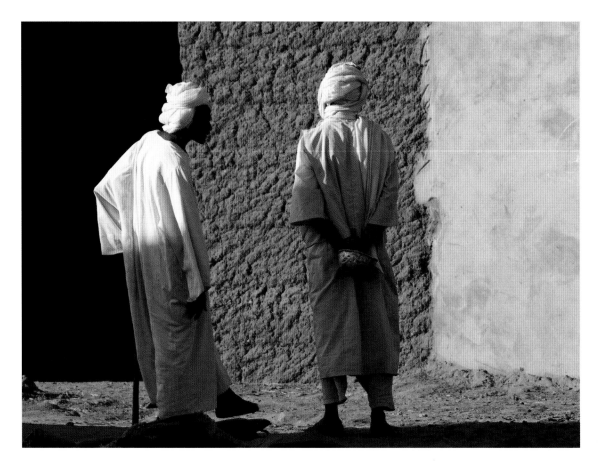

"I found I could clarify the image by using the harsh Australian sunlight to create deep shadow areas. That searing light that is very much part of Sydney—it just rattles down the streets."

TRENT PARKE

Balance—fitting things neatly, tiny main subject, symmetry, asymmetry, breaking the frame, things just touching, minimalism, complexity

Directing Attention—using lines to point, frames within frames, things receding in a line, tunnel effect of dark toward light

Light and Tone—edge-lighting, pervasive all-around light, sun stars, chiaroscuro, golden light, harsh shadow edges, high-key, low-key, silhouettes

Color—muted colors, garish hues, small color accents, specific color combinations, complementary color combinations, overall color wash

Timing—precision, peak of action, balletic postures, quirky facial expressions, contrast of sharpness against motion blur

Lens—telephoto plane-stacking, immersive view with wide-angle, selective focus

Look hard enough and you'll discover your personal image habits. I had one that I wasn't consciously aware of until I went through this exercise. I discovered that I was drawn to things that were just about to touch, just about to happen, almost but not quite. I was doing this with the timing of a shot (someone's foot just off the ground) and also with composition when there was plenty of time (making a subject almost touch a line or an edge). Once I knew what I was subconsciously doing, I kept it closer to the front of my mind when I was out shooting and was better able to make use of it when the opportunity arose.

That really is the value of this creative path: to be more than usually aware of your personal preferences so that you can apply them more consciously when possible. In other words, you are purposefully developing and working on these personal habits. From personal experience and in my experience teaching other photographers, this always works, 100 percent of the time. No one ever failed to gain from doing this exercise, so give it a try knowing that your photography will benefit from it.

Getsemani, Cartagena, Colombia. 2016
Mandari wrestler, Terekeka, South Sudan. 2004

Repertoire also usually includes certain styles of lighting, and one that I keep returning to time and again is the inelegantly named three-quarter backlighting. It falls into the space between edge-lighting and side-lighting, and has its own distinctive nuances. In street photography and other unplanned portraits, it almost always leaves the face in ambient shadow, and this can help the image in a particular way—faces always attract attention anyway, so why concentrate the light on them as well? For that reason alone it arguably makes an image more interesting to look at. It's a tangible kind of lighting—you can almost feel the light falling on the subject and shaping its form.

161

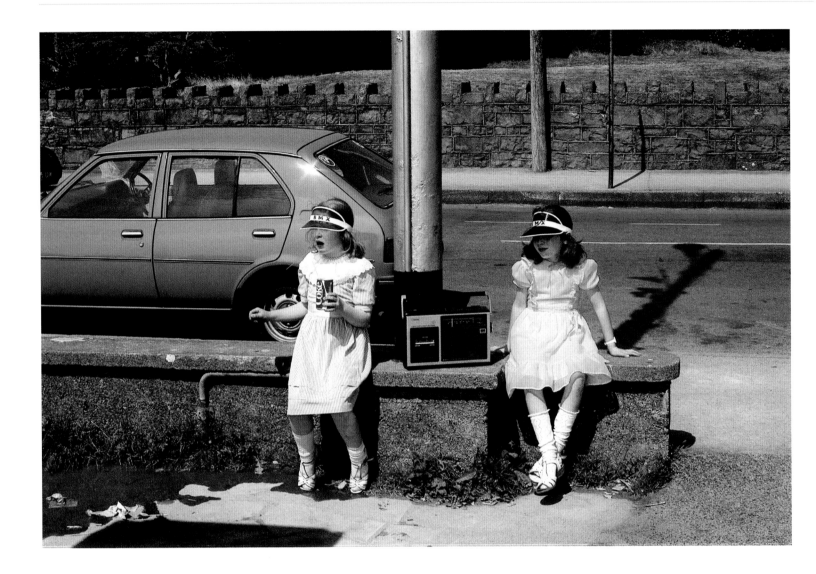

Galway, Ireland. 1988

Harry Gruyaert wrote of this picture, "In Ireland the landscape was
really amazing. I remember I was touched by those two girls, the
way they dressed and all that green, maybe they reminded me of my
daughters; I think that was the first time I took a picture of a young
girl. I liked the symmetry and the can of Coke, but what made me stop
was their attitude, they looked Irish. The whole picture looks Irish to
me." This and the accompanying photograph from Belgium show how
a visceral feeling for color and the sense of place that this evokes can
give clear identity to a photographer's body of work.

ABOVE

ABOVE

Province of Brabant, Flanders region, Belgium. 1988

Despite early difficulties in shooting to his satisfaction in his native Belgium ("It's hard to work in the place you are from"), Harry Gruyaert found the answer in banality. This photograph, of spectators in the town of Boom waiting for a carnival celebrating the Battle of Waterloo to pass by, works because of the intense red and that no faces are visible—one of them neatly obscured by a balloon. He says about this image "I'm making fun of my people and my own upbringing." When combined with the green theme of the Irish picture opposite, a sense of Gruyaert's established style becomes obvious.

Harry Gruyaert 1941–

Belgian-born Gruyaert began with an inherent love of color which he has never lost. He did, however, find it difficult for a long time to shoot color in "gray" Belgium, with which he admits to having a "complicated" relationship "because of my strict Catholic upbringing." It was his discovery of "the beauty of banality" that allowed him to move on, and detach himself from narrative and the the too-obvious color vibrancy of locations like Morocco and India, where he had been shooting.

38. CULTIVATE THE CASUAL

One of the shortest creative paths to explain is to lighten up from the usual shooting mode of full concentration and a high level of effort. Most of the paths here involve various ways of doing a lot more in order to raise your level of creativity. This one, however, is about cultivating a more playful, casual approach. While on the surface it is seemingly at odds with the other paths, it can in fact be complementary to them. A useful way to think of this is as taking a short break and relaxing.

It's based on an idea that has kept cropping up for decades among writers and critics. The thought is that there's something special about the camera's ability simply to deliver a fully formed image that might contain surprises, even to the photographer. The influential critic Clement Greenberg wrote that photography "works best… when it calls the least attention to itself and lets the almost 'practical' meaning of the subject come through."

The old word for this is snapshot, which in turn comes from shooting with a rifle and means taking a quick shot without aiming. This has long been used with derision as a way of separating worthless images from great ones by great photographers, but attitudes have changed. Gonzo journalist and writer Hunter S. Thompson wrote that "snapshooting is not, by definition, a low and ignorant art," and in its defense, "when photography gets so technical as to intimidate people, the element of simple enjoyment is bound to suffer."

Taking a casual approach and, dare I say it, just snapping away, is now more relevant than ever before because of smartphones. Technically, most smartphone cameras are now perfectly good for prints and for any kind of display that you might want. No objections there. Bruce Weber—who with David Bailey did a well-publicized shoot for a smartphone manufacturer in Harlem, New York—said that it "not only matches the capabilities of many high-end

RIGHT

Sailing ship El Gloria, West India Docks, London. 2012
What could be more casual than a cell phone? Despite manufacturers' heroic efforts at bringing image quality to the level of purpose-built cameras (largely successful for most uses), it encourages a lack of seriousness and a true snapshot ethic. All of the images here were shot on an iPhone. They still underperform in low light, but the motion blur that real camera manufacturers have worked hard to eliminate by making better and better sensors, has its own charm, recalling more carefree, technically incompetent days.

"I am a passionate lover of the snapshot because of all photographic images, it comes closest to the truth[.] ... [T]he snapshooter['s] pictures have an apparent disorder and imperfection, which is exactly their appeal and their style."

LISETTE MODEL

RIGHT

Pink Mini, South Kensington, London. 2011

A cellphone is always at hand, on the many occasions when you might want to leave a real camera at home. The idiosyncrasies of normal street life, even without people, such as this personalized pink Mini parked in a London street, can be turned into a collection of trivia without a second thought.

cameras, but in most cases surpasses them."If the phone is in your pocket, you have a perfectly good camera for an uncomplicated shot, and the result will be publishable. That alone is reason enough to play it casually. If something takes your fancy, anything at all, a play of light in the corner of a cafe, a dog on a leash trotting by with bootees, a smile on a face across the table, just shoot. No one is likely to notice or care. Raise a top-of-the-line DSLR with a professional lens and you're announcing that you're a photographer. Hold a smartphone and you're anyone. It gives you access to the whole world. As Bruce Weber went on to say, "It simplifies creative photography."

You might not think that there was much more to add to this lighten-up-and-don't-try-too-hard prescription, but it's worth mentioning the reasons why this is a useful technique. Not surprisingly, they relate to other creative paths in this book. First is the value of being playful and curious (Path 11, page 52) because these stimulate exploration without the need to hesitate over whether or not a subject or a viewpoint is actually worthwhile. Second is the possibility of turning up new and unexpected imagery by breaking with habit (Path 6, page 32). Finally, if you use a smartphone for this path, it's always interesting in any case to try out a new tool and see where its idiosyncrasies may lead you.

RIGHT
Golden Jubilee Bridge, River Thames, London. 2011
A few dedicated photographers do always carry a camera at all times, but the vast majority of us have on-days and off-days. It was always natural to make an excuse to oneself about missing a potential shot as a result (variations on "it wasn't important"). With a cellphone there's no longer any need for that.

OPPOSITE
Yellow table and taxi, Cartagena. 2015
Simply trying out images without thinking is quite a free experience—freedom from the usual creative pressure to get things "right." Casual imagery has its place, and the loosening effect of using a phone can even lead to a generally more relaxed way of shooting with a real camera.

39. SURREALISM & THE FOUND

Since its invention, Surrealism has had a long run for its money in all the arts and shows no signs of giving up its popularity. It's easy to see why, because the best-known Surrealists took the mystery and intrigue we were just talking about (on page 154) to the next level of weird. Mass audiences enjoy strangeness, and even more so when it's a familiar kind of strange. Dali, Magritte, and Escher are the most copied artists when someone wants strange imagery, especially in Photoshop-altered photography.

That said, Surrealism has its subtle side in addition to the bizarre, psychologically inspired imagery that made it famous. Its core idea was to find the extraordinary in the ordinary, and the Surrealists found photography perfect for the job. Including André Breton, the movement's founder, and Salvador Dalí, they were drawn in particular to urban photography of details, absent of people, so that they could find their own interpretations that went far beyond the objects themselves. Inanimate objects, in other words, could be suggestive.

Dalí wrote a 1935 article entitled "The non-Euclidean Psychology of a Photograph." He presents a photograph of two women and a man in a Paris street, and then asks the reader not to look at them, but to search the lower left corner, where there is a threadless bobbin in the street: "completely naked, completely pale, completely bare, immensely unconscious, clean, solitary, minuscule, cosmic, non-Euclidean, a bobbin without thread." Strange words for a seemingly ordinary object of no significance, but that was the point. You find an object, a scene, and by taking the trouble to isolate it and photograph it, you invest it with meaning.

For instance, the Surrealists "discovered" the Parisian photographer Eugene Atget with his curious eye on the normally available views of Paris and made him an icon simply by reinterpreting his work. Albert Valentin wrote of his photographs that "everything has the air of taking place somewhere else, somewhere beyond," while the renowned critic Walter Benjamin likened the city-street pictures to a crime scene, meaning that they were invitations to explore and uncover hidden meanings.

Whether Atget himself intended this is another matter; he told Man Ray "these are simply documents I make." Other photographers have followed this creative path more

OPPOSITE
Rue de Seine and Rue de l'Echaude, Paris. c.1900
Without artifice of any kind, Atget's simple curiosity in recording the urban fabric of Paris, usually minus people and out-of-hours, made for images that lent themselves to being examined and interpreted in different ways. He was anything but a conscious Surrealist, but that didn't stop the Surrealist movement in the 1920s from discovering him and seeing his large-format photographs as scenes from which normal familiarity had been stripped away.

Eugene Atget 1856–1927

Though little is known of his early life, Atget took up professional photography in the late 1880s, working in a solitary way and, from 1897 until his death, embarked on a project to record disappearing Paris as modernisation swept through the city. He held no great ambitions, selling prints inexpensively to artists, museums, and libraries, but fame came with his late "discovery" by Berenice Abbott and Man Ray, who saw in him a strange and dreamlike quality that coincided with Surrealist thinking of the time.

deliberately. Frederick Sommer, for example, arranged together different "found" objects, and said that things which at first might not appear to have anything in common can still "meet and work together." The contemporary artist Gabriel Orozco uses photography to invest everyday objects with significance and humor, like a deflated football and the condensation of breath on a polished piano top.

Then there's pareidolia, a word I've been dying to get into a book somehow, which means seeing some familiar, recognizable shape where non exists, like a face in a cloud. Frederick Sommer's 1966 photograph *Virgin and Child* is a close-up of a lump of molten metal that bears more than a passing resemblance to his title. Brassaï did the same in Surrealist mode with his close-ups of bits of wall and street furniture that resembled faces. As with juxtaposition (Path 19, page 84), there's a risk of being very silly, which an Internet trawl of the word pareidolia will reveal, but it's still a part of the Surrealist idea that you, the photographer, can create your own meanings from anything. If Marcel Duchamp could see a urinal as a fountain (and Alfred Stieglitz, no less, was around to photograph it as such), that opens up the field to anyone.

RIGHT & OPPOSITE
Bank of England from the Royal Exchange. 1980
Giorgio de Chirico's invented world of classical columns and statues in lonely piazzas can be found in real life with a little effort. Summer days in London are very long, and even the normally bustling City, with the Bank of England at its heart, is fairly deserted at 6 o'clock in the morning. Raking sunlight, emptiness, and a careful chosen viewpoint with a large-format film camera deliver a similar feeling.

Giorgio de Chirico 1888–1978

An Italian painter raised in Greece, de Chirico moved to Paris in his twenties, and there began his distinctive series of mysterious, classically inspired scenes of empty town squares. Like Magritte, though better trained in the tradition of Old Masters, he used a simple, clear, and direct style of painting that, through its bareness, focused attention on concept, which in de Chirico's case meant metaphysics, and he described this as Metaphysical Art. This period of his work led to his acceptance by the Parisian avant-garde Surrealist, though he fell out of favor with them over his later move towards Renaissance and Baroque styles.

For some reason, unhealthily to my mind, creativity in photography is becoming associated more and more with Photoshop manipulation. There's nothing intrinsically wrong with moving content around in an image, or putting a giraffe on the beach next to the Golden Gate Bridge, or having models float ethereally over landscapes. In fact, done well, all this can be very appealing, but it isn't actually photography. It's photo illustration, and that's another, separate creative activity, a hybrid, a mixing of photography and illustration with its own rather different creative standards.

However, rather than ignore it here in this book about photography, I want to show it as just one option that may be worth exploring. For some people it will be the main focus of their creativity, but others will reject it totally as being a perversion of pure photography. Personally, I'm happy to take it on board as an occasional set of tools and techniques to use for fun. A cleverly Photoshopped image taken in its entirety can certainly be highly creative (though perhaps more often excruciatingly silly), but it achieves its success from something other than photography. When it works, it works because of a great idea, while the execution is about artisanship.

OPPOSITE

Ruby Rumié and studio, Getsemani, Cartagena, Colombia. 2015
One of Colombian artist Ruby Rumié's major works involved the entire community of one street in the city where she set up her studio. She documented in multiple ways every inhabitant. One form this took was a series of silhouettes which she had made into flat die-cut metal figures, and another was a chart arranged by family. Bringing them together into a portrait of the artist suggested an image in which the silhouettes were projected onto the façade of her studio, practically achieved in a Photoshop layer. Rumié's cooperation legitimized this use of manipulation. Another part of the project appears in Path 47: Try a Typology.

"Oh, yes, I was a great retoucher. A retoucher is an esthetic surgeon!"
MAN RAY

"Change reality! If you don't find it, invent it!"

PETE TURNER

The way forward along this path is to put all your imagination into the idea, the concept, while making sure that your Photoshop skills are finely honed. Just don't confuse the two. The glove that becomes the hand in the image of the album cover owes more than a little to Magritte's The Red Model, 1934 in which a pair of shoes have "real" toes, and this qualifies the example here as homage (Path 18, page 80). In fact, a great deal of photo-illustration has to do with combining unlikely things, from a hairless four-legged creature with a semi-human face (Daniel Lee's Origin, 2000) to a giraffe crowded into a cramped study (Miss Aniela's High and Hungry, 2012). There's a strong vein of unusual juxtaposition running through this. When done purely through straight photography, which we saw in Paths 19, 22 and 23 (pages 84, 98, and 102), the appeal is in finding such combinations in real life. Here in illustration land, the surprises need to be greater.

OPPOSITE

Away with the Canaries, New York, 2015
A fashion shoot that evolved into what photographer Natalie Dybisz calls her "Surreal Fashion" fine-art series, created in the Hamptons, New York. She wanted a sense of motion to show the full volume of the huge yellow tulle dress, and so posed the model on a spiral staircase, shooting two stitched frames to cover a larger area of the room. For movement, she developed her original thought that the dress suggested a flock of yellow birds, and in post-production added multiples of an image of canaries so that they would fly out of the dress.

Natalie Dybisz 1986–

Working under the name Miss Aniela (from her middle name), Dybisz began as a self-portrait photographer in 2006, making liberal use of Photoshop to create staged, atmospheric tableaux, quickly establishing herself as a leading fine-art fashion photographer. Her current work explores a number of Surrealist themes.

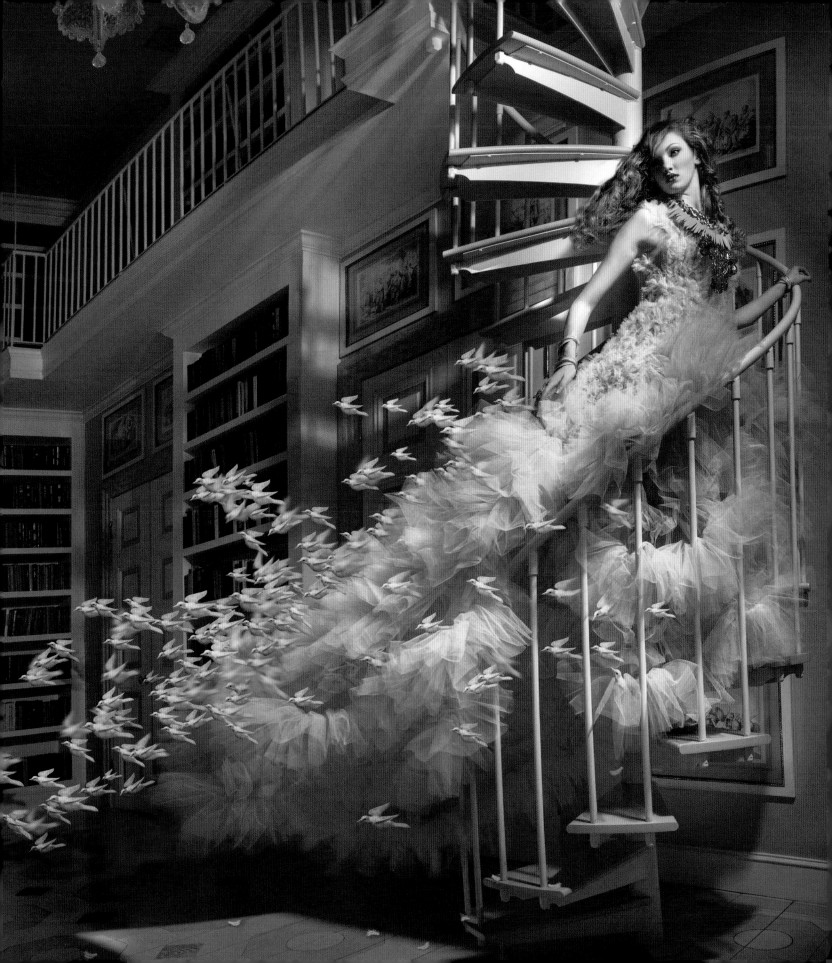

41.

FALL IN LOVE WITH A LENS

Lenses deliver character and other subtle features to an image. They don't just magnify or get wider. Some will fit your personality while others will leave you unmoved. If you own several, explore the character of each one and decide how you relate to them personally. It's quite likely that you get a kind of pleasure out of doing certain things with a particular lens, and that's worth following. This is, of course, risky advice, because it teeters on the edge of one of photography's great ills: obsession with equipment. If you follow this advice, tread cautiously and stay skeptical.

"Choice of lens is a matter of personal vision and comfort." Those are the words of American photojournalist Mary Ellen Mark, and pretty well echo the way in which most experienced photographers feel about their lenses. And I do mean "feel" because the glass in front of the camera has more to do with defining a photographic style than it does with simply being convenient for a type of subject. Henri Cartier-Bresson, the master of street photography, used a selection of lenses when he was on paid assignments for clients, but for his own work—which are his defining pictures—he used only a 50mm, for the simple reason that he firmly believed that his camera was "the extension of my eye," and that 50mm gave him the view that he considered most eye-like. Other photographers have different styles. For instance, Annie Leibovitz said, "I look for images that are a bit different— a little surreal. The normal lens is a challenge to me. I have to work to avoid getting normal-looking pictures. My favorite lens is the 28mm because it gives me a different perspective with a minimum of distortions."

Tea-picker, Dong Ding Mounatin, Taiwan. 2014
A 40-year-old 500mm mirror lens, no longer fashionable in photography, creates doughnut rings from out-of-focus specular highlights, here glinting from leaves in a Taiwanese tea plantation. Its fixed *f*/8 aperture made for slow shutter speeds when used with color film, and gave a dim impression through the viewfinder, but a digital SLR with good ISO performance solves both of these problems and gives the lens a new, useful life.

"It is essential for the photographer to know the effect of his lenses.
 The lens is his eye, and it makes or ruins his pictures."

BILL BRANDT

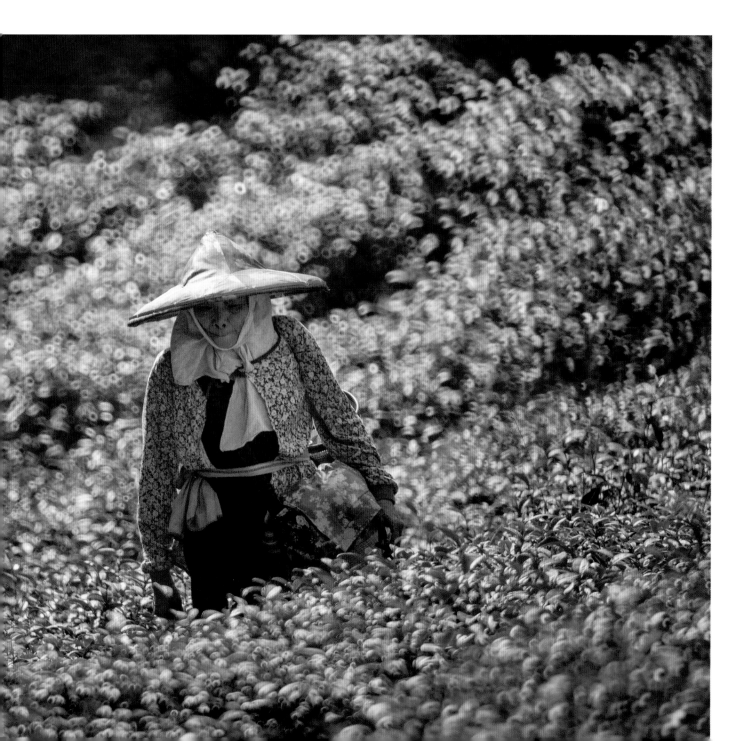

Acupuncture figures in wood, Bangkok. 2011
A fast lens, in this case a Zeiss 85mm with that manufacturer's renowned optics and a maximum aperture of ƒ/1.4, gives a particular character to an image when used wide open. The depth of field is extremely shallow, which gives prominence to the contrast between a tiny, sharply focused area and the soft surrounding blur that usually fills the rest of the frame. Lens manufacturers put extra care into the visual quality of the optical blur, which varies subtly between makes.

Yet distortion is something that other photographers seek out and enjoy because it adds graphic novelty… or perhaps I should say "did add," because the enthusiasm with which most people in photography, publishing, and advertising welcomed the ultra-wide lens when it first arrived has waned simply because of over-familiarity. Ultra-wide lenses made their mass-market debut in the early 1960s, came as 20mm and 21mm, and were quickly picked up by advertising and editorial photographers who wanted to have an edge to their imagery. They were encouraged by art directors and picture editors at a time when pop culture was taking off and everyone wanted visual excitement. Art Kane and Guy Bourdin were two of the best-known practitioners, and both made close-and-distorted fashion photography a hallmark.

Just as ultra-wide lenses define themselves by offering views we don't normally experience because they go beyond the eyes' side-to-side field of awareness, telephotos become super-telephotos when they reveal views so small and distant that they come as a surprise. That happens for most people at around 500mm, and the key is the surprise factor, provoking the reaction of "I've never seen that!" Many photographers use super-telephotos to explore and search for images. Jay Maisel, who built a reputation on his use of telephotos, said,

"[M]y proclivity is to look at the center and zoom in on something that I want a detail of rather than photographing the whole thing." Adding to the telephoto stylist's essential argument, he said, "I think if you add too much to your picture, you dilute it."

Adding an extra stylistic wrinkle to the super-telephoto was the mirror lens (aka reflex, aka catadioptric, aka "cat"). The optics are borrowed from telescopes, specifically from a design known as the Cassegrain, in which internal mirrors are used to achieve impressive focal lengths (most typically 500mm, but longer have been made) in a short, compact lens barrel. They had their heyday in the 1970s and '80s, and were actually liked for their doughnut-shaped, out-of-focus highlights and slight lack of contrast. Art Kane, once New York's most sought-after advertising photographer, used one, saying, "Again the incredible soft backgrounds. That lens influenced me and altered my vision." Its compactness and light weight make it practical in street photography and for rapid use, while digital cameras help overcome its traditional drawback of being slow in an aperture sense (ƒ/8 is typical). I recently found an unused one, almost 40 years old, and rediscovered its pleasures and frustrations (so light that it's hard to hold steady). Since mirror-lens imagery is so distinctive, I still find it stimulating to explore scenes with it.

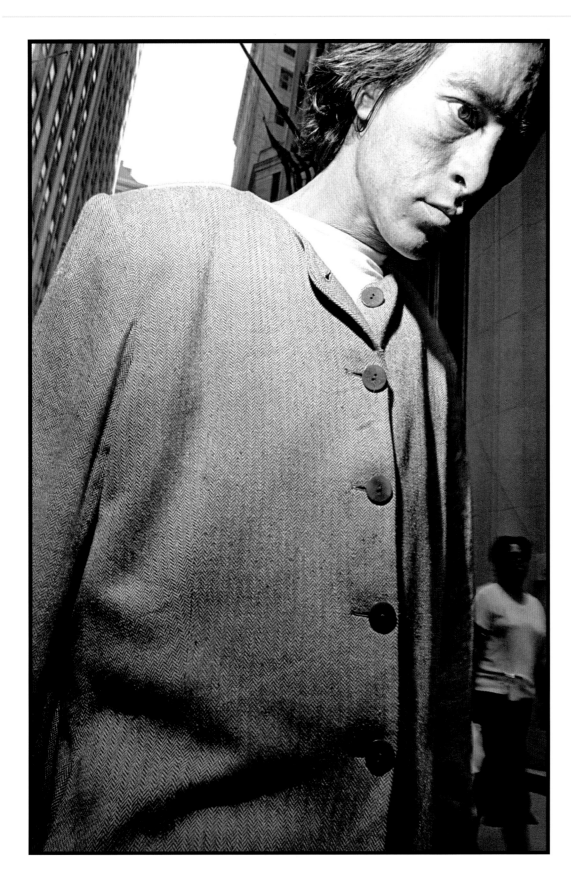

Man walking in Wall Street area, New York City, USA. September 17th, 2001.
Bruce Gilden's apparently aggressive and certainly in-your-face style of street photography depends partly on using his preferred 28mm lens from less than a meter, often from low. As he says, "The viewer gets the feeling that he's in the middle of the action."

Another entertaining lens quality that can inspire is selective focus with a very fast lens, such as $f/1.4$ or $f/1.2$. At these very wide apertures, particularly with a medium telephoto (85mm is typical), the softness of the defocused areas offers room to play creatively. This can influence the entire style of shooting in setting a small, sharp subject against large color washes. Though perhaps unscientific, many photographers talk about this kind of imagery in words like dreamy, smooth, presence, and three-dimensionality. Vague and emotional though terms like this may be, they try to express total visual effect and, in the end, good photography is about visual appeal and feeling.

The vocabulary to get this across is as elusive as that for describing the flavor profile of a wine or the aroma of a scent. Some photographers who try this path simply hand things over to the equipment. In a late period in his photographic career, Bill Brandt acquired an old Kodak camera with a fixed and extremely wide-angle lens and began photographing nudes with it. He wrote, "Instead of photographing what I saw, I photographed what the camera was seeing."

Frans Lanting 1951–

Lanting is a Dutch photographer specialising in wildlife, with a long association with National Geographic. In a field that is highly demanding and competitive, Lanting's work stands out for his ability to bring creativity to subject matter that is normally judged only on accuracy, moment and behaviour.

OPPOSITE

Dead camelthorn trees, Dead Vlei, Namib-Naukluft National Park, Namibia. 2011

In this well known and heavily photographed location in Namibia, with a 400-meter sand dune towering over a dried salt pan dotted with dead acacias, wildlife photographer Frans Lanting has remarkably been able to pull off an original image by hard work. He photographed the location shortly after sunrise (the classic time for this spot) with a variety of focal lengths, including this long telephoto lens. The result is pronounced compression, giving to a flattened, almost painterly quality. The white patches that further confuse the perspective by giving the dune the appearance of a painted backdrop are out-of-focus white grasses, blurred by the shallow depth of field of the extreme telephoto.

42. WORK THE LIGHT

t's a cliché to go on about how photography needs light to work and therefore light is somehow at the heart of it all. You can, however, vastly improve the creativity of your photography by bringing light to the forefront of your shooting technique. In other words, make a conscious effort to think about it and handle it. You can even treat it as a commodity, as a very specific ingredient. Just as with the pie chart in Path 31 (see page 136), consider raising the contribution made by the quality of light to your shot. In one sense, there's not very much more to it than just making that decision: Make the step to showcase light when you shoot. In another sense, though, that decision is just the beginning and you can then spend the rest of your life learning about the effects of light and experimenting with it.

There are infinite ways of working with light, and it would need at least one whole book to do justice to it (for instance, there's my book, *Capturing Light*). For the purposes of this path, however, I'll pull out just a few reliable strategies for exploration:

> Low, strong sunlight
> Shooting into the light
> Dutch interior light
> Bare-bulb light

If you haven't consciously explored any of these in depth, you might be surprised at the opportunities they offer. In each case, what we're concerned about is not efficient light but creative light, and this calls for some explanation. Efficiency throughout photography is what is normally taught, and for very good reasons, not least of which is because there is such a strong technical component to using cameras—and lights. You need to know how everything works even though modern digital cameras make it extremely easy.

The first and most basic job of photography is to communicate, to show the audience what things look like and what's happening. Efficient lighting is a part of this. Over a long period, lighting that reveals certain qualities has been revealed. Beauty lighting for fashion and glamor portraiture, for example, calls for a broad light such as an umbrella almost directly over the camera, frontal and backed up by reflectors to fill all the lower shadows that the structure of the human face is prone to creating. Still-life images, particularly of many commercial products, also look attractive under area lights, but these are suspended overhead and point down for a directional yet soft effect, with softened shadow edges.

Liquids in glasses and bottles, on the other hand, sparkle and look enticing when carefully backlit, either against a large area backlight or, more dramatically, against a dark background, which is technically more demanding… and so on. This is what a good lighting manual will teach— how to get positive and efficient results. The digital revolution that has made cameras foolproof hasn't reached lighting yet, which is why it remains a big step for photographers learning their craft.

OPPOSITE

Marigolds and boulder, Bali. 2005
The setting here was attractive but prosaic: a contemporary house in Bali with pool, wooden deck, and a large boulder in the water as a decorative feature. The play of late afternoon sunlight, however, looked like something worth exploring, with high contrast, reflections in the water, ad above all a narrow band of sunlight that struck the centre of a tray filled with marigolds. Closing in like this cropped the boulder and pool so that they became abstracted, leaving the attention firmly on the play of light and color.

"You only get one sunrise and one sunset a day, and you only get so many days on the planet. A good photographer does the math and doesn't waste either."

GALEN ROWELL

Creative lighting, however, is different and more exploratory. Instead of specific sought-after effects, which are very much the province of commercial shooting, this is about experiment and surprise. We're looking out for unexpected effects, such as unusual reflections, bounced light, forceful shadows, and strange contrast. The first of our four strategies here—low, strong sunlight—can deliver on all of these, though unreliably. Strong, low sun, and clear air: This sounds suspiciously like the formula for Golden Light, a perennial favorite that requires shooting within about an hour of sunrise or sunset. The key ingredient that makes it special for creative use is crystal-clear air, which is not very common in cities, though it is possible after rain and in high-pressure winter weather. The configuration of buildings, trees, and so on block the light in patterns so that it falls in unexpected ways, like a shaped spotlight.

The second strategy is shooting against a light source, whether the sun or a window, and this allows a great deal of creative experiment with the possibilities of silhouettes, flare in all its forms, backlit glow, and confusing patterns. As we'll see in Path 44 (page 192), things that go technically "wrong" with light on its way to the sensor offer all kinds of creative opportunities, simply because they work against efficiency.

Dutch interior light—my own shorthand term—is a particular way of using single-source natural light indoors. Dutch genre (everyday life) and still-life painters from what was known as the Dutch Golden Age developed this style based on a single, north-facing window, or at least a window without direct sunlight. Johannes Vermeer's *The Milkmaid*, painted between 1658 and 1660, is a well known example.

Typically, you shoot close to the window with the light to one side of you and slightly in front of the camera, toward the sidewall and the corner with the wall that has

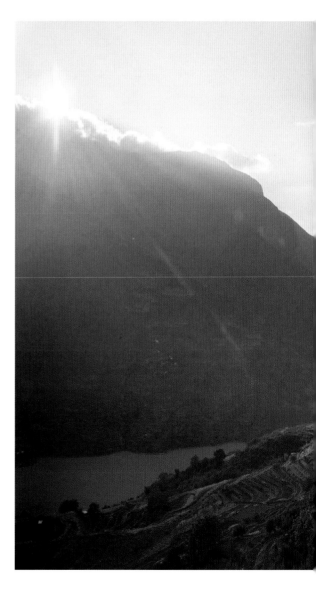

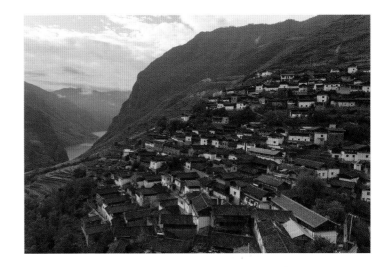

Baoshan village, Yangtse River, Yunnan. 2013

A spectacularly located and remote village in southwest China faces over the upper Yangtse River, here called the Jinsha. As the morning sun cleared the mountains above the opposite bank, the houses were suddenly bathed in light, an obvious time to shoot, but including the sun itself in the frame made the image much more striking and full of atmosphere. Including all of this in the same image called for six exposures to cover a 6 *f*-stop range, which were then given restrained HDR processing. Taken on another day without sun, the smaller picture shows what a difference light can make.

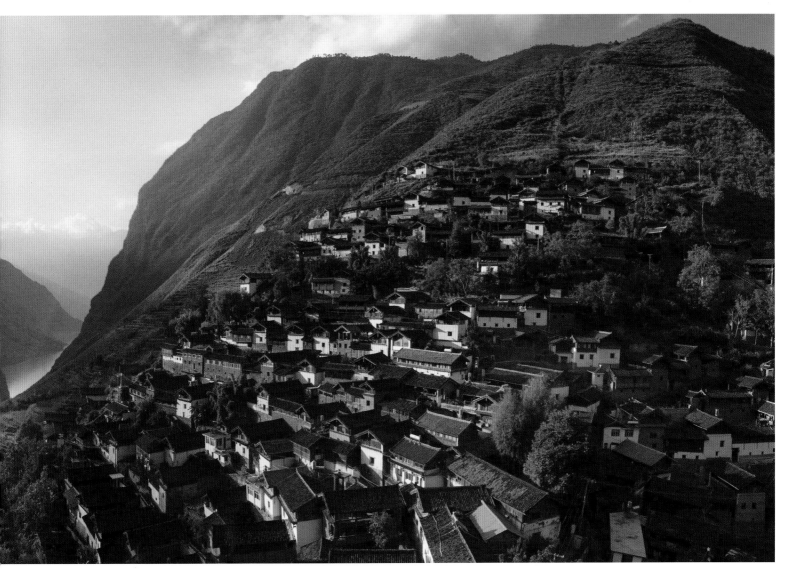

ABOVE

Yixing teapot. 2015

A contemporary Chinese teapot in traditional Yixing clay at the potter's workbench. The style of natural light favored by Vermeer and other painters of the Dutch Golden Age works reliably if you follow the same principles: set up close to a window that does not catch direct sunlight and is just out of frame to the side and back of the subject. At the same time use the way the light falls on the rear wall, which is at right angles to the subject as counter-shading to the fall of light on the subject. Keep the color balance cool.

the window. If you frame to exclude the window itself, the contrast stays moderate. With minimum to no shadow fill from reflectors, the effect is a beautifully atmospheric, rounded modeling light that stresses the lit edge and makes use of what is called counter-shading. In this, the shading from light to shadow on the subject runs in the opposite direction to the shading along the wall behind, and this lifts the subject and adds a lovely three-dimensionality.

Bare-bulb light is a term from studio photography that means stripping away all the coverings and diffusers and modifiers of light from the basic source. Studio lighting is and always has been constructed on the premise that the source of light is simply the engine and is never intended to be used directly. Photographers who use constructed lighting have always accepted the need to modify, from diffusing to concentrating to bouncing to whatever it takes to change that raw light source. So, the idea of using only the naked point light is creative by contrast.

It was, however, done with creative intent a long time ago. Exactly when depends on your view of the history of photography, but from a professional perspective, Irving Penn, arguably the master of still-life studio work and who worked principally commercially, began experimenting with this counter trend in the early 1980s, halfway through his 70-year career. You could also note some earlier experiments among modernists (Penn followed modernism), such as Paul Outerbridge in the 1920s. Creatively, this style or strategy conjures up the appeal of things unadorned, a clear view, no trickery, and the chance to play with hard shadows.

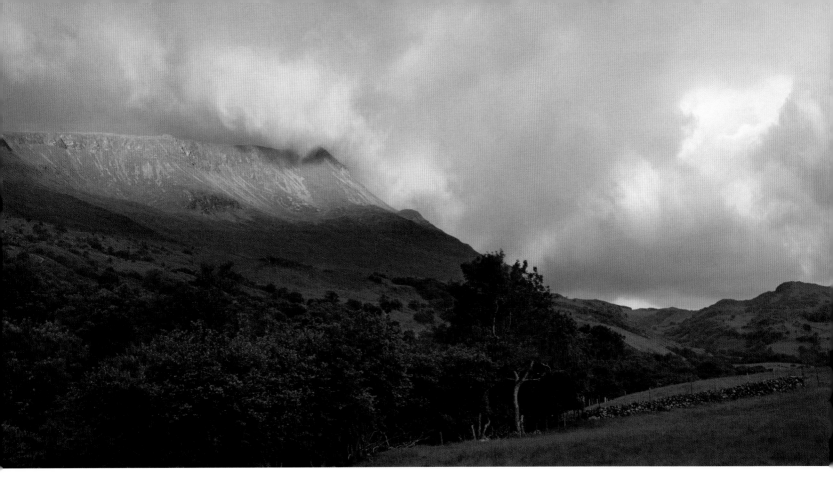

Cader Idris, Wales. 2006

It doesn't always communicate itself in a photograph which is the tricky part, but short-lived light is always the most special and urgent. Here's a break in heavy clouds just after sunrise, and you know it's not going to last long. In photography, landscapes are hardly ever as urgent as people, so when they are, they come alive. The strip of four smaller images taken after the main image shows the descending band of light as the sun rose—all in seven minutes.

EXTREME LIGHT

ight quality can be a massive chunk of what goes into a good photograph. Now, if you want to please the crowds, stick to golden light at the Golden Hour and you won't go wrong, guaranteed, but it's not very creative. If you want to get interesting, in light as in any other quality of a photograph, you should explore. Exploring means going where most people don't, and there's a whole lot of that territory in photography.

Think of all the "rules" of lighting. Don't shoot until that cloud moves. Don't forget the catchlight. It's advice for putting people off whole swathes of unpopular lighting. Ignore it. It's advice for the mediocre. Instead, look for lighting effects that seem impossible, harsh, maybe even ugly. More often than not the results will be "failures," but it's the occasional exception that we're looking for, the one strange but successfully lit shot that makes the challenge worthwhile.

Here's a practical example (and by practical I mean it was an assignment that had to be done, and done well). This is an engineering factory where they make transportable racks to hold natural gas tanks. Well, how interesting is that? Actually, if you're an engineer or in the oil and gas business, it's pretty interesting. To anyone else though, one factory floor looks much like any other. The first idea I had was to find a different view. There was a high window near the roof, accessed from an outside terrace—possible, but distant. Directly overhead, however, would make a nice shot. I asked if it was possible, and as it happened there was a gantry crane and a cage that could put me about 10 meters above. This

looked like a plan of action, because plan views can be very graphic, with a touch of the abstract.

That alone, however, wasn't so exciting, and I needed something else. How about lighting? This was the tropics, with every day sunny, and that meant that at some point in the day there was very harsh light falling on the factory floor from the high windows. Normally that might be something to avoid, but here, possibly, it could provide the unexpected quality that this shoot very much needed. We asked workers at their stations if and when there was sunlight on them—it's the kind of thing you would remember—and from that worked out the approximate time to start shooting the following day.

We spent two hours suspended in the cage, very slowly tracking to follow one patch of sunlight as it moved across the floor. That gave me plenty of time to look for patterns and alignments, and also for the light that bounced up onto people, giving a satisfying glow. In the final part of the shoot, the light reached a welding station, and the combination of harsh sunlight, almost-black shadows, and sharp blue light from the oxyacetylene torch made an image I would hardly have guessed at when we first arrived at the factory. The moral of the story is that a different viewpoint and extreme lighting that you would normally avoid transformed the scene. It also put many people to a lot of trouble, but far from this being a cost penalty, it involved them in the creative act, which they enjoyed and that made the result all the more satisfactory for the factory management and workers.

BELOW & OPPOSITE (ALL IMAGES)

Engineering factory floor, Cartagena, Colombia. 2015

Making deliberate use of harsh midday tropical light with a different viewpoint turned a very unpromising situation into a strong, graphic image, as described in the text. The production shots below show the setting and the gantry crane used.

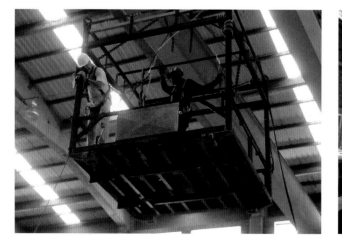

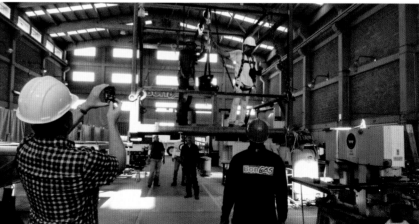

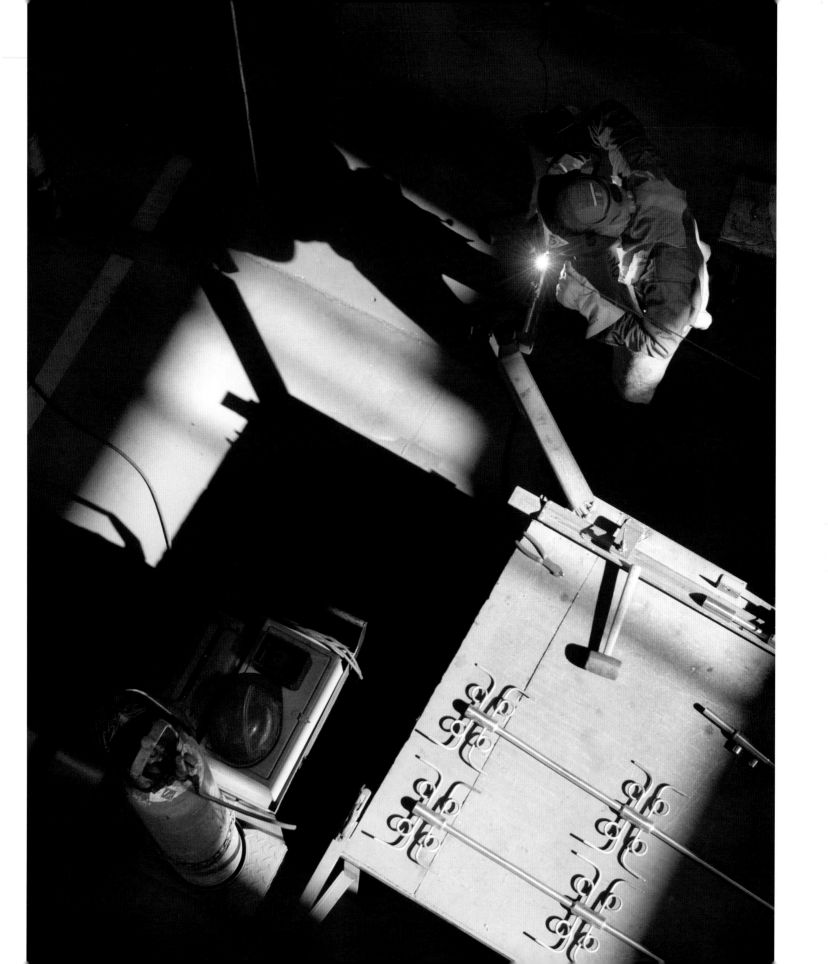

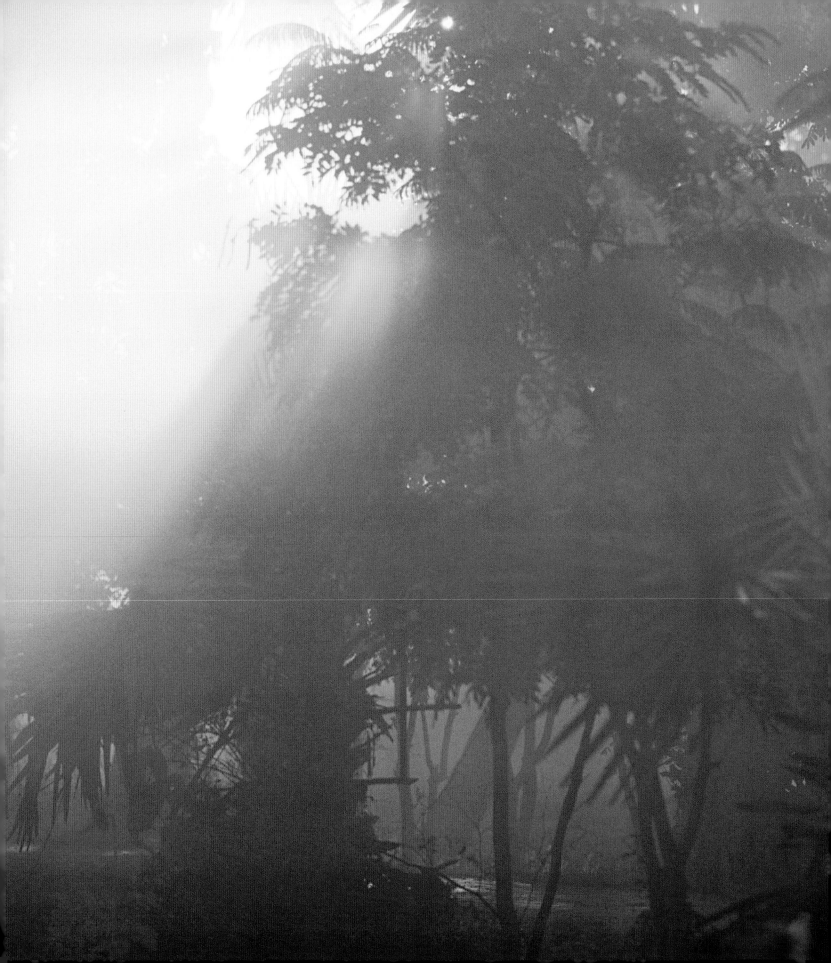

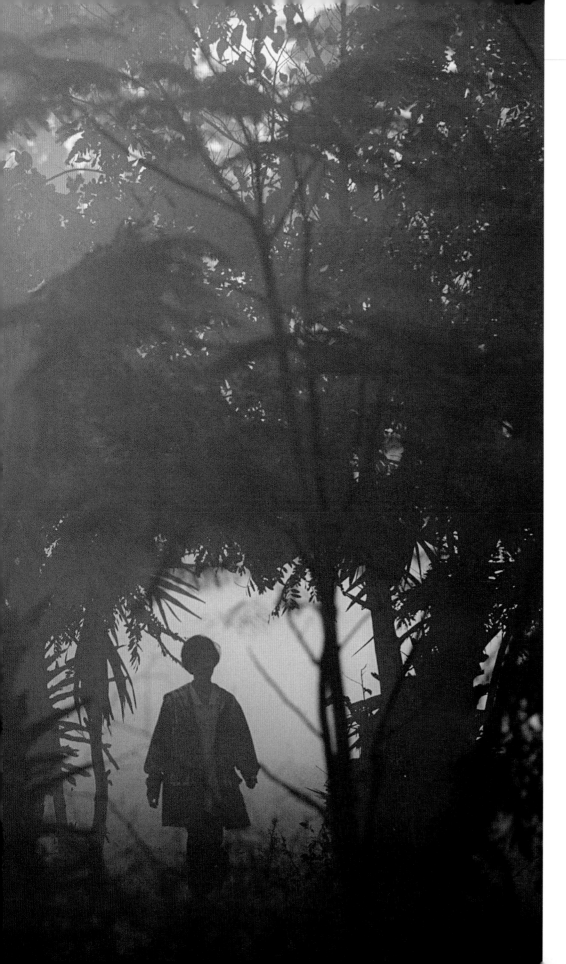

"The drama of light exists not only in what is in the light, but also in what is left dark. If the light is everywhere, the drama is gone."

JAY MAISEL

OPPOSITE

Country lane, Ava, near Mandalay, Myanmar. 1996

Another form of extreme lighting, highly unpredictable, is into the sun through an atmosphere of some kind, whether smoke, mist, dust, or even snow. There's no planning possible with this kind of lighting situation, as there was with the factory floor shot on the previous pages, and it needs to be dealt with quickly, as this combination of strong sun and dense atmosphere is very changeable.

44. MAKE LIGHT
THE SUBJECT

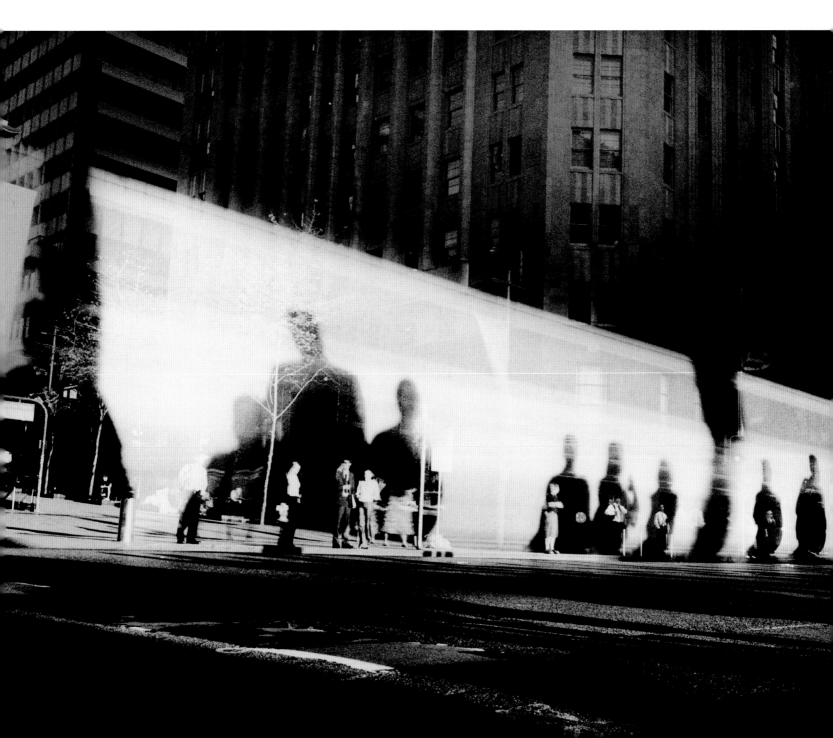

If you buy into the idea of treating light as a commodity and as a component to be deliberately woven into your images, then push it right to the front of your shooting method every so often to make it the actual subject of the photograph. This is yet another creative approach to light: to focus on the way it falls, reflects, and refracts in patterns that take on substance. It may be an exaggeration to say that it hardly matters what physical things it falls upon, but the surfaces may well be more important to the image in the way they receive and modulate the light than in what they are.

This really is a change of mindset from just being attentive to the quality of light. To ease yourself into this way of thinking, you could start by trying to ignore physical subjects, at least as an experiment. Also, using a technique of reduction (see Path 32 on page 138), consider shooting in black and white in order to remove the color component, which can easily take over an image. That prepares the ground, but the next step is to see the fall of light as the primary focus. It might help to look at how light-obsessed photographers talk and think. Few have been more obsessed and obsessive than Australian photographer Trent Parke, a member of Magnum. He even moved to another city, Adelaide, because of its light.

Parke's commentary on the image shown opposite gives an idea of the lengths you could go to in capturing a special light effect: "I went each evening, for about 15 minutes, when the light came in between two buildings. It happens only at a certain time of the year: You've just got that little window of opportunity. I was relying so much on chance, on the number of people coming out of the offices, on the sun being in the right spot, and on a bus coming along at the right time to get that long, blurred streak of movement. If I didn't get the picture, then I was back again the next day. I stood there probably three or four times a week for about a month." This finally paid off for Parke with a single, unrepeatable image. "I shot a hundred rolls of film, but once I'd got that image I just couldn't get anywhere near it again. That's always a good sign. You know you've got something special."

Without going down a life-changing path, it's perfectly possible to dip into this slightly specialized world of chasing light. Simply prepare yourself for the opportunities when they present themselves—as they always will when you put in the time and go out to shoot day after day. It's also worth remembering that light most easily becomes a subject when something interferes with it, whether on its way to the camera or once inside. Outside interference is usually atmospheric; steam, mist, and smoke are good candidates for magnifying the presence of light.

Inside the camera, there are many more opportunities for interference, usually via some kind of technical fault. Technically wrong can, of course, be creatively right. Lens flare is one possibility, either generalized or in the form of polygon streaks radiating out from the sun or another bright light in the frame. As with atmospheric effects, you can best cultivate these by shooting into the light source or a reflection of the source.

Australia. Sydney. Martin Place, Moving bus. 2002
As described fully in the text, this strange moment of sunlight reflected from and shadows cast on a passing bus in the late afternoon was the culmination of a month's work by Trent Parke, self-acknowledged light-obsessive. There's a point, certainly reached here, at which light takes over an image, subordinating all else, including the physical subject.

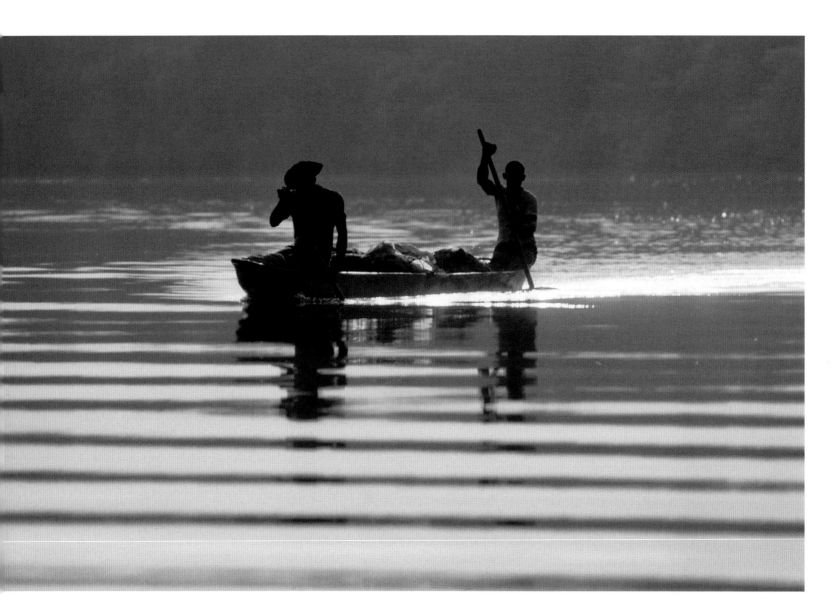

ABOVE

Canoe, Baru, northern Colombia. 1979

After an entire night spent in a small boat negotiating wetland channels behind the coastline of northern Colombia, I was rewarded with a single shot as we emerged from mangroves into a small tidal lagoon, utterly still at dawn. Two villagers in a canoe were paddling toward us, the paddle and the wake stirring glittering highlights. The horizontal, water-level view from our small boat caught the full play of reflections from the sun that had only just risen across the water.

Rainbow over tea fields, Meishan, Alishan, Taiwan. 2015

I don't normally get too excited about rainbows—at least not photographically, though they're always engaging to experience—but in this case it was a gift that came unexpectedly in the last minutes of a shoot for a book on tea. We were on Alishan, one of Taiwan's most important tea mountains, and a landscape with a difference (or rather, a teascape) would have been welcome. It was almost sunset, the air unusually clear after a long storm, and as we were at over 2,000 meters, the sun was actually below us, hence the rainbow's arc was more than a half-circle—a rarity.

45. MAKE COLOR THE SUBJECT

RIGHT

Rajmahal ballroom, Baria, Gujarat. 2012
Colored light always makes a good star. This old ballroom in a palace in Gujarat, India, unused for decades, is bathed every day in the late afternoon sunlight filtered through the multi-hued panes of its windows. The contrast between the color choice for a lost world (the ballroom was added to the palace for a Viceroy's visit) and the gentle decay evokes a special nostalgia.

f light can be its own subject, why not color? The camera shoots in color, and for some photographers that's just a fact of life and never mind anything more than that. For others, it's a reason to explore and play with something that works on the emotions as well as the eye. The painter Kandinsky, the ultimate colorist, said that "color is a means of exerting a direct influence upon the soul." Painters have had almost all the attention when it comes to color, but photography is just as potent, and for great colorist photographers like Ernst Haas, color was often the subject.

As photographers, it's really tempting to think of color as just another bit of an image, along with light, shadow, focus, noise, and so on. However, that would be missing quite a lot, because most people don't just look at colors and note what they are; they react to colors in all sorts of ways in terms of feeling and sensation. Color semantics was kicked off by J. W. von Goethe—poet, philosopher and all-round polymath—and has gone on to be used by everyone from artists to food-package designers and interior-design consultants as a way of working on people's preferences. We can actually like and dislike certain colors according to who we are and how we were brought up. By now there's a whole folk science of color likes and dislikes, most of it on the Internet and little of it backed by any proof. Nevertheless, what is beyond doubt is that most people have the capacity to enjoy color and to enjoy it personally without necessarily agreeing with other people's views.

This is a great opportunity for photography, which is by far the easiest way for anyone to create combinations of colors. You can even blur them in the camera or do other tricks to separate them from reality. There's no need to study color theory (though if you do you'll be better able to manage your audience's reaction); just simply pay more attention to it than to other aspects of a scene or subject.

One note of caution: Not everyone connected to photography thinks this is a good idea. When all this sensory feeling for color is run through the filter of curator/gallery/critic approval, some strange things happen. It gets almost as disputed as in the fashion business, with different gurus claiming that different color combinations are in or out for

RIGHT

Taungpulu Monastery, Mindat, Chin State, Myanmar. 2013

A single-color-themed shot of novice nuns in a meditation class. The delicate pink, both of the garments, and the painted pillar could be made to dominate the frame by carefully choosing the viewpoint and using a fast lens (85mm Zeiss) at a full aperture of *f*/1.4 to blur and spread the color.

RIGHT

Book stall under the Public Clock, Cartagena. 2009

Also with a single-color theme, this time a painted yellow, this shot works partly because the yellow unusually covers both walls and cabinets, and partly because of the spot color accents of pink and blue.

the season. Everyone has an opinion when it comes to color, and it doesn't get much more rigorous than like/don't like. So, for example, back in the 1970s when a new wave of American photographers began working in what was claimed to be a new color sensibility (New Color), one of them, Stephen Shore, was praised for his richly saturated hues: "Shore's work has virtually always been distinguished by his use of saturated color."

At the same time, Ernst Haas—one of the most famous advertising and editorial photographers of the time and who made his name with richly saturated hues—was completely ignored by the New York photo-art establishment. Why? Color used in order to please the masses was considered cheap and vulgar. The Director of Photography at New York's MoMA called earlier color photography "puerile." Sally Eauclaire, the author of the book The New Color Photography, which gave the movement's mission statement, called it, "the medium once consigned to amateurs and photographers." Just a tad arrogant, you might think, but color, or rather colorfulness, encourages divisiveness in photography. You've been warned!

LEFT

Taxidermy case, Calke Abbey, Derbyshire. 1985
Another multi-colored-light style of picture, similar to the old Indian palace ballroom on the previous pages, but here, the falling light through stained glass onto a domed glass case completely fills the frame. The multi-color effect was enhanced by the use of a rare film type, AutoProcess Polachrome, a 1980s descendant of the failed Polavision instant movie camera system.

RIGHT

Kiosk, Cartagena, Colombia. 2016
Managing a number of distinct
colors, particularly when they're quite
strong, puts a special responsibility on
composition. In a case like this, where
the yellow walls of the kiosk form the
base of the combination, it meant trying
to separate the elements as distinctly as
possible. That meant both the figures and
the blocks of color. This is intrinsically a
brightly colored culture, with preferences
for primaries, and that was ultimately
the point of the picture.

46. BODY OF WORK

One successful shot is immensely satisfying, but please never make the mistake of thinking that one great image will make your career or reputation. The reality of doing photography seriously for a lifetime is that you need to build up a body of work. There's more than one reason for this. First is consistency, being able to show that you can pull it off time after time. Next is that any photographer's style is larger and broader than one image, and only several at the very least can give a rounded picture of your work.

Perhaps the most important reason, though, is the highly practical one that you need to shoot image after image so you can get better at and explore your artistry. All of the ideas in this book benefit from being worked on, time and again, and each time new things happen. You simply need to keep shooting and improving. This is, roughly, how most creative people work, not just photographers. They try out ideas and some of them develop. So, always think about a sequence or series of photographs that you're gradually

Alec Soth 1962–

Soth began his career as a staff photographer on a Minneapolis suburban newspaper, and has since earned a strong reputation for creating collections of images that explore American society's difficulties with sense of place and sense of community. He uses a wide range of platforms and is described in one exhibition note as "a photojournalist, blogger, self-publisher, Instagrammer, and educator."

LEFT & OPPOSITE
Charles, Vasa, Minnesota, USA. 2002
Ste. Genevieve, Missouri, USA. 2004
Alec Soth is one of the most successful American photographers to bridge the gap between documentary and fineart, establishing his reputation with the 2004 book *Sleeping by the Mississippi*. His focus is narrative and his preferred medium is books because, as he says, "Anyone can take a great picture, but editing those pictures and, more importantly for me, putting them together and having them resonate off each other—that's the ultimate task. It's the body of images I'm most interested in." A mark of the editing is that there are just 46 photographs in the book, all shot with a large-format film camera, covering a range of physical subjects that go from landscape to contextual portraits to interiors and found still lifes. The spacing of these and the cool, clear style speak strongly of a conscious body of work.

"I just work and I throw the pictures in a box that says 'X' or whatever, and eventually if the box gets full it merits looking at. … People tell me that they all look like they've been well thought out, and that's because I've worked on them for so long."

LEE FRIEDLANDER

building up. You don't have to consciously follow any particular direction, but eventually you'll find that your best images start to look coherent. They become, in other words, a body of work.

"Body of work" easily translates into the very practical idea of a portfolio. This is where photographers put on their best public face, and it ought to be a distillation of your best imagery. It's worth spending time, thought, and effort on making the selection because the portfolio is all that most people will ever see of your skills.

In a world of photography flooded with imagery and dominated by the web, attention spans even among interested professionals (like a picture editor you're hoping to impress) are short—very short. On a website, if that's how you present your photography, you'll be lucky to have someone who's coming fresh to the screen seeing even your first dozen images, so they had better be very good. Twelve isn't a particularly magical number, but it's somewhere between reasonable and optimistic. In fact, people who are practiced and in the creative industry will probably know after seeing just three or four of your photographs whether or not they're interested in examining further.

It's very common (and a bad mistake) to insist on showing too many images, particularly if some of them are similar. However difficult it is (and it is), we all need to be ruthless about culling the "also-rans" from our portfolio of prized photographs. A few very good or very surprising images should make up your portfolio. Show more and you'll dilute the effect. Plus, you'll be demonstrating that you're not decisive enough. This is not easy if you have hundreds of what you believe to be very good images, but it has to be done. A reasonable compromise on a website is to have a few—let's say between ten and 20—of your best images as your "front of house" portfolio. You can then have other secondary galleries that people can click through if they're interested in seeing more of a particular style or subject.

Dance N Style, Sandusky, OH, USA. 2012
In his 2015 book *Songbook*, Soth extends his body of work but at the same time breaks the continuity of photographic technique. The subject is the generally failed attempts at finding and engaging in a sense of community in American society, for which Soth visited hundreds of social gatherings across middle America. The studied large-format, tripod-bound approach of *Sleeping by the Mississippi* was replaced by black-and-white handheld, often using on-camera flash. Body of work is clearly not bound by technique.

TRY A TYPOLOGY

Arguably shallow as a concept and too easy as execution, a series of near-identical photographs is popular among curators, and certainly has staying power, having survived since August Sander's *People of the 20th Century*, Irving Penn's *Worlds in a Small Room*, and Bernd and Hilla Becher's *Typologien, Industrieller Bau*. One of the great advantages of a typology is that, provided you've got the idea and the style right, the more images you add, the stronger it becomes. Good typologies are different in either concept or execution from what most people expect. The fuller they become, the more they establish just what a good idea you had. When the audience reaction becomes something like "I never realized there was so much of that around," and "I never noticed," you are on the rising curve of success.

So, what to choose? Forget gas stations; the artist Ed Ruscha did that in 1963 with *Twentysix Gasoline Stations* and thereby kicked off the whole typology craze. Industrial structures? Forget it. The Bechers from Düsseldorf did that

endlessly, and despite it being repetitively boring managed to found a whole new school of photography on the basis of it (one of their alumni, Andreas Gursky, currently holds the world record for price paid for a photograph, with his *Rhein II*). It's becoming a slightly crowded market for subject matter, so you'll need to find a subject with an idea that really resonates.

Check out what's been done already so that you don't waste your time doing seconds. If it's something you already have a special interest in, so much the better. Here are a few predictable or overdone ones to avoid: old cinema façades, house number plates, postboxes, unusual street signage, and eyes. And here are some recently seen typologies that seem fresher: old nuclear test sites, Japanese imitations of the Eiffel Tower, plastic bags caught on trees and bushes, and old books from public libraries.

The example here is a typology of a typology, which you might see as doubly interesting if you like these things, or

THIS SPREAD & NEXT (ALL IMAGES)
Residents of Callejon Angosto with their project portraits 12 years later, Cartagena. 2015
Colombian artist Ruby Rumié made an art project out of community, involving all the residents of the small street in which she leased her studio (Callejon Angosto means Narrow Alley). In her studio, on a table, she photographed each one from the six directions necessary to create scaled boxes as three-dimensional portraits. Each resident received their box after the show. Twelve years later, I photographed some of them with theirs.

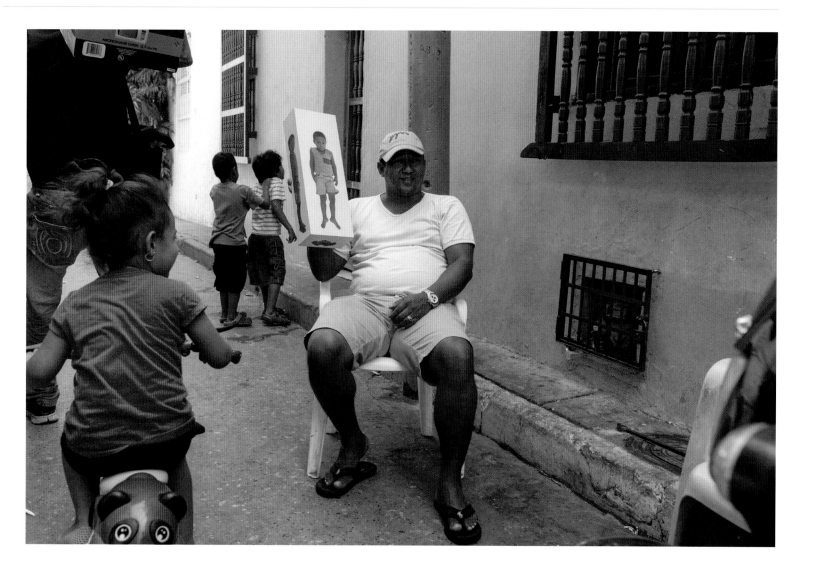

twice as questionable if you don't. In any case, it had a function, which was reportage for a book on the city of Cartagena, Colombia. In 2003, local artist Ruby Rumié documented all the inhabitants of one street in a very traditional and poor part of town, persuading each of them to be photographed in her studio from every direction: front, back, top, beneath, side. She turned the results into boxes printed with the photographs on all sides, and these formed the artwork she exhibited. After the show, she gave each person their own three-dimensional portrait. Twelve years later, we returned to see who still had them and was willing to be photographed with them.

Typologies are mainly and by definition about sets of subjects, but if you can bend the material to a distinctive style of your own, you can widen the net. For example, Nadav Kander's acclaimed book on the Yangtse River, which won the Prix Pictet, may not strictly be a typology—the subject is huge—but the way in which he photographed it, with a large format camera and restrained, formal compositions of big scenes all bathed in a yellowish haze, give it the hallmarks of this sub-genre.

48. VARIATIONS

Typology (see previous spreads) is one direction in which you can take the idea of multiple imagery tied together by a common theme. Another is a single subject treated differently anywhere from a few to many times. This technique actually has rather better creative credentials than typologies because it relates closely to the form in music known as theme and variations. I like this particularly because it's a chance to revisit Path 14: Crossover (see page 64). Anything you can steal from a different creative medium is good because there are whole new ideas and inspirations without any whiff of plagiarizing. From Mozart's *Piano Concerto No. 14* to Louis Armstrong's *Wille the Weeper* by way of Elgar's *Enigma Variations*, we could do worse than looking at how composers and musicians handle the idea of repeating something in an altered form. Maybe there are some principles that could be used in a photographic series.

The theme in music is usually a catchy melody, or at least pleasant and memorable. It's often quite short, maybe 8 or 16 bars, and good enough to stand alone, the sort of thing most people could hum. This is played first, unadorned. Next comes the first variation, followed by others, typically more and more inventive, as there's a sense of showing off the composer's imagination and skill (or the performer in the case of improvised jazz).

How can one go about varying? In music, ways of varying include adding notes or ornamentation to melody, changing the key or the time signature, altering the rhythm, adding chords underneath the melody, using different instruments, and trying different textures. Photography needs to find its own way of doing something comparable.

What can we learn from this? Critically, we need to choose a worthwhile theme. The photographic equivalent of a melody is a stable physical scene (though Bach, for instance, in his *Goldberg Variations*, did not choose a melody and instead chose the bass line). At the very least, the viewer needs to be able to see the strong link between all the variations. The other important lesson is that the theme should be almost able to stand up to being looked at alone, without variations. If you're tempted to shoot your back garden over the seasons because it's convenient, you might want to consider whether or not the view is interesting. The stronger the theme, the better the final result will be.

Then we get to the variations. This is where the virtuoso part is supposed to come in, and you can expect the varying events and happenings around your theme to vary in value. The important lesson here is: Don't be satisfied with just having variation. It needs to be a clever or surprising variation. Fu Yongjun's lovely theme and variations make a good example. He shot over time around West Lake in Hangzhou, China, where he lives, and basically leveraged his access and local knowledge to show this famous tourist attraction in non-touristy ways. One part of his book, *Lens on West Lake* (which won him the World Press Photo award), was this minimal setting of a tree and benches. He kept on returning, gradually building up variations in activity and weather. The point is that not all the variations are equally interesting, but the best are clever and raise a smile.

Fu Yongjun 1969–

Fu Yongjun, who won a 2009 World Press Photo award for this series of images, is the director of photography for the Hangzhou City Express. He has numerous other awards within China and also for the 2013 World Press Photo.

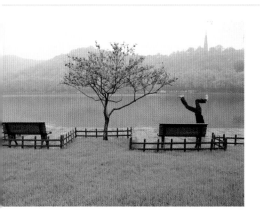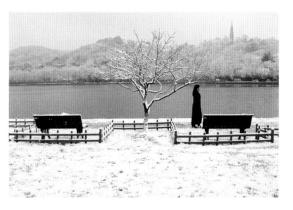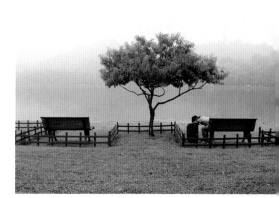

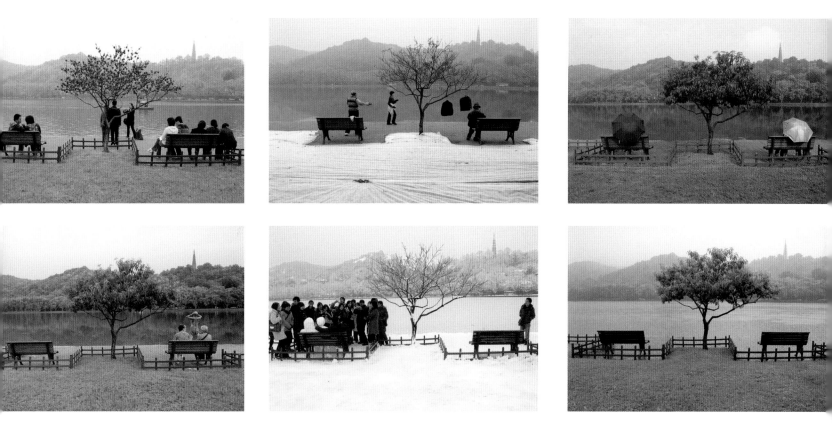

"Keep taking pictures of the same thing and watch the images mature and grow."

JAY MAISEL

49. THE THIRD EFFECT

The last two paths we covered draw their strength from being conceived as sets of images—sets destined to be displayed together, never in isolation. Now we go one step further to hone in on not just creating images that work together, but in the creativity that goes into displaying them a long time after shooting. Very simply, if you show two images next to each other, everyone will see them and judge them as a pair. Nothing too earth shattering about that, perhaps, but the dynamics of that relationship means that you can use the pairing deliberately to do something. This is very much a print phenomenon. In a book or magazine that's made up mainly of images, the visual unit is the double-page spread, not the page. And if the images are big, there will often be one on each facing spread. Any thoughtful art director or designer takes this into account.

Intentional pairing started with the first wave of European illustrated magazines in the 1920s, and the first people to experiment were the manager and editor in chief of the German publishing group House of Ullstein. It was *Life* magazine, however, that took it to maturity under its picture editor Wilson Hicks. He coined a term for it: "the principle of the third effect." As he explained, "the reader's interpretative and evaluative reaction" works on the individual images and creates something new. At its simplest, it involves "juxtaposition of two pictures with different subjects but similar designs or patterns" so that the "overvalue goes no further than amusing the reader, frequently with his not knowing exactly why." We already saw the power of juxtaposition within a single shot in Path 19 (see page 84); here, it is applied using two fully formed photographs. This doesn't mean that you have to see the possibility of the pairing while you're shooting; you just need to be able to find the connections later.

This kind of meaningful pairing works perfectly well just as visual entertainment, but you can take it further, using the ideas behind the photographs, not just their surface form. There's a long history of this, and indeed, magazine editors in the 1930s began using it to make political points in the increasing chaos of Europe. Stephan Lorant, first editor of *Picture Post*, caused uproar by juxtaposing British Prime Minister Neville Chamberlain with a dopy looking lama. Hitler, of course, came in for much more of this treatment, paired with images of, for example, the Warsaw Ghetto.

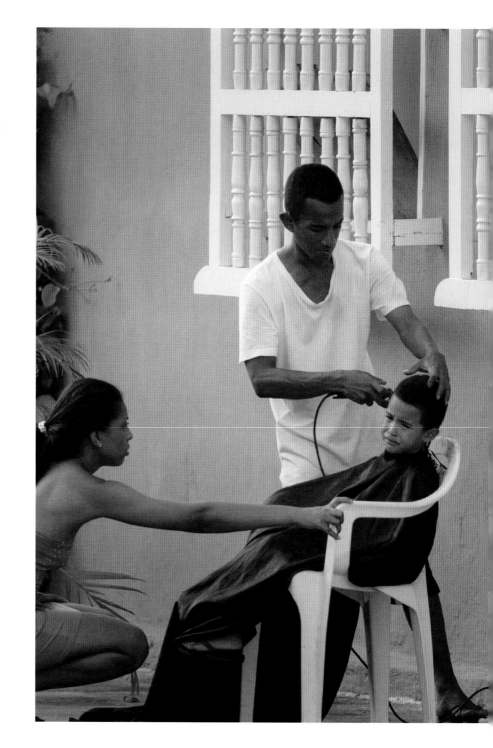

"When certain pictures are placed side be side, something happens; their individual effects are combined and enhanced, and a third effect is educed in the reader's mind."

WILSON HICKS

OPPOSITE & BELOW
Street haircut, Cartagena. 2015
Fashion show, Cartagena. 2008
Two very different kinds of hairdressing, for different reasons and different strata of society. The pairing points out these social contrasts by asking the viewer to consider them together. Seen alone, they would have quite different meanings.

Harold Evans (editor of *The Sunday Times* for many years and founder of *Condé Nast Traveler*) had strong views about the effectiveness of all this, which he called coupling: "There is nothing particularly clever about the design or the underlying idea; that is the source of this example's success. It is forceful because it is simple."

Evans also sounded a cautionary note which is still relevant, that "coupling represents such an obvious effort it runs the risk of being ponderous: nudge, nudge, wink, wink." Rather like adding an arch or cute caption to a photograph (a bad camera club habit), you always run the risk of exposing your own lack of subtlety or wit.

Construction workers, Pasacaballos, Colombia. 2015
Hat painted on horse carriage, Cartagena, 2014

The sombrero vueltiao, which means "turned hat" in the Spanish dialect of northern Colombia, is a flexible hat braided from the leaves of the caña flecha, iconic of the Coast. It's so much a part of countryside life that this worker wouldn't dream of removing his just for a safety helmet. Pairing it with its symbolic representation on the back of a horse carriage in national colors emphasizes its cultural importance.

50. CREATIVE IMAGE PROCESSING

OPPOSITE

Magnum lab printing notes

Pablo Inirio, the master printer at Magnum Photos' New York lab, made these notations on a work print for making the final print of Dennis Stock's 1955 image of actor James Dean in Times Square. The areas, with their numbers in seconds, indicate local area adjustment, mainly through burning-in.

Processing occupies a delicate place. If you are shooting Raw, processing is a necessary step because the file has much more image information than you can view on a screen or in a print. That very fact gives you a lot of choice over many basic image qualities, such as how bright, how much contrast, what color balance, etc. If the scene had a very high contrast, you might need the processing stage to recover information from the shadows or highlights. Beyond these thoroughly practical matters, however, processing can be creative. Here, though, the warning flag goes up because processing isn't what it used to be.

With film, and in the early days of Photoshop, what you could do with your negatives or digital files was limited. You could adjust brightness and contrast and, with some effort and skill, employ dodging and burning to alter parts of the image locally. Even if it seemed you could work minor miracles the tools were basic. Now, however, the software engineers are constantly finding extremely clever ways to alter all kinds of image qualities and tonal relationships.

How about de-hazing, for example? Atmospheric haze causes scattering and replaces direct reflectance from surfaces with what's called air light. It increases with distance and it adds some color, usually blue. Sounds impossible to deal with from a single image, right? Well, with some clever algorithms it can be worked out in many cases. So, assuming that you don't want that haze, this tool can clear it for you in yet another feature of Adobe Camera Raw (ACR). I'm introducing this as just one of many ways in which you can change image qualities without downright manipulation. The problem, of course, is that it tempts many people to go too far and produce strange, cartoon-like and not very photographic results. Just think of the early fad for horribly tone-mapped HDR images. They really gave HDR a bad name.

Processing, then, is an open field for doing what you want. Staying well within the bounds of normal-looking photography, it's possible to transform the atmosphere and mood of many images. For inspiration, you need only to look at the high-end world of wet-darkroom printing. In this kind of printing, the clock is running, literally, which means that dodging and burning, the techniques of choice (no other

choice, really), have to be planned in advance. The printing plan for this famous Dennis Stock photograph of James Dean (shown opposite) was made by the Magnum printer Pablo Inirio, and shows the areas for dodging (holding back the light from the enlarger) and burning (concentrating extra light). A black-and-white negative, with its long tonal scale, can handle a serious amount of such local control.

Digitally, this means using radial filters and grad filters, and some carefully and softly applied local adjustment brushes, as in the example on the following spread of Bridal Veil Falls in Yosemite National Park, California. The shot was taken on 120 Tri-X with a favorite camera, a Hasselblad SWC with a 38mm Biogon. Unfortunately, the light seal on the magazine had worn, and some light leaked onto part of the negative. This wasn't a total disaster, however, as I wanted a very dense lower area of rocks. The negative was scanned, and then processed digitally in ACR—twice.

I was happy with the first result for a while. In it, I had deliberately pushed for a strong atmosphere, emphasizing the burst of sunlight illuminating the rocks in the mid-foreground. The printing plan explains how; note how little use I made of the newer tonemapping algorithms—highlights, shadows, and clarity—despite their ability to reveal and generally smarten up an image. I stuck to traditional global controls, applied overall and then locally: exposure, contrast, whites, and blacks. This was purely a personal choice because even though I aimed for a dramatic, intense finish, I still wanted a traditional photographic feel. It seemed appropriate for a silver negative.

A year later, I came back to it afresh and decided to go for a more powerful effect and concentrate attention more in the center. The second printing plan shows how I accomplished this, and it was applied not to the original scan, but to the first version. There's a tradition in photography, particularly with black and white, of revisiting images to make new interpretations. Bill Brandt is a notable example; as time went by, he printed his images with higher contrast and deeper blacks for more graphic drama. Everyone's tastes change with time; I quite often do this as an experiment, particularly with shots that have the potential to evoke a mood.

> "There are certainly no rules about the printing of a picture. Before 1951, I liked my prints dark and muddy. Now I prefer the very contrasting black-and-white effect. It looks crisper, more dramatic, and very different from color photographs."

BILL BRANDT

RIGHT
The processing sequence begins top left with the scanned Tri-X negative, low in contrast as is typical with film negatives and covering a long range. The next step, top right, was a "straight" unadjusted positive version. The third step, lower left, shows this marked up for local adjustments to be applied. The fourth, lower right, is the result, but here marked up for a second round of local adjustment decided some months later.

OPPOSITE
Bridal Veil Falls, Yosemite. 2011
The final processing of a scanned 60x60mm black-and-white negative, in which local radial and brush adjustments raise and lower the tone and contrast of specific areas of the image. The aim was lighting drama with rich blacks, and as the sequence of smaller images shows, this is very much a matter of personal interpretation. Processing can sometimes approach creativity.

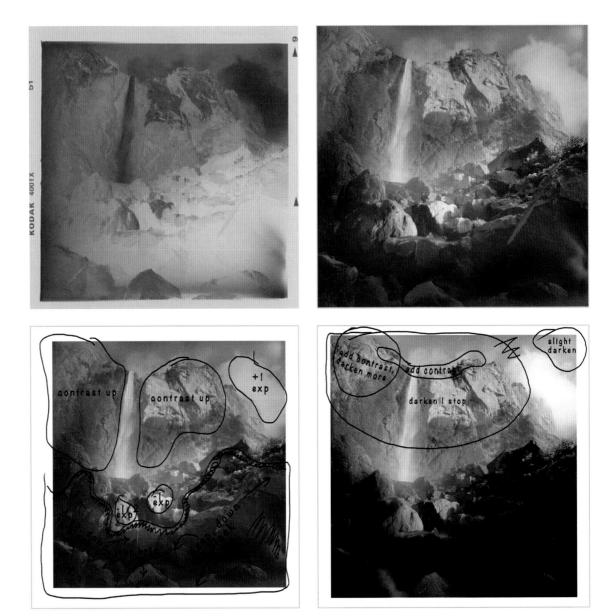

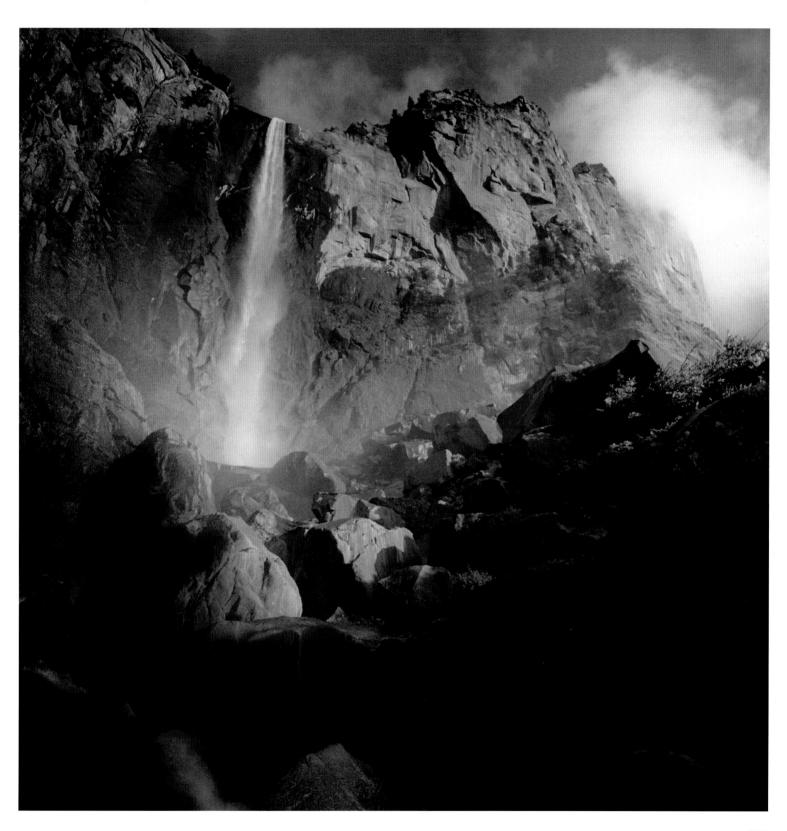

RECOMMENDED READING

I'm trying my best to stay on target, but as this is a book about being creative, you'll kindly excuse the odd choice below, the oddness being all mine. For reasons best known to publishers and authors (including me), there a lot of *The…* titles. Dates are of the original edition, but most have been re-published.

About Looking, by John Berger. 1980

Berger, as usual provocative and left-wing, makes photography political. You'll love it or hate it, as they say, but in either case he is certainly thought-provoking.

Beauty in Photography, by Robert Adams. 1981

The other Adams landscape photographer, who couldn't be more different from the more popular Ansel.

Cape Light, by Joel Meyerowitz. 1978

Meyerowitz began as a New York street photographer, then in the early 1970s switched to color (the New Color, as it became known) and an 8x10-inch view camera. *Cape Light*, in which he explored the nuances of Magic Hour around Cape Cod, became one of the best-selling photography books

Genesis, by Sebastião Salgado. 2013

Almost any book by the prolific humanitarian economist-turned-photographer Salgado is worth having, but his latest is remarkable for being a surprisingly original take on well worn themes: the beauty of nature and the lives of people who still live in harmony with it. A classic example of creativity applied to material that you might think has been done to death.

Guy Bourdin: Untouched, by Guy Bourdin. 2016

Bourdin, the first photographer featured in this book, was of the generation of 60s and 70s photographers who were iconoclastic and full of outrageous ideas at a time when imagery could be sexy, color-saturated, and popular, before postmodernism raised its dreary head. A well overdue retrospective from Steidl, the publisher whose list is an authoritative view of the world of photography (see also *The Americans* and *The Decisive Moment*).

Let Us Now Praise Famous Men, by Walker Evans and James Agee. 1941

Evans and Agee spent several weeks in Alabama in 1936 with the sharecropping families that are the subject of this book about the Great Depression. A heartfelt combination of images and words, in an attempt to forge a new kind of visual-literary experience.

Looking at Photographs, by John Szarkowski. 1973

Szarkowski was determined to overhaul photography and make it recognized as a fully fledged art form when he took over at MoMA as Director of Photography in 1962. He succeeded. In 1973, he wrote this groundbreaking book on how to look at photographs beyond the obvious and superficial.

Mirrors Messages Manifestations, by Minor White. 1969

The first monograph by the original spiritual photographer, friend of Edward Weston and Ansel Adams, who saw emotion and mystery in photographic abstraction. We're in the land of *Equivalents* here, as defined by Alfred Stieglitz in 1925. As White wrote, "I had a feeling about something and here is my metaphor for that feeling." Transcendental stuff.

On Photography, by Susan Sontag. 1977

Hard to avoid, this one; arguably the first serious and literary survey of photography as it was in the 1970s. Not everyone's cup of tea because of its intellectual approach.

Photodiscovery, by Bruce Bernard. 1980

A highly personal selection of photographs from 1840 to 1940 from the late Bruce Bernard, picture editor of London's *Sunday Times* magazine. Refreshing and enthusiastic.

Pictures on a Page, by Harold Evans. 1978

Though dated in many respects, this remains the definitive book on how photographs are laid out in newspapers, books, and magazines. Things that art directors and picture editors do that you never thought about. Written by one of the great newspaper editors.

Requiem, by Horst Faas and Tim Page. 1987

The premise is obvious once you think about it (images of the Vietnam war by the photographers who died in it, on both sides), but it continues to haunt. Very powerful—so well put together, so beautifully produced. The only multi-photographer compilation in my list.

Richard Avedon: Photographs 1946-2004, by Richard Avedon. 2014

Avedon, featured here under Path 21: Unguarded Expression, was a master of both uncompromising portraiture and fashion. This is probably the best compilation of his work over a long career.

Sleeping by the Mississippi, by Alec Soth. 2004

A tightly edited (just 46 images) photographic journey along the Mississippi that bridges the usually uncrossable gap between fine art and documentary. A highly personal view with a large-format film camera that mixes place, people, and their possessions.

Slightly Out of Focus, by Robert Capa. 1947

Laconic, a bit too smart in the style of the forties, and self-declared as a script proposal for a Hollywood biopic on himself. But emotionally honest even if some of the factual details slip. About Capa's coverage of the war—D-Day is especially compelling.

Sumo, by Helmut Newton, revised by June Newton. 2009

You generally like or hate Helmut Newton's slightly perverted scenarios, but either way there is no denying his creative imagination. I personally love his work. The original of *Sumo* weighed in at 78lbs (35.4kg)—that's not a typing error—and came with its own stand. The new version is more reasonable.

The Act of Creation, by Arthur Koestler. 1964

After all this time, there is no other book that successfully and practically explores the imaginative machinery behind creativity. As a backgrounder, hard to beat, and if it seems at times a little hard going for its intellectual blend of philosophy and psychology, it's hard to dislike any heavy writer who begins his explanation with how jokes work (with some good examples).

The Americans, by Robert Frank. 1959

Of course, everyone knows this book, so it wasn't a struggle to put it on the list. It changed American photojournalism—very few people liked it at first—and it also changed the way (some) Americans saw their country. Almost all the reviews were terrible, and Frank recalls that "people said, 'That's too sad. We don't want to look at that.'" There's a new edition, edited by Frank, published by Steidl. One lesson from this is that it doesn't matter what most other people think is good subject material and how it should be treated. If it interests you, shoot it.

The Decisive Moment, by Henri Cartier-Bresson. 1951 (reprinted 2014)

A classic of observation, timing, and composition with more than a touch of Surrealism (the kind I write about in this book). Steidl have produced a beautiful new version—a facsimile really—of this long-unobtainable book. Still expensive, but worth it.

The Mind's Eye: Writings on Photography and Photographers, by Henri Cartier-Bresson. 2004

A slim volume, poetic almost, and the master at his most quotable, with his customary hauteur.

The Ongoing Moment, by Geoff Dyer. 2005

From someone who doesn't even own a camera (his admission, and normally a red flag), this is a wonderful and erudite stroll through photography that classifies pictures in a Borges-like way (hats, for example, and overcoated men in the background), Any writer who can describe William Eggleston's photographs as "like they were taken by a Martian who lost the ticket for his flight home and ended up working at a gun shop in a small town near Memphis" has my vote.

The Painter's Secret Geometry, by Jacques Bouleau. 1963

How painters (who of course had a lot more time than photographers to spend on their images) throughout the ages calculated their compositions. Did you know that Botticelli's *The Birth of Venus* was designed musically?

The Photographer's Vision, by Michael Freeman. 2011

Not sure about the etiquette in plugging my own books, but of all of them—and there've been quite a few—this one is probably the most relevant to what we're talking about here. It's a view of photography across the world and through time, with the work of some of the world's best practitioners (and not at all the same hoary old examples you might be used to).

The Photography of Nature & The Nature of Photography, by Joan Fontcuberta. 2013

Maybe I should have included him under Path 40: Photo Illustration. His intentions are subversive, and he invents highly unlikely events. Conspiracy theorists might just love or hate. Quite mad, possibly brilliant.

Understanding Media: The Extensions of Man, by Marshall McLuhan. 1964

Rather out of fashion these days, and famously unreadable at the time (which was part of its appeal), but McLuhan coined "global village" and "the medium is the message." A couple of chapters relate directly to photography. This is the classic that defined mass media in the 1960s.

William Eggleston's Guide, by William Eggleston. 1976

Either the man who made color photography and casual choice of subject artistically acceptable, or the master of the banal, Eggleston focused on a kind of Americana with a Southern edge. In any case, his work was highly influential, and a key weapon in John Sarkowski's MoMA campaign to take over the world of photography in the 1970s. This is his seminal book.

Worlds in a Small Room, by Irving Penn. 1974

Penn, better known for his still-life and fashion work, usually for *Vogue*, built for himself what he called an "ambulant studio" that he took around the world for portraiture, so committed was he to the "sweetness and constancy to light that falls into a studio from the north sky." What, you've seen this done already? Avedon's *In the American West* and countless others? Penn did it first, starting in 1948 in Peru.

INDEX

PICTURE CREDITS

Ilex Press would like to acknowledge and thank those photographers and their agents who have kindly provided the following photographs. All other images are by Michael Freeman.

11 © Estate of Guy Bourdin/Art + Commerce; 15 photo Art Kane, courtesy Art Kane Archive; 16 Trent Parke/Magnum Photos; 17 Ernst Haas/Getty Images; 42–3 Aperture Foundation Inc, Paul Strand Archive; 48–9, 50–51 Robert Golden; 60, 61, 62–3 Jacob Aue Sobol/Magnum Photos; 76, 77 Bruce Gilden/Magnum Photos; 79 Dave Schiefelbein/Getty Images; 85 Library of Congress, Prints and Photographs Division; 97 Photo Richard Avedon © The Richard Avedon Foundation; 102–3, 106–7 Richard Kalvar/Magnum Photos; 110 FineArt/Alamy; 129 Siegfried Hansen; 132–3 courtesy Bartle Bogle Hegarty Ltd, photo Alan Brooking; 134–5 Gueorgui Pinkhassov/Magum Photos; 146–7 Alex Webb/Magnum Photos; 156 Stuart Franklin/Magnum Photos; 157 Sean Gallup/Getty Images; 162, 163 Harry Gruyaert/Magnum Photos; 169 Eugene Atget/Private Collection/ Bridgeman Images; 170 Digital image, The Museum of Modern Art, New York/Photo Scala, Florence; 174–5 Miss Aniela; 179 Bruce Gilden/Magnum Photos; 180–81 Frans Lanting/Corbis; 192–3 Trent Parke/Magnum Photos; 202, 203, 204–5 Alec Soth/ Magnum Photos; 211 Fu Yongjun; 217 Dennis Stock/Magnum Photos.